A Mile and a Half of Lines

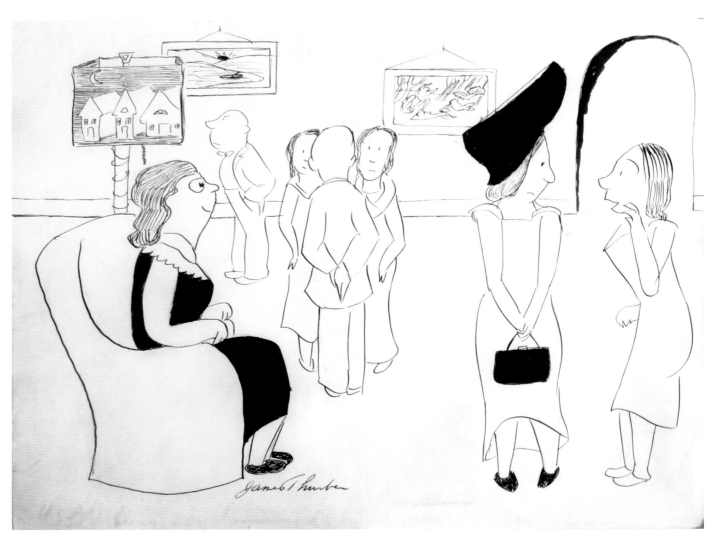

The Art Show

A Mile and a Half of Lines
The Art of JAMES THURBER

Michael J. Rosen

with contributions from
Ian Frazier, Seymour Chwast, Liza Donnelly,
Michael Maslin, and Rosemary Thurber

TRILLIUM, an imprint of
THE OHIO STATE UNIVERSITY PRESS · COLUMBUS

Library of Congress Cataloging-in-Publication Data
Names: Rosen, Michael J., 1954– editor. | Thurber, James, 1894–1961. Works.
 Selections.
Title: A mile and a half of lines : the art of James Thurber / Michael J. Rosen ;
 with contributions from Ian Frazier, Seymour Chwast, Liza Donnelly,
 Michael Maslin, and Rosemary Thurber.
Description: Columbus : Trillium, an imprint of The Ohio State University
 Press, 2019. | Includes bibliographical references.
Identifiers: LCCN 2019012317 | ISBN 9780814214008 (cloth : alk. paper)
Subjects: LCSH: Thurber, James, 1894–1961—Criticism and interpretation.
Classification: LCC NC1429.T47 M55 2019 | DDC 741.5/6973—dc23
LC record available at https://lccn.loc.gov/2019012317

Cover and text design by Sara Thurber Sauers
Type set in Quadraat

PRINTED IN CHINA

Invaluable support for this book was generously offered by Rosemary A.
Thurber, Donn F. Vickers, Thomas McCollough, Grant Morrow, and Cordelia
Robinson. Additional support was provided by Furthermore, a program of the
J. M. Kaplan Fund, as well as from an anonymous donor.

Furthermore:
a program of the J.M.Kaplan Fund

If all the lines of what I've drawn were
straightened out, they would reach a mile and a half.
I drew just for relaxation, between writing.

JAMES THURBER

Contents

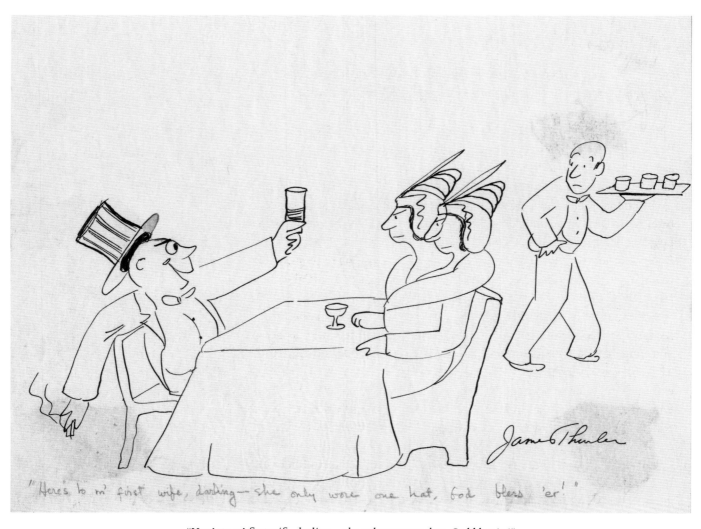

"Here's to m' first wife, darling—she only wore one hat, God bless 'er!"

A Few Toasts

THE PREPARATION OF THIS BOOK, even while it seemed "the times are falling apart like dunked toast"[1] (as a 1954 letter from Thurber himself stated—the year I was born!), has been the richest and most fulfilling of my collaborations with the three people who oversee the James Thurber estate and canon: James's daughter, Rosemary Thurber; his granddaughter, Sara Thurber Sauers; and Barbara Hogenson of the Barbara Hogenson Agency. For some thirty-five years, I have been honored by their trust and confidence as we have endeavored to re-present James Thurber's canon. My gratitude knows no bounds.

Additionally, I am indebted to the instrumental support and contributions from Tanya Dean Anderson. Likewise, my thanks to Jolie Braun, Eric Johnson, Lisa Iacobellis, and Rebecca Jewett of Ohio State University Libraries Rare Books and Manuscripts Library, to Therese Terndrup for her preliminary research, and to Nannette Maciejunes and Carole Genshaft of the Columbus Museum of Art.

For much of his adult life, Thurber's best-selling books made him a recognizable celebrity. He lived something of "the goldfish life," as actor and comedian Ed Wynn described it in a 1932 "Talk of the Town" piece that Thurber wrote. (At the time, Wynn's radio program, "The Fire Chief," was extremely popular.) Traveling by train to Manhattan, the celebrated Wynn entered the dining car for breakfast. "'Hardly was I seated,' said Mr. Wynn, 'when a woman sent a waiter to me with a piece of toast and asked me to autograph it. So-o-o-o I took a bite out of it and sent it back.'"[2]

And so, on behalf of the Thurber family and myself, a toast to Tony San-filippo and The Ohio State University Press for allowing this book to exclaim and reclaim Thurber's notoriety as an artist.

A Mile and a Half of Lines

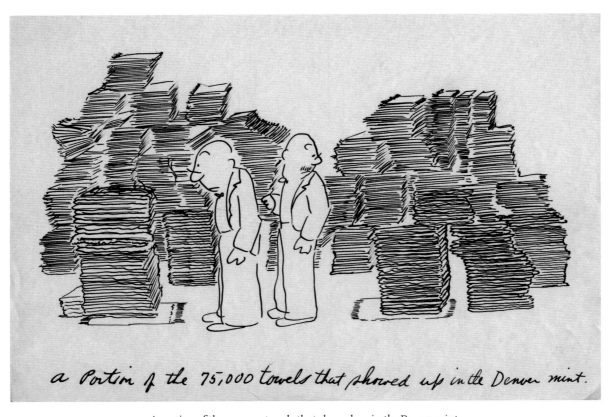

a Portion of the 75,000 towels that showed up in the Denver mint.

A portion of the 75,000 towels that showed up in the Denver mint.

This illustration of James Thurber's could be depicting me, me and a research librarian, standing among archival file boxes, original drawings, tear sheets, magazines, oral-history transcripts, letters, and all the other "materials" that are part of the permanent Thurber archive housed at the Ohio State University Libraries' Rare Books and Manuscripts Library. But, no, the unconquerable stacks in the drawing are bath towels.

The illustration is a metaphor Thurber concocted when the *New Yorker* was considering photo-documenting all visitors. "The office will, of course, be as cluttered up, finally, as the Denver mint was during the Harding administration when secret service men discovered 750,000 [sic] bath towels stacked up there."[1]

"Cluttered up" does not describe the Rare Books and Manuscripts' rooms. But to carry on Thurber's metaphor, the daunting challenge of discovering, requisitioning from the vaults, photographing, scanning, note-taking, and organizing using the library's finding aid that enumerates over 3,000 items—let's just say I could have neatly folded 75,000 towels faster.

One-Line Storyteller

An Introductory Note by Michael J. Rosen

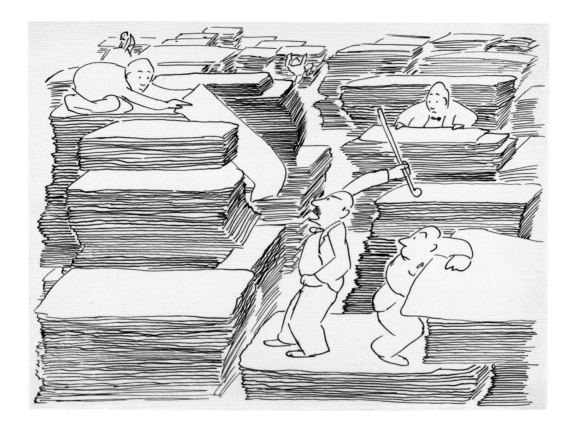

HOW I'D LOVE TO SAY THIS book allows us to see the full range of the artistic career of arguably the best-known twentieth-century cartoonist—his early and late periods, his work in various media . . . except there were less than three decades in which Thurber's drawings appeared and very little to witness other than the shifts from pencil to pen and ink to chalk as Thurber's complete blindness approached.

Thurber was well aware of his slight breadth of range. In a preface to the 1950 edition of his first book of drawings, *The Seal in the Bedroom and Other Predicaments* (1932), he wrote,

> I went back over these drawings in the wistful hope that I would find
> evidence on which to base a fond belief that my work, or fun, somehow
> improved after this "first phase." The only change I could find, however,

in comparing old and recent scrawls, was a certain tightening of my lack of technique over the eras, the inevitable and impure result of constant practice. In the case of a man who cannot draw, but keeps on drawing anyway, practice pays in meager coin for what it takes away.[2]

Likewise, I'd like to emphasize that this book is the first to truly consider James Thurber's opus from one or another art historical or sociological point of view—except it's the first, period. And while Thurber's work was continually presented in one-man shows at small galleries and in group exhibits at major art institutions, and while his unmistakable drawings appeared in a host of magazines beyond the *New Yorker*, on dresses and ties and scarves and linens, on the covers and interiors of other books—to say nothing about his greater renown as a writer—with his death in 1961, his popularity and stature have waned.

Therefore, this book is a rallying cry: a host of preeminent cartoonists and writers reacquainting us with the significance and importance of Thurber's drawings, which changed the nature of the cartoon in America and paved the way for an entirely different approach to visual art. It's a showcase of some 250 drawings that coincides with the first major exhibit of Thurber's art. Even though the Columbus Museum of Art, back when it was called the Columbus Gallery of Fine Arts, did mount two smaller shows of Thurber's work, and even though works of Thurber's appeared in several solo and scores of group shows during and after his lifetime, this year, 2019, the 125th anniversary of Thurber's birth, offers the first chance to review the character of his contribution to American illustration, cartooning, and children's books.

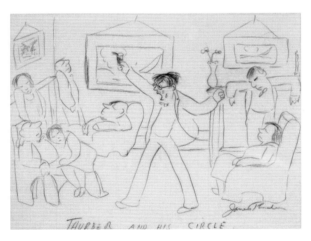

Thurber and His Circle

There are several variations of this self-portrait—Thurber holding forth—with a variety of bored or sleepy listeners. The version to the right of Thurber declaiming to late-night guests appeared in the *New Yorker*.

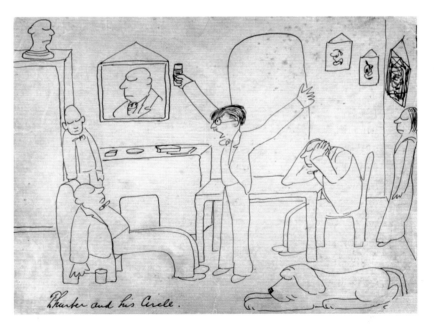

Thurber and His Circle

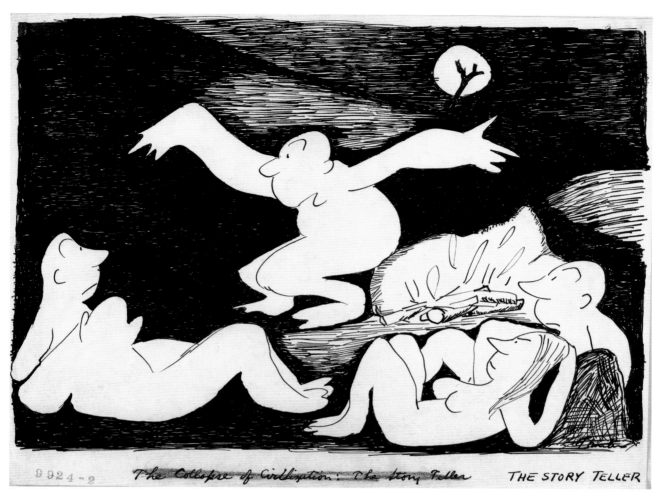

The Story Teller

JAMES THURBER was a storyteller, even in his one-line captions. We always find the subjects in the midst of things. Something has just happened . . . and something's about to happen, but in the interval of that ellipsis? It's a moment that invites guessing, intuiting, extrapolation—and still no clear or even likely answers arise. It's only the middle—the *muddle*—of things with which we are left. Amusingly stranded with a permanent fascination, we have a renewable opportunity to project our own experiences or recollections onto the figures. Thurber's men and women, often bare as cherubic dolls, stand there unselfconsciously, waiting for us to outfit them in some context and logic.

While Thurber did not draw himself into "The Story Teller," the scene certainly reveals his most natural rhythm. Talking, reciting from memory, regaling, sharing. It's just as easy to imagine Thurber at a dinner party, at a

This is the final scene in a series of eleven drawings entitled "The Collapse of Civilization," from Thurber's first collection of drawings, *The Seal in the Bedroom and Other Predicaments.*

5

speakeasy, in the offices of the *New Yorker*, and holding forth. He's a raconteur with a photographic memory whose lines are highly polished and keenly paced, amply furnished with details but never bogged down in logistics, and delivered at a pace that only nervous energy can provide. Moreover, from his mother, Mary "Mame" Thurber, he acquired whatever gene holds the allele for perceiving the quirky shades of others' speech patterns or accents.

As Rosemary Thurber recalls, "My father always made fun of the Ohio/Midwest twang. [His wife] Helen always kidded him about the fact that the minute he stepped off the train in Columbus he automatically started talking like a native. It wasn't 'Ohio' any more, it was 'Ohia.' And his imitative skills were directly inherited from his mother, Mame, a gifted prankster.

"Getting the right words was a challenge and labor of love to my father. And it was a celebration when exactly the right word came to him and was put in its place. I especially remember this when he was writing his fairy tales. A true Thurber sentence and paragraph will scan flawlessly when read out loud. No doubt one of the reasons that people love to read Thurber out loud—and audiences enjoy listening! (And why he was such a good storyteller in person.)"[3]

Newsweek's cover story of February 4, 1957, describes Thurber: "There is a touch of powerful authenticity in the sight of James Thurber, hair tumbling over forehead, raising his 6 feet 1½ inches awkwardly from a chair and flopping his long arms about like a scarecrow in Hydra-Matic drive, as he duplicates the nasal platform delivery of long-dead Ohio politicians. . . . [His] Ohio roles ring truest."[4]

If this subject, "Thurber and His Circle," weren't an image he repeatedly drew for friends or guests or the trapped or entranced person next to him at a restaurant's banquette, we might not make such a strong connection between this and the one wide-awake storyteller gesticulating at the campfire. But Thurber was very much the person at the evening's wind-down around some equivalent to that campfire, regaling interested, bored, tipsy, or sleepy friends with anecdotes of growing up in Columbus or working at the city's newspaper in his early twenties or from his extended stays in France or England or Bermuda. He's the one composing limericks or poems in his head, or hilarious, if rather garish, portraits of colleagues at the *New Yorker* and their latest bullheaded treatment of his work. He's the one venting about the nation's sunk economy, the world's lame attempts at peace, the irresponsible education of young people, or any number of topics about which he felt passionately both on the page and in person. He's the "nightblooming monologist,"[6] as biographer Harrison Kinney describes him. He's the "pertinacious blurber," as a Connecticut neighbor, the *Herald Tribune* book critic Lewis Gannett, rhymed in a Thurber birthday poem from 1951.[7]

I have made this introduction a shorter note because Dorothy Parker's insightful and more personal introduction to her friend James Thurber's first book of drawings is included next. So let me conclude this with an envoi

IN THURBER'S drawings husbands and wives drove each other absolutely, unconditionally crazy while huge silent dogs looked on like Buddhas, patiently waiting for the human race to come to its senses, or not, as the case may be."[5]—Wilfred Sheed

from Shakespearean scholar and author Edward Hubler: "These drawings are creations in their own right. They are Thurber. There is no other word for them. You must accept them, like certain passages in Shakespeare, even when you don't understand them, since the alternative is to reject them, and that is unthinkable. Sometimes they make you feel like Bottom [a comical character in *A Midsummer Night's Dream*] after he has awakened from his dream: 'I have had a most rare vision. I have had a dream, past the wit of man to say what dream it was: man is but an ass if he go about to expound this dream.' Here are the pictures. Look, and dream for yourself."[8]

A NOTE ON THE DRAWINGS Throughout this book some Thurber drawings are printed solid black on the white page. Others are printed in full color—even if the color is only the original page's tone and the shade of graphite, chalk, or ink used.

Prior to this book, all Thurber drawings in his previous books and magazines were printed as solid black on a page's white background. Even his covers for the *New Yorker*, which represent the very few works with any shading or color, were reproduced by photographing the original art, enlarging or shrinking it to the layout's requisite dimensions, adjusting contrast to eliminate paper color and texture, and removing or cropping out any extraneous lines, shadows, handwritten notes, or captions. In this book, if original art was not available—many of Thurber's most notable cartoons were freely given to friends or lost—the drawings are also reproduced in this familiar manner.

But when actual artwork is available, or in some cases, magazine tear sheets, the digital scans for this book do show the subtle graduations of paper color: off-whites, creams, and tans, as well as the yellows typically used as second sheets for carbon-paper copies.

And, when of interest, incidental lines, cropping instructions, or remarks by Thurber or the *New Yorker*'s art department are included. Also present in these images, despite archival and preservation measures, are artifacts of the initial production process and the aging while in different storage places: ghosts of rubber cement and tape; foxing and stains; warping and tears; ink bleeding or transferring to adjacent sheets. Thurber's preferred "canvas" was whatever he had on hand: notepads, typing paper, craft paper, or even cardboard; he never considered sketch books or archival papers. Nor did he treat his drawings as valuable art that warranted acid-free folders, glassine envelopes, or a temperature/humidity controlled storage system.

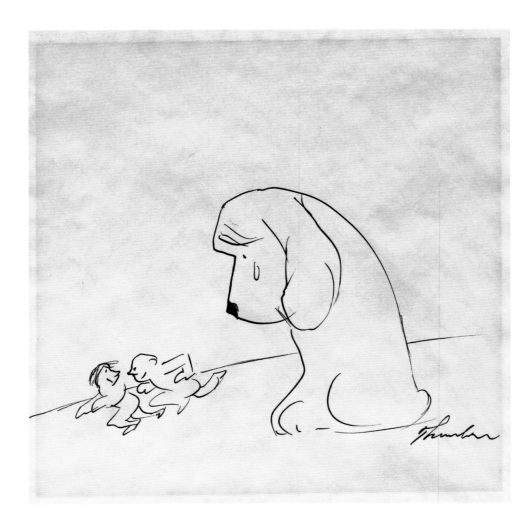

This unpublished, untitled drawing offers an opportunity to show how "simple lines," when inked from Thurber's hand, offer a bounty of information, even as they welcome a similar amount of interpretation. There's description and identity of each figure in play. There's an evocation of mood as well as action. And then the lines cohere into a composition—people are helpless but to make an attempt, however tentative, to recall or create some familiar context for this entirely unfamiliar content.

The tear on the dog's cheek—a tapered, drooping U—may be the first thing noticed, once the splotch of a nose, nearly dead center, focuses the attention: That tear is an unhurried yet unlabored gesture. It draws us to the slightly elongated dot (little more than an errant comma) that is the eye. Above that, the furrows of the brow echo the curl of the toes and the one long slope of the dog's back. (They even lead the eyes to the running woman's hairs, each a blurry repetition of the dog's baleful expression.) What are the humans—plump balloons inflated with the artist's inspiration—doing exactly . . . or even inexactly? Racing? Chasing? Fleeing? That hardly crosses one's mind.

It's the giant dog's posture and state of mind that we study. Is its posture one of resignation? Is the tear offered in pity? Or is the dog feeling left out of the fun, stuck in the foreground?

Upon seeing this newly discovered drawing, Rosemary Thurber wrote, "First I smile and then comes weeping. I believe it's pity (maybe when it was drawn it could have been resignation, but I don't think so). This is what I learned from my father from earliest times: dogs are better, kinder, and smarter. If only they were in charge. . . ."[9]

In fact, Thurber wrote consistently about animals' instincts being much more suited to life on the planet than *Homo sapiens'* choice of logic and imagination: "Abstract reasoning, in itself, has not benefited Man so much as instinct has benefited the lower animals. In moving into the alien and complicated sphere of Thought and Imagination he has become the least well-adjusted of all creatures on the earth and, hence, the most bewildered."[10]

James Thurber's *The Seal in the Bedroom and Other Predicaments*, 1932

An Introduction by Dorothy Parker

ONCE A FRIEND OF A FRIEND of mine was riding a London bus. At her stop she came down the stair just behind two ladies who, even during descent, were deep in conversation; surely only the discussion of the shortcomings of a common acquaintance could have held them so absorbed. She heeded their voices but none of their words, until the lady in advance stopped on a step, turned, and declaimed in melodious British: "Mad, I don't say. Queer, I grant you. Many's the time I've seen her nude at the piano."

It has been, says this friend of my friend's, the regret of her days that she did not hear what led up to that strange fragment of biography.

But there I stray from her. It is infinitely provocative, I think, to be given only the climax; infinitely beguiling to wander back from it along the dappled paths of fancy. The words of that lady of the bus have all the challenge of a Thurber drawing—indeed, I am practically convinced that she herself *was* a Thurber drawing. No one but Mr. Thurber could have thought of her.

Mr. James Thurber, our hero, deals solely in culminations. Beneath his pictures he sets only the final line. You may figure for yourself, and good luck to you, what under heaven could have gone before, that his somber citizens find themselves in such remarkable situations. It is yours to ponder how penguins get into drawing-rooms and seals into bedchambers, for Mr. Thurber will only show them to you some little time after they have arrived there. Superbly he slaps aside preliminaries. He gives you a glimpse of the startling present and lets you go construct the astounding past. And if, somewhere in that process, you part with a certain amount of sanity, doubtless you are better off without it. There is too much sense in this world, anyway.

These are strange people that Mr. Thurber has turned loose upon us. They seem to fall into three classes—the playful, the defeated, and the ferocious. All of them have the outer semblance of unbaked cookies; the women are

IN A LETTER to editor Harold Ross from 1938, Thurber gripes about how the magazine's art committee turned down a cartoon because they assumed that the male figure's baldness was the point of the humor. 'The fact that one sees no hair on my men does not mean they are bald. George Bellows's prize fighters had no faces, but that didn't mean they had no faces.'"[1]

of a dowdiness so overwhelming that it becomes tremendous style. Once a heckler, who should have been immediately put out, complained that the Thurber women have no sex appeal. The artist was no more than reproachful. "They have for my men," he said. And certainly the Thurber men, those deplorably désoigné Thurber men, would ask no better.

There is about all these characters, even the angry ones, a touching quality. They expect so little of life; they remember the old discouragements and await the new. They are not shrewd people, nor even bright, and we must all be very patient with them. Lambs in a world of wolves, they are, and there is on them a protracted innocence. One sees them daily, come alive from the pages of the *New Yorker*—sees them in trains and ferryboats and station waiting-rooms and all the big, sad places where a face is once beheld, never to be seen again. It is curious, perhaps terrible, how Mr. Thurber has influenced the American face and physique, and some day he will surely answer for it. People didn't go about looking like that before he started drawing. But now there are more and more of them doing it, all the time. Presently, it may be, we shall become a nation of Thurber drawings, and then the Japanese can come over and lick the tar out of us.

Of the birds and animals so bewilderingly woven into the lives of the Thurber people it is best to say but little. Those tender puppies, those faint-hearted hounds—I think they are hounds—that despondent penguin—one goes all weak with sentiment. No man could have drawn, much less thought of, those creatures unless he felt really right about animals. One gathers that Mr. Thurber does, his art aside; he has fourteen resident dogs and more are expected. Reason totters.

All of them, his birds and his beasts and his men and women, are actually dashed off by the artist. Ten minutes for a drawing he regards as drudgery. He draws with a pen, with no foundation of pencil, and so sure and great is his draughtsmanship that there is never a hesitating line, never a change. No one understands how he makes his boneless, loppy [sic] beings, with their shy kinship to the men and women of Picasso's later drawings, so truly and gratifyingly decorative. And no one, with the exception of God and possibly Mr. Thurber, knows from what dark breeding-ground come the artist's ideas. Analysis promptly curls up; how is one to shadow the mental processes of a man who is impelled to depict a seal looking over the headboard of a bed

occupied by a broken-spirited husband and a virago of a wife, and then to write below the scene the one line "All right, have it your way—you heard a seal bark"? . . . Mad, I don't say. Genius, I grant you.

It is none too soon that Mr. Thurber's drawings have been assembled in one space. Always one wants to show an understanding friend a conceit that the artist published in the *New Yorker*—let's see, how many weeks ago was it? and always some other understanding friend has been there first and sneaked the back copies of the magazine home with him. And it is necessary really to show the picture. A Thurber must be seen to be believed—there is no use trying to tell the plot of it. Only one thing is more hopeless than attempting to describe a Thurber drawing, and that is trying not to tell about it. So everything is going to be much better, I know, now that all the pictures are here together. Perhaps the one constructive thing in this year of hell is the publication of this collection.

And it is my pleasure and privilege—though also, I am afraid, my presumption—to introduce to you, now, one you know well already; one I revere as an artist and cleave to as a friend. Ladies and gentlemen—Mr. James Thurber.

The Line of Matisse or a Doodling Child?

"Drawn by James Thurber the boy artist from the corn belt."[1]

His style of drawing is completely his own. Even an unsigned Thurber
is as unmistakable as an unsigned kangaroo.[2]
—ROSEMARY AND STEPHEN VINCENT BENÉT

The most wonderful thing to me about Thurber's cartoons was how
they are a perfect example of how the point of a cartoon is not to show
off the cartoonist's mastery of perspective or anatomy, or that he or she
can render a horse—or a sea—better than anyone else on the planet.
Not that I can tell you what the point is, other than it has a lot more to
do with being funny than anatomy.
—ROZ CHAST, cartoonist for the *New Yorker*

THE BRITISH PAINTER AND CRITIC Paul Nash was an early advocate
of Thurber's work, and considered the cartoonist a draughtsman "of the
single line, using it as a child might—carefully—with protruding tongue;
or apparently vaguely scribbling, which Thurber affects, and Matisse."[3] So,
somewhere between a child scribbling and Matisse, Nash locates "the boy
artist's" inimitable quality of line. (Yes, Thurber sometimes signed his letters
and notes with that appositive.) Nash's attention surely pleased Thurber, if he
found himself repeating to interviewers over the years that he did not aspire
to be a "fine artist," and that he was not in a league with twentieth-century
masters. In fact, Thurber frequently balked at the idea of being a serious
artist. He never studied art or even imagined that what he was doing would
ever be considered "art." Drawing for him was child's play that simply evolved
into "adult's play." It was, like smoking cigarettes or clinking ice cubes in a
glass, something one did while waiting for or even while doing other things.

(The art of writing, however, Thurber took very seriously. His stature as a
serious writer was foremost in his mind, even while aspiring and apprentic-
ing, even before the string of best-selling books, even as he needed to defend
humor as a serious thing itself. As he confesses, "I write mostly soi-disant

humor . . . since I haven't brains enough to write more solid articles and wouldn't if I could. I often worry about my future since I am no doctor and at best but a mean scrivener, but out of all the things one does, from pipe fitting to testing seamless leather belting and from ceramics to statesmanship, I can do only one thing, even passably, and that is make words and space them between punctuation points."[4])

"Child's play" is not to diminish his talent. The notion that his drawings resemble those that a child might create—alternately mentioned with wonder and with derision by viewers, readers, and critics—never escaped Thurber. Rather, it dogged him throughout the decades when he published cartoons weekly in the *New Yorker*. His daughter Rosemary recalls Thurber frequently recounting a version of what he said in a televised interview on Alistair Cooke's *Omnibus*: "Some people thought my drawings were done under water; others that they were done by moonlight. But mothers thought that I was a little child or that my drawings were done by my granddaughter. So they'd send in their own children's drawings to the *New Yorker*, and I was told to write these ladies, and I would write them all the same letter: 'Your son can certainly draw as well as I can. The only trouble is he hasn't been through as much.'"[5]

In his acceptance speech for an award from the National Cartoonists Society in honor of his contributions in the field of humor, he said, "As a man who came, untrained and untaught, into cartooning, like a presumptuous child invading a roomful of accomplished adults, I am especially moved by the honor of the award the grownups in graphic art have given me tonight. Some years ago my eye doctor told me that it was a miracle I didn't go completely blind when I was seven years old, and he added, thoughtfully, 'It's hard to believe God really wanted you to do these drawings.'"[6]

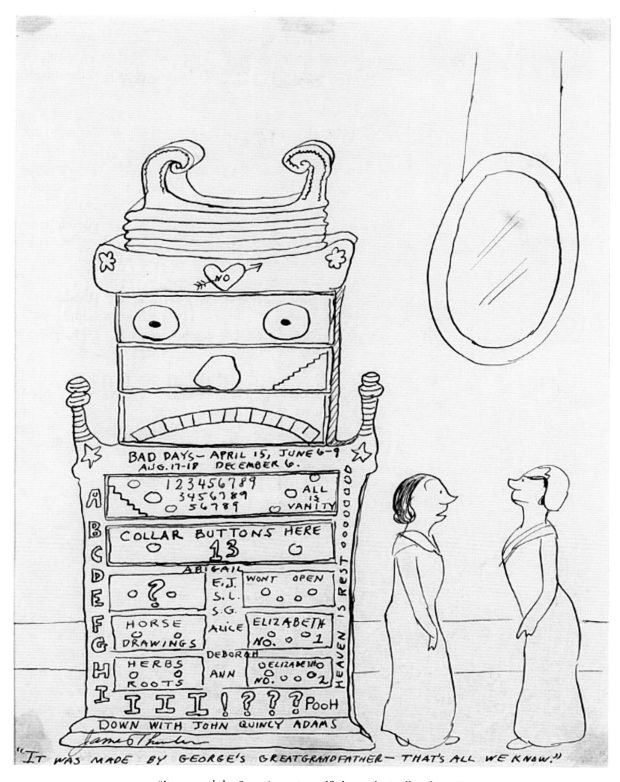

"It was made by George's greatgrandfather—that's all we know."

◗◖ SEYMOUR CHWAST

Ordinary Except for This

JAMES THURBER'S ART is nothing like conventional drawing . . . no big noses, round eyes, or hands with four or five plump fingers. If his failing eyesight forced his anarchistic style, so be it. Whenever I've seen it, I've loved it.

Thurber examined the status of our humanity: our foibles, weaknesses, and pomposity. We laugh at other people's travail and suffer our own.

I suspect the overbearing wife, henpecked husband, and quizzical dog were always created in one take, with the characters in just the right positions. Unlike my labored art, his always had a fresh and spontaneous look. Everything just right.

It happens that man's relation to dogs figures so often as a tool to comment on our conceits and silliness. Thurber happily took advantage of that.—SC

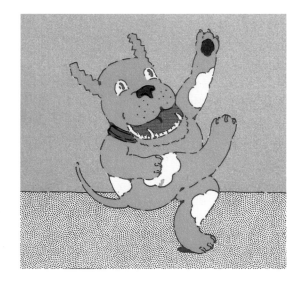

My dog is based on conventional cartoons of the 1930s. —SC

However, aside from a floor lamp and overstuffed chair, Thurber showed little interest in decorating a living room for his cartoons.

What we know and love about Thurber's style is that it is done as a measured gesture that complements the straight-laced language of the caption.

The vast majority of Thurber's work was rendered with pen and ink or pencil. Later, with deteriorating eyesight, he worked large with China marker pencil on white boards or blackboards with white chalk. (The printer then reversed this to black on white.) The round characteristic shapes were countered by jagged lines, as seen in the way he did hands.

Thurber's earliest drawings were rendered in a style that lacked distinction. This one from 1917–1918, created for Ohio State University's humor magazine, *The Sundial*, is a good example of evolving style. All illustrators evolve.

Thurber's subjects covered such topics as pretension, nudism, the battle of the sexes, animals (wild and domesticated), and conflict of most kinds. It is often said that Thurber's men have to reckon with mostly women who want to do them in. Sometimes the dog is the grown-up and the man is the puppy. With all humor, expectation is turned upside down and incongruity is king.

And somewhere therein is an underlying truth.

"Perhaps *this* will refresh your memory!" is among my favorite Thurber cartoons. Its humor comes from language, a nonsensical situation, and the wit of the line drawing itself. No one thinks using the kangaroo as evidence is unusual. That is the humor and Thurber's genius.

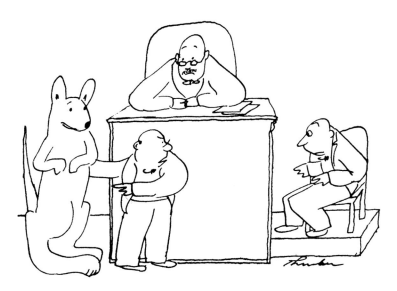

"*Perhaps this will refresh your memory!*"

The Last Flower: A Parable in Pictures, University of Iowa Press, 2007.

"Living with the Bomb," cover, The Atlantic, ca 1980, by Seymour Chwast. Used by permission of the artist.

"The Life and Adventures of Nicholas Nickleby." Poster by Seymour Chwast, Mobile Showcase Network's 1984 presentation of the Royal Shakespeare Company's production. Used by permission of the artist.

Here are two works of mine that have a visceral connection to Thurber. His book *The Last Flower*, written at a time when Nazi Germany was consuming most of Europe, was a simple parable of a single flower that inspired civilization, and which fell to destructive forces. I was struck by the simple art and message of peace. Surely this book inspired this *Atlantic* cover illustration that shows a prosaic American family with an atomic missile inexplicably sitting in the corner of the living room. Ordinary except for this.

The other illustration with a nod to Thurber is a poster I created for *The Life and Adventures of Nicholas Nickleby* that shows the protagonist with a load of characters—Nicholas has a heavy burden on his shoulders, like many of Thurber's cartoon characters.

Thurber's cartoons are a legacy that continues to inspire. I think of other, more recent, *New Yorker* cartoonists who possess Thurber's same absurd sensibilities. Roz Chast confronts her subjects head-on. They are often confused with despair and sometimes they shout out with terror. Bruce Eric Kaplan's ideas and language are close to Thurber's. His cartoons cover similar banal situations, minimal art with captions that may or may not explain the art. He offers domestic strife as well. Likewise, Glen Baxter's enigmatic ideas share Thurber's spirit.

Which shows that I am not the only one to be aligned with, or inspired by, James Thurber. At the core of our work is a desire to expose the humanity that binds us while we want our audiences to smile with us. ◆●

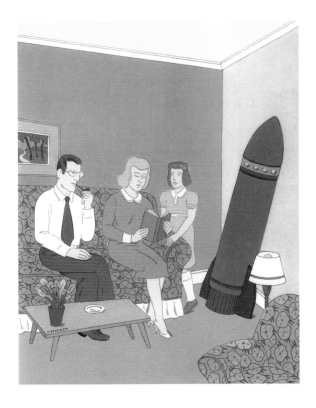

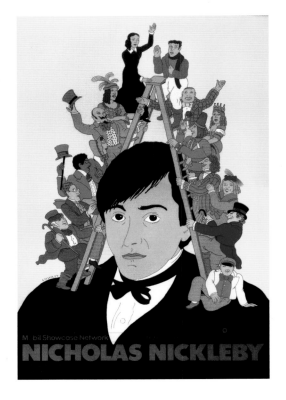

One-Line Humor, Few-Lines Drawing

Thurber's drawing is winning in the way of a man who does not know a language very well but compensates by speaking it very fast; he can't be stopped. His technically challenged style delivered a shock amid the opulently finished, subtly washed, anatomically correct *New Yorker* cartoons of mostly, in those days, art-school graduates; his more crudely amateurish successors in minimalism demonstrate by contrast how dynamic and expressive, how oddly tender, Thurber's art was—a personal art that captured in innocent scrawls a modern man's bitter experience and nervous excess.[8]

—JOHN UPDIKE, novelist, poet, essayist, and *New Yorker* contributor

Thurber entered college during World War I. His drawings for Ohio State University's humor magazine, the *Sundial*, were not so much cartoons as illustrations for articles—articles he often wrote as well, since the publication's other contributors were serving overseas.

As William Murrell discusses in *A History of American Graphic Humor* (1865–1938), while World War I continued on foreign soil, the nature of America's cartoons was highly influenced by the Bureau of Cartoons (later incorporated into the Committee on Public Information). They mailed weekly bulletins with subjects suggested by various government agencies to cartoonists nationwide. "Thus a considerable cartoon power was developed stimulating, recruiting, popularizing the draft, saving food and fuel, selling Liberty Bonds, etc. . . . [Or, cartoonists] concentrated their efforts on Uncle Sam buckling on armor, or the Kaiser with a bomb. . . . [E]xceptions . . . are almost impossible to find."[9]

Even in 1926, when Thurber entered the year-old *New Yorker* magazine as managing editor, its cartoons still suffered from regimented, typical situations, albeit post World War I. But like the writing, *New Yorker* drawings looked to eschew the pedestrian and appear more sophisticated. Often its cartoons were more cruel than clever. From its ivory tower, the magazine skipped most politics and economic issues—what other periodicals covered—and preferred to comment on society. The magazine's staff, its cabal of talented artists, became what Murrell calls "idle singers of an empty day."[10] About Thurber's first collection of drawings from the magazine published in 1932, reviewer Guy Munger suggests, "if that wasn't a golden age for cynicism then the great depression was a dream and 1950 is the start of the millennium."[11]

The middle-class, upper-middle-aged women and perpetual party goers: These were prime targets for the cartoonist's barbed pen. Very fine illustrators of the time, such as the *New Yorker*'s Peter Arno, achieved a sardonic line, but

not quite humor. From multi-paneled comics to single-pane gag cartoons to remarkable caricatures, the *New Yorker* published some of the finest art by some of the most accomplished draughtsmen.

And then Thurber arrived through the back door. Thurber, the untrained artist of few unstudied lines. Thurber of the *humorous* cartoon with a single-line caption. (The magazine had one other exception to its formally trained stable of artists: Clarence Day, Jr., whose oddly shaped people possessed rather large heads that appeared to lift straight off the page, also created very simple drawings, frequently without captions. "Picture writing" is what he called his technique, claiming that all "anyone needs is a legible style."[12])

Murrell offers his impression of Thurber's cartoons as a summation—or, perhaps, sublimation—of cartooning once his images populated the magazine's pages: "The sources of Thurber's inspiration are impenetrable; his indefinite people ooze mystery even after they are drawn. They may and probably will have other misadventures, but they will not become more definite. They are children of the subconscious, and if the hand that draws them becomes more skilled they will vanish beyond recall. And it is more than likely that Thurber knows this too."[13]

Robert Mankoff, the cartoon editor for the *New Yorker* from 1997 to 2017, calls this moment "James Thurber's Giant Swoop." He writes:

In the early twentieth century, cartoons were illustrated anecdotes:

A cartoon from *Life*, April 22, 1915, by C. F. Peters.

HE: *"Beastly snobs, those Van Grunts, I bowed to them. But they cut me dead."*
SHE: *"Never mind, here are the Smiths, let's cut them; they've tried to bow to us."*

The same style was found in the early days of the *New Yorker*:

"I think this New York traffic is terrible. If this had been in any other city we would have been at Times Square long before now."

More than thirteen years later, the more explanatory punchlines persisted. Leonard Dove, the *New Yorker*, December 15, 1928.

Even this refreshingly less stilted and beloved cartoon from 1928 comes from the same template:

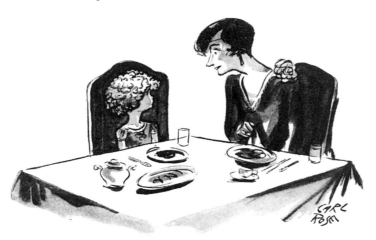

"It's broccoli, dear."
"I say it's spinach and I say the hell with it."

A cartoon from the *New Yorker*, December 8, 1928, by one of the magazine's earliest contributors, Carl Rose, who also submitted the original concept of the "Touché!" cartoon that Thurber was given to draw (see page 116).

Something more refreshing was needed, and James Thurber provided it in one fell swoop in 1932. That year, Thurber published an astonishing forty-two cartoons in the magazine. Other swoops—by Peter Arno, Charles Addams, and others—would follow, but Thurber's was the earliest and the swoopiest.[14]

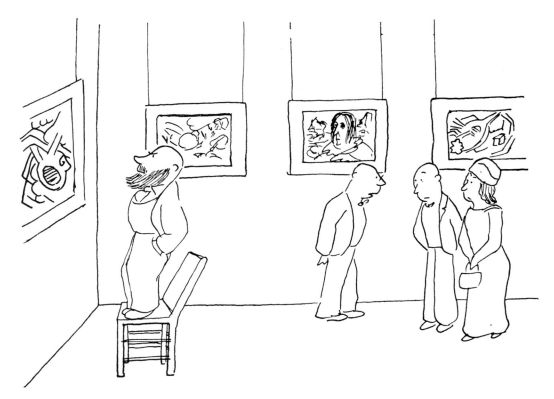

"He knows all about art, but he doesn't know what he likes."

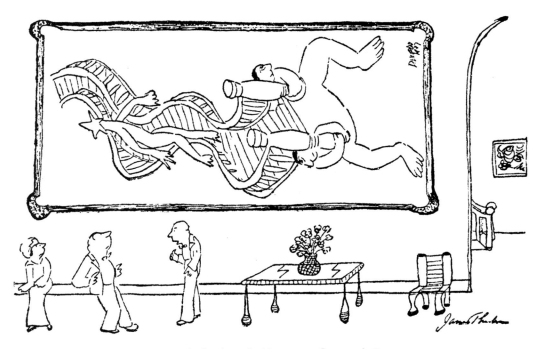

"We had to hang it sideways, unfortunately."

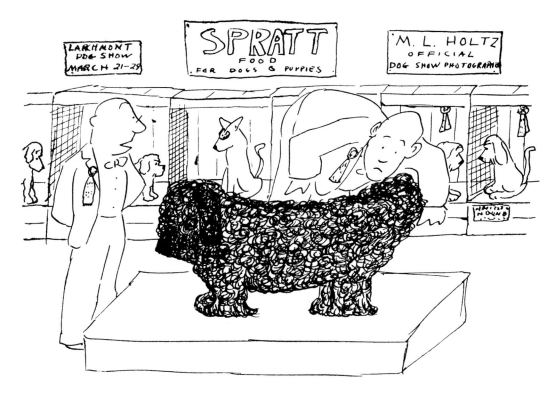

"Other end, Mr. Pemberton."

Dogs were certainly "high art" in Thurber's life. One of his first wife Althea's standard poodles won a first place at the Westminster Dog Show in 1930.

Portraits and Paraphrases

An Evening with Sandburg

During Thanksgiving week of 1936, after a performance by Carl Sandburg at Capital University, Thurber met "the singing poet" for the first time at the home of Dorothy and Herman Miller. For the remainder of the night, the two authors alternately shared anecdotes, diatribes, songs, and monologues. In 1953, Thurber describes Sandburg as "one of the monuments of America and one of our reassurances that this country will get over its jitters. . . . I met him for the first time twenty-two years ago and as he left he waved his hand and cried, 'Lots of life!'"[15] The feeling was clearly mutual. In 1947, Sandburg sent Thurber a letter: "It is long since that dandy all-night session in Columbus, Ohio and you keep growing all the time, gathering a permanent audience that cherishes you as very real to them. . . . May you go on."[16] By way of thanking both the Millers and Sandburg, Thurber sent sheaves of drawings, these three among them.

called "Toasted Susie is my Ice Cream",the god damndest thing you
ever saw. I'll send it to you when it comes back.

I did a
piece for Why dont you drop us a line?
The Forum on Are you bastards in New York by any chance?
the psychologist Or what?
who analyzed "Alice in Wonderland" Love from Helen, And me,
and a review of "How to Win
Friends & Influence People" Jim
for the Sat. Review.
Also 10 drawings,
2 pieces.
Whee!

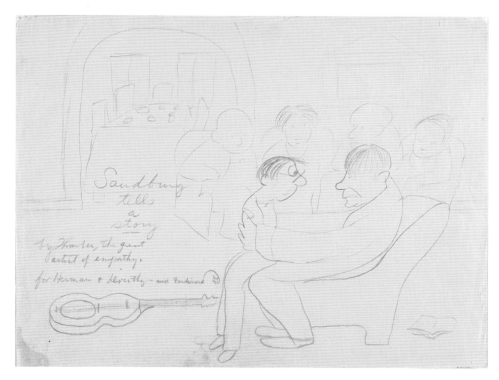

Sandburg tells a story, by Thurber, the great artist of empathy.
For Herman & Dorothy—and Ferdinand.

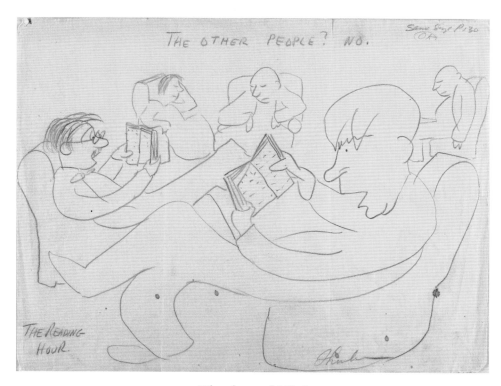

"The other people? No."
The Reading Hour

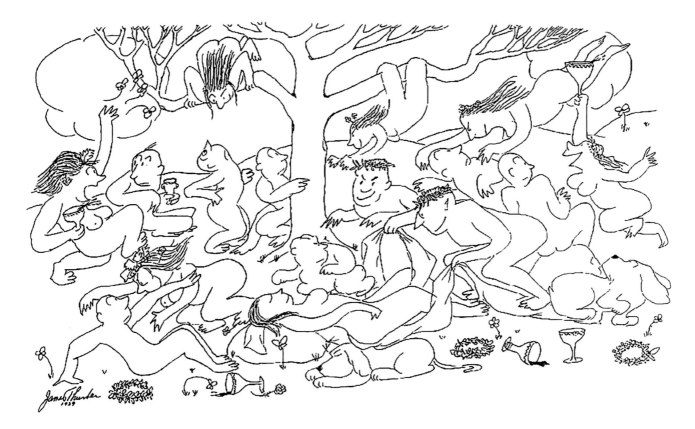

"Venus Surprised by Satyrs in the Midst of a Bacchanalian Dance." Pen and black ink over pencil, 1939. From the estate of Eardley Knollys, owner of the Storran Gallery of London.

Poussin's Sleeping Satyr

In 1939, the Storran Gallery of London prepared a show entitled *Paraphrases*. The exhibition included twenty artists, each of whom created "paraphrases," or free versions of works by other painters: Claude Rogers created a work after Corot; Vanessa Bell after Titian; Lawrence Gowing after Goya. Thurber's version of a Poussin received particular attention from the press. Under the subheading, "A Comic Bacchanalia," *The Scotsman* wrote, "The way Bacchus and his gang throw themselves around would make a Bishop explode with laughter. . . . Thurber's drawing is a triumph . . . degradation of a high original."[17]

And following that show, Thurber reprised the scene for a springtime *New Yorker* cover. As featured in chapter two, the subject of nudity was a source of both titillation and consternation for the public—that is, an ideal subject for the magazine and Thurber.

Earlier, in May 1937, the Storran Gallery ran a show of forty works by James Thurber. The gallery was known for exhibiting the avant-garde, including Modigliani. The co-owner, painter and critic Eardley Knollys, was a friend of Picasso's. (See page 208, chronology of exhibitions, 1937, for more about this exhibit.)

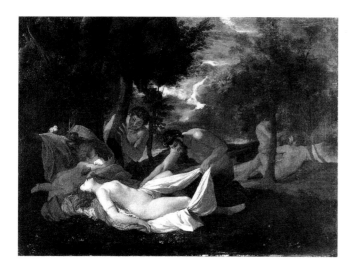

Nicolas Poussin: *Venus Surprised by Satyrs*, c. 1625. Image copyright © 2017 Kunsthaus Zürich. Used by permission.

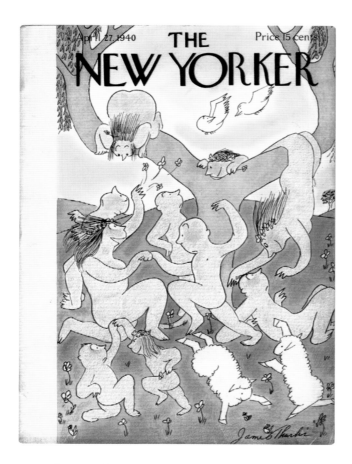

Cover, the *New Yorker*, April 27, 1940.

"BUT IT IS LUCKY that at the moment that the greatest of English satirical draughtsmen is exhibiting there should also be on view a show of the works of Thurber, who in a rather different way can claim to be one of the greatest American satirists. His drawings at the Storran Gallery show that his method of attack is much more general than that of [eminent caricaturist and political cartoonist David] Low. He is never concerned with immediate political events but with the more permanent failings of the human race. Sometimes his satire is allusive rather than logical so that it is hard to define his precise intention, but this does not reduce the effectiveness of the attack. There are drawings which condemn the eccentricities of a priggish and unreal type which we are pleased to suppose exists only in America, but which is unhappily as common in Europe. Others, by showing the most romantic scenes enacted by squalid and repulsive figures, blow the gaff about many of the false values attached to human activities."[18]
—Anthony Blunt

Another Paraphrase: George Bellows

Like Thurber, painter George Bellows was a boxing enthusiast, native son of Columbus, and alum of Ohio State University. Even when Bellows was in his twenties, his stark realism, mixed with modernism techniques, made him a standout. The youngest member of the Ashcan School, Bellows painted boxing scenes, upper-class polo players, and New York City tenement residents with equal, unfiltered bluntness.

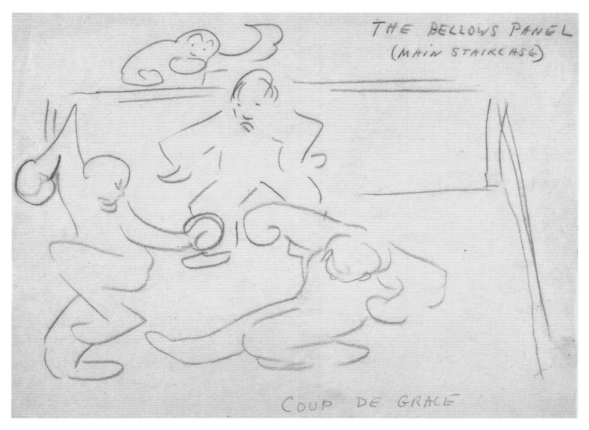

The Bellows Panel (main staircase). Coup de grace.

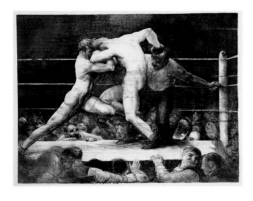

Thurber's unpublished cartoon (above) is a variation or "paraphrase" of George Bellows's famous painting *Stag at Sharkey's* (1909) or his iconic lithograph (1917), reproduced here. Image courtesy Columbus Museum of Art.

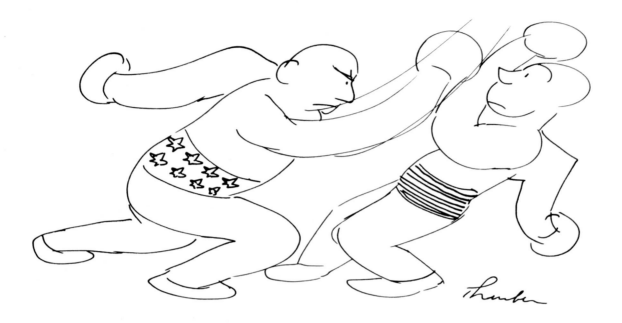

Thurber's two boxers in a clinch led the "Goings on About Town" section of the *New Yorker*, June 22, 1940.

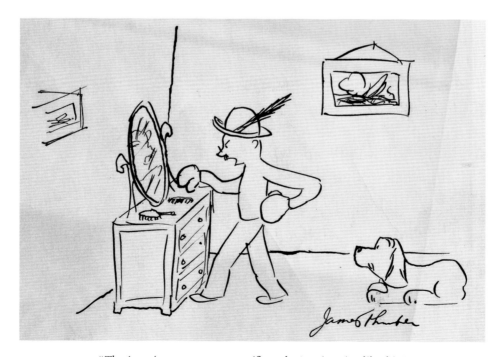

"They're going to put you away if you don't quit acting like this."

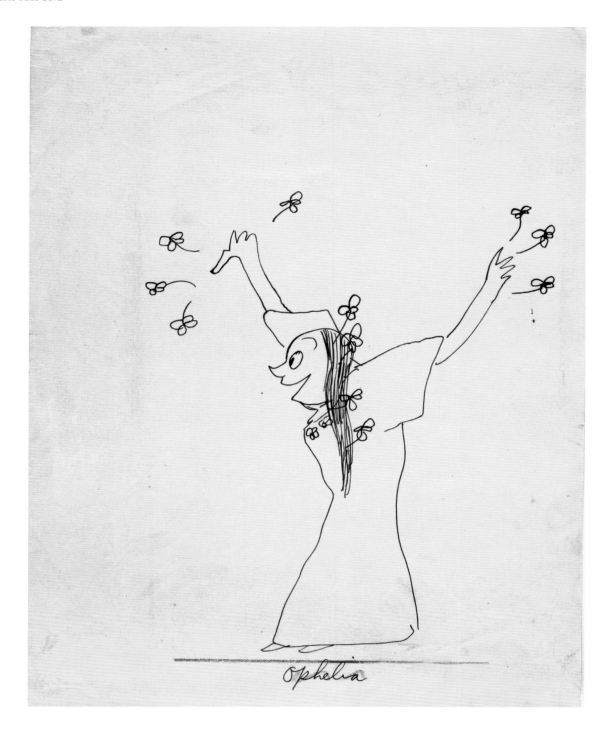

"Ophelia," from a suite, "James Thurber Presents William Shakespeare," *Stage*, September 1935.

Shakespeare and Poe

From 1935 to 1937, Thurber contributed a variety of reviews, drawings, portraits, and other "paraphrases" to *Stage* magazine. A short series, "James Thurber Presents William Shakespeare," also ran with his illustrations for *Othello*, *Macbeth*, *King Lear*, and *Anthony and Cleopatra*.

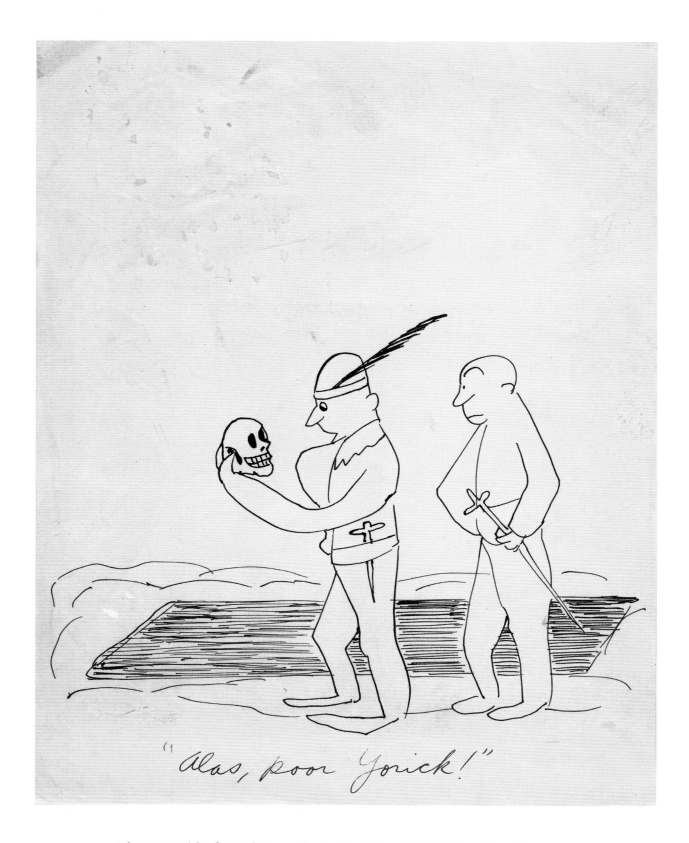

"Alas, poor Yorick!" from "The James Thurber Production of *Macbeth*," *Stage*, November 1935.

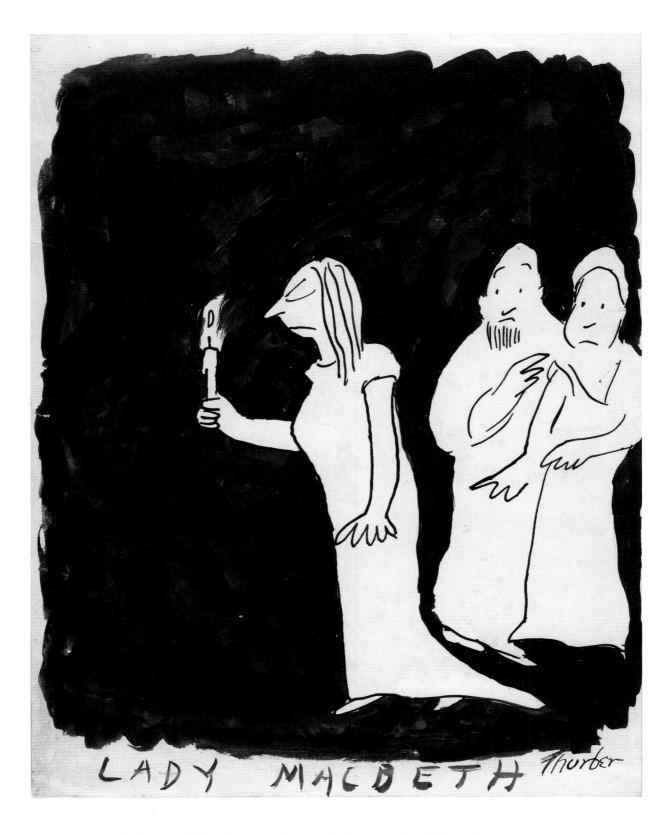

"Lady Macbeth," from "The James Thurber Production of *Macbeth*," *Stage*, November 1935.

Although a group of nine poems was included in *Fables for Our Time and Famous Poems Illustrated*, the seven drawings for Edgar Allan Poe's "The Raven," including these three, were only published after his death in a collection, *Thurber & Company*, edited by Helen Thurber.

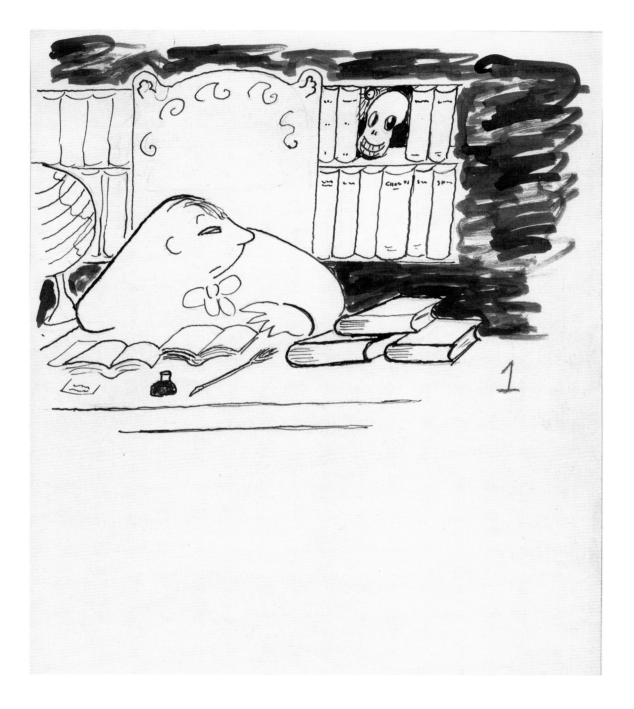

"Once upon a midnight dreary, while I pondered, weak and weary,
Over many a quaint and curious volume of forgotten lore,—"

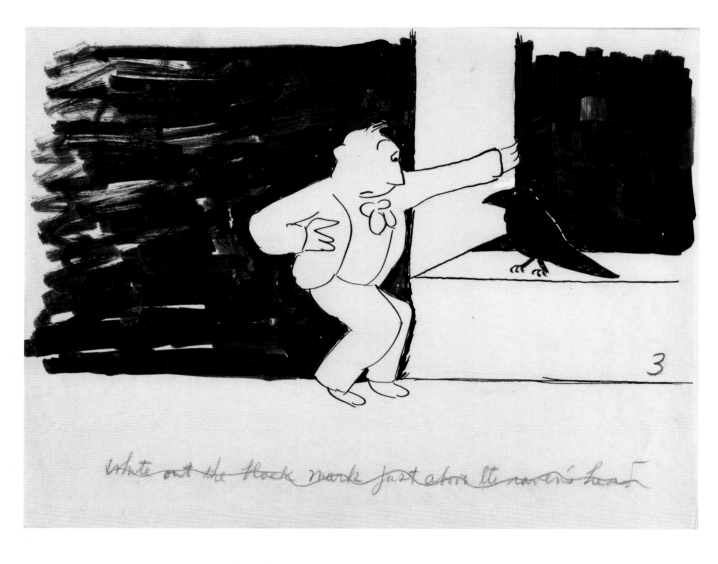

white out the black mark just above the raven's head

"Open here I flung the shutter, when, with many a flirt and flutter,
In there stepped a stately raven of the saintly days of yore."

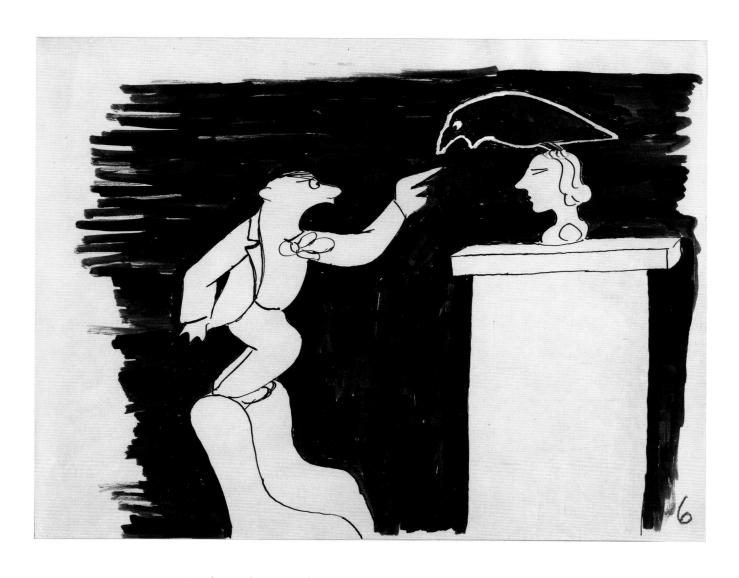

"'Be that word our sign of parting, bird or friend!' I shrieked, upstarting,—
'Get thee back into the tempest and the night's Plutonian shore!'"

Moonlighting

During the 1930s and 1940s, opportunities to draw arrived from a host of editorial directors and advertising agencies. Many he declined, but with his characteristic humor. For instance, in 1945, the president of American Portrait Artists inquired if Thurber would sit for a portrait. An unnamed distillery wanted to feature him in their promotions. He declined, "not only because my face from the eyebrows down has been an insurmountable barrier to both photographers and painters . . . but because I have figured that the company in question must either be Rheingold Beer or Calvert Whiskey and I am an inveterate drinker of Pabst Blue Ribbon and Seagram's V.O."[19]

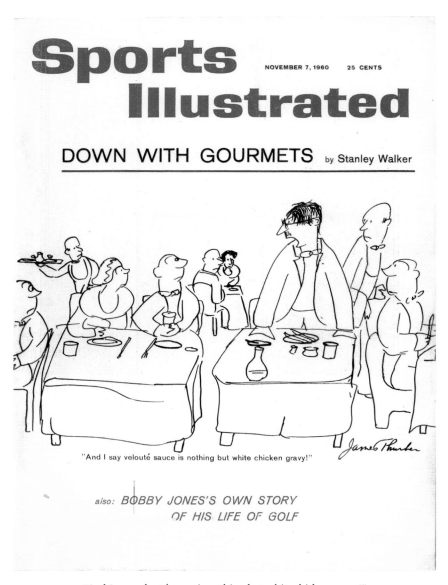

Thurber's cover for *Sports Illustrated*, November 7, 1960, appeared a year before his death. Considering the line quality and level of detail, Thurber created the drawing some thirty years earlier, although no previous appearance of it has been noted.

"And I say velouté sauce is nothing but white chicken gravy!"

Illustrations by Thurber promoted a hodgepodge of establishments, household goods, luxury items, and books: Heinz soups, war bonds, American Radiators, Franklin Simon & Co. (a women's department store), Talon Zippers, *Ladies' Home Journal*, Fisher Body, Bergdorf Goodman, French Line cruises, Bug-a-boo insect spray, Perfect Circle piston rods, and Libby's tomato juice, among others.

Thurber drawings graced the dust jackets of friends' books, such as *Tales of a Wayward Inn* by Frank Case and *The Best Is Yet* by Morris Ernst. His cartoons became patterns for ties, dresses, and tableware.

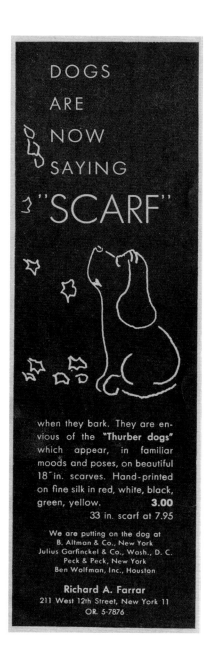

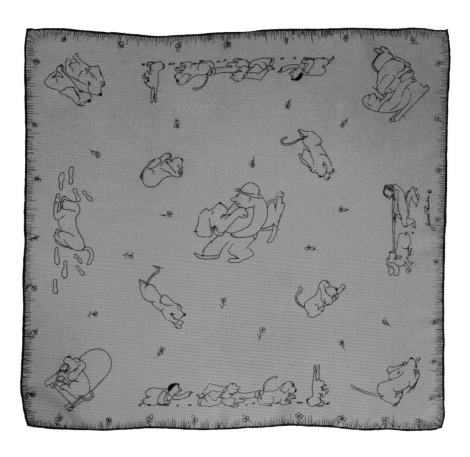

"Dogs are now saying 'scarf' when they bark. They are envious of the 'Thurber dogs' which appear, in familiar moods and poses, on beautiful 18 in. scarves."

Morris Ernst settling the Russo-Japanese trouble.

MORRIS ERNST says he is James Thurber's favorite whipping boy and that one can still find pictures like these on the walls of many of New York's bars and saloons, even on odd table cloths. Thurber doesn't like the title of this book and has started an after-dark game to find a better one. Some of the suggestions have been *Exhibit I, The Life of the Party of the First Part, Morr-is the Pity, My Life On a Limb, Beware of the Greenbaum Wolff* . . .

MORRIS ERNST has sold shirts and furniture, he has defended every cause he believed in, and they've been many. Besides being a lawyer he is an expert sailor, a carpenter, an amateur scientist and a writer.

"There's been some mix-up or other—we're waiting for Morris Ernst."
No. 2257

"Morris Ernst settling the Russo-Japanese trouble" and "There's been some mix-up or other—we're waiting for Morris Ernst," from the back dust jacket of *The Best Is Yet* by Morris Ernst. Cofounder of the American Civil Liberties Union and prominent New York City attorney, Ernst may be best known for defending James Joyce's novel *Ulysses* against obscenity charges, although he also authored or coauthored nearly forty books. A key member of the *New Yorker*'s legal department, he was a longtime friend of Thurber's and handled the separation between James and Althea.

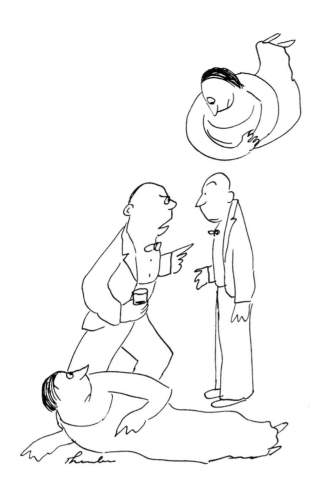

"Don't you think the subconscious has been done to death and that it's high time someone rediscovered the conscious?"

Advertisement for *Rain from Heaven*, a play by S. N. Behrman, that appeared in the *New Yorker*, January 26, 1935.

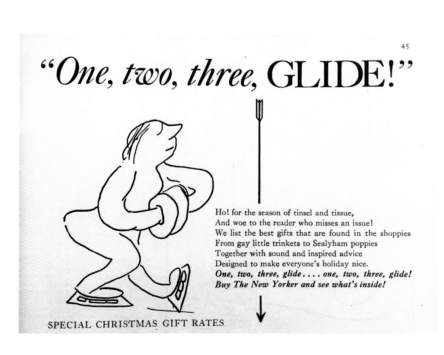

"One, two, three, GLIDE!" A November 28, 1936, advertisement in the *New Yorker* offering special subscription rates for holiday gifting.

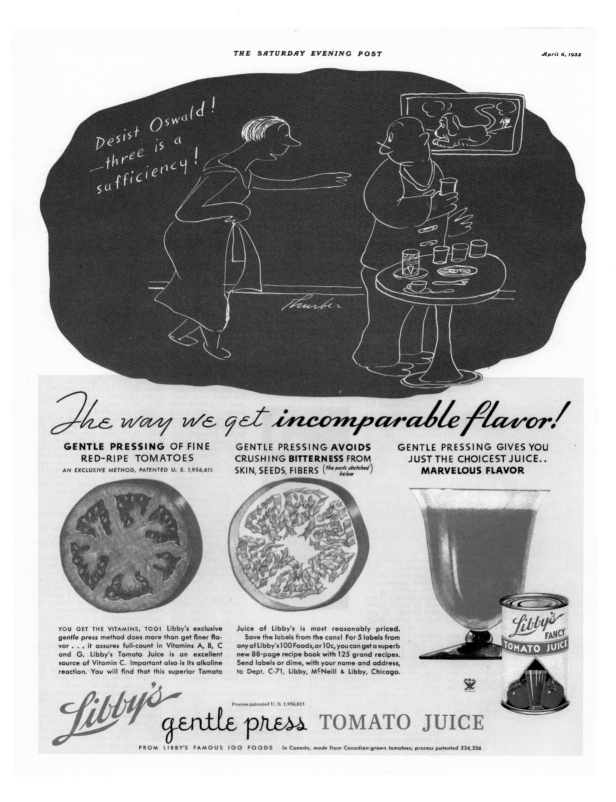

"Desist Oswald!—three is a sufficiency!" Advertisement for Libby's
tomato juice from the *Saturday Evening Post*, April 6, 1935.

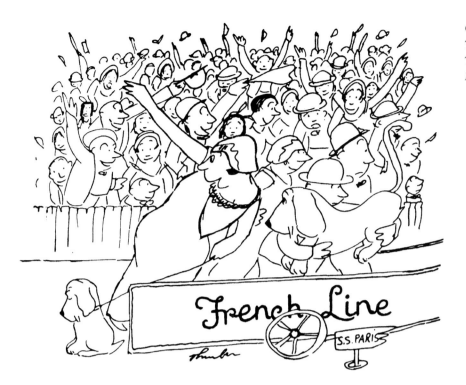

One of several large advertisements Thurber created for French Line cruises. This one appeared in the *New Yorker*, May 6, 1933.

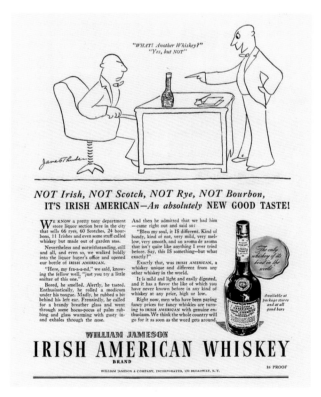

Advertisement for William Jameson Irish American Whiskey. From the *New Yorker*, December 12, 1936.

"WHAT! Another Whiskey?" "Yes, but NOT."

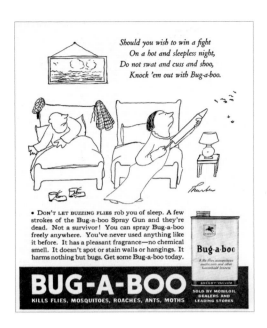

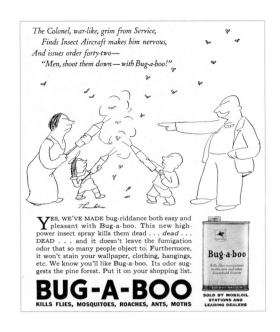

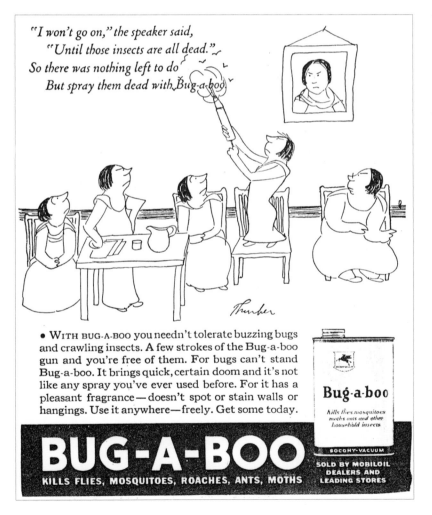

While Thurber enjoyed composing humorous poems and often used verses to banter with a few friends, there's no record that he contributed more than just the dozen drawings for the Vacuum Oil Company's insect repellent campaign. These ran in the summer issues of *Collier's* and the *Saturday Evening Post* in 1935 and 1936.

Fashion designer Elizabeth Hawes's book-length rambling on the unnatural nature of men's clothing was graced with fourteen Thurber illustrations.

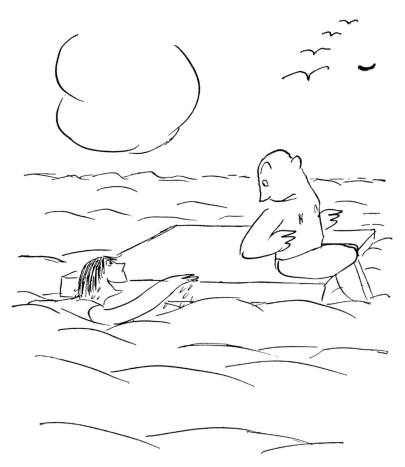

"Isn't it wonderful to be alone together?"

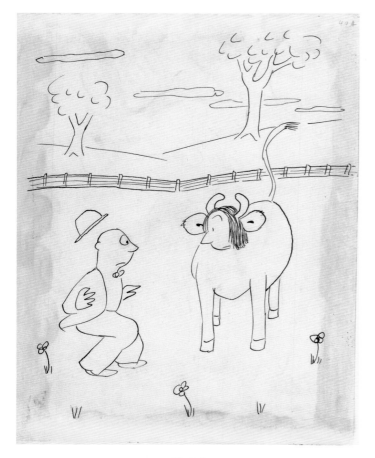

Chattel

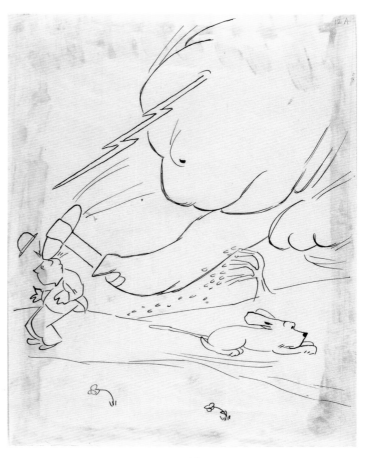

Astonish

Thurber contributed sixty-three drawings to Margaret Ernst's collection of amusing etymologies, *In a Word*, published in 1939. In the book's preface he admits, "The drawings that accompany some of these words are among the last that I was able to do in pen and ink before my sight began to dim in 1940."[20]

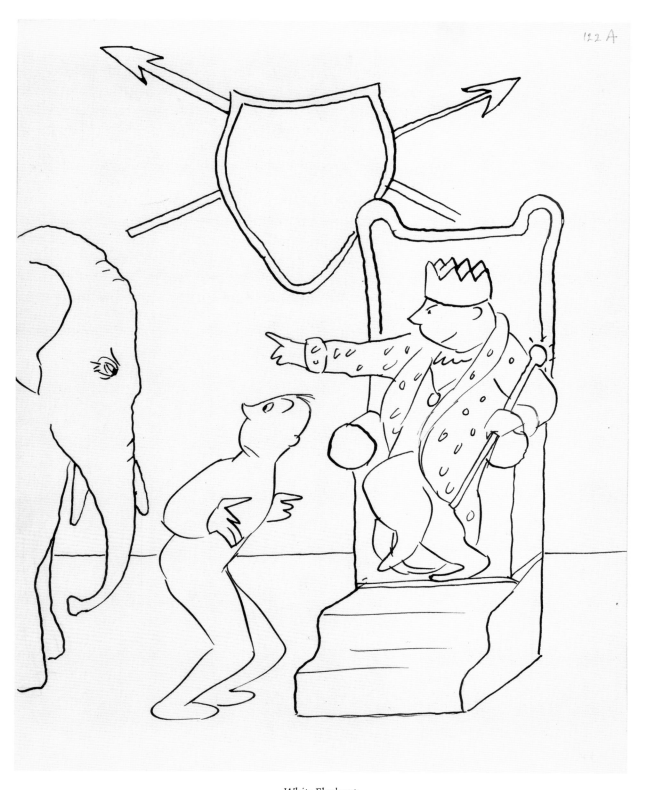

White Elephant

Idling

To release some of his jumpy energy and his mind's ceaseless inventory-ing and inquisitiveness, Thurber drew. It was as habitual as his smoking. Writing—*rewriting*, as he often called it—required discipline, focus, research, an amped-up armature of full brain power that included memory, grammar, word and sentence sounds, a dialing in of the humorous and the heartfelt, the meandering and the meaningful. But drawings? He considered his to be fluid, spontaneous, unhindered, and with rarely a need for erasure, revision, or polish. His daughter Rosemary remembers her father saying that he could even whistle while he drew.

Even when he wasn't drawing on assignment or intentionally creating images to submit to the *New Yorker*, he drew to entertain friends or friends' children or fellow patrons at nearby barstools. He gave drawings as thank-you notes, greeting cards, and even apologies for an evening's regrettable behavior. He filled the empty pages of colleagues' notepads. He illuminated menus, closets, washroom walls, hallways, and the offices of various colleagues at the magazine. Biographer Harrison Kinney quotes Katherine and E. B. White as saying, "Every time someone went on vacation, his office usually got a fresh coat of paint and the workmen would brush over Thurber's murals. . . . Ross finally gave orders that none of Thurber's drawings be painted over, but that didn't always work."[21]

And he drew—perhaps we think of this as doodling—in books, both his own and those of others. Margins, endsheets, or blank pages—all were options for his pencil. I prefer the word "idling" to "doodling," imagining Thurber waiting or detained or stymied or merely paused between dinner courses while his hand with the pencil-baton raced onward across the page.

Opposite: *Enjoyment of Laughter* (Simon & Schuster, 1936) by Max Eastman contains an extended appreciation of Thurber's humor and reprints "Touché!," one of his most famous *New Yorker* cartoons. But only one copy of Eastman's book has two variations penciled in by Thurber. The added sketches are more sanguine, no? The very opposite of why editor Harold Ross suggested that Thurber give the caption a try (see page 116).

Three of the thirteen "supplemental" drawings Thurber penciled on the endsheets and among the printed decorations by Edward Shenton in his copy of Ernest Hemingway's *The Green Hills of Africa* published by Scribner's in 1935. The book is Hemingway's autobiographical account of a month on safari in East Africa with his second wife, Pauline Marie Pfeiffer. Courtesy of Princeton University Library.

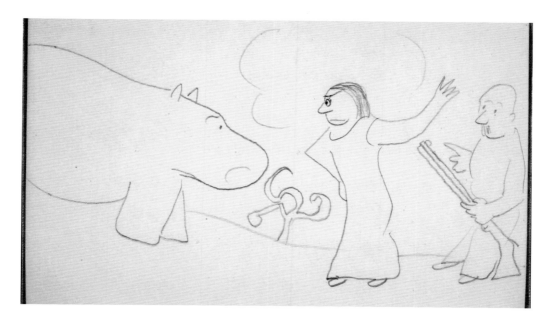

Thurber personalized a collection of illustrated Mother Goose rhymes in his daughter's library with several pencil drawings.

Another "tablet" for Thurber's idling mind: the wall of a favorite bar, Costello's in midtown Manhattan. Thurber's mural of drawings occupied an entire wall on one side of the saloon. The images included:

"Quit acting like Katherine Cornell. All you've got is spinster's booze gloom." [Editor's note: Katharine Cornell, "the First Lady of the Theatre,"[22] as *New Yorker* critic Alexander Wolcott dubbed her, was a consummate tragedienne.]

"Wellesley 42, Harvard 13" (see page 192).

"Her husband went upstairs to bed one night about a year ago and was never seen again."

"This is my house, Mr. Wolfe, and if you don't get out I'll throw you out!" [Editor's note: The novelist Thomas Wolfe, a writer of both hefty stature and hefty page counts, told Thurber his short pieces didn't really qualify him as a real writer. Thurber retaliated with several cartoons—in magazines as well as on Costello's wall.]

"I'm leaving you, Myra, and you might as well get used to the idea!"

Attic Drawings

In 1976, eight pencil-on-plaster drawings from the attic of the home James and Althea purchased in Sandy Hook, Connecticut, in 1931 were personally transported to the Rare Books and Manuscripts Library at Ohio State University by Lewis Branscomb, then director of Thurber Studies.

"Bill [William] Windom, who is the movie and TV actor, became interested in doing 'A Night with Thurber,' just as [actor James] Whitmore has done Twain."[23] Branscomb entertained Windom in Columbus, shared the university's archives with the actor, and duplicated images for Windom to project during performances. Some years later, Branscomb explains, after a show in Connecticut, a couple came backstage and said that beneath a corner of peeling wallpaper, they noticed some pencil lines. And they knew that their home, forty years earlier, had belonged to the Thurbers.

Windom joined Mr. and Mrs. Allan Coster at their home, 71 Riverside Road, and exclaimed that the scrawls certainly had to be Thurber's. He contacted Branscomb, who confirmed that Jim and Althea had indeed resided at that address from 1931 "to 1935 when they got divorced, and Thurber, who was writing avidly would go up in the attic to get away from Rosemary, their daughter, and Althea, and all the noise going on downstairs so he could write in privacy."[24]

After the divorce, Branscomb relates, Althea had the attic's plaster walls covered with wallpaper. Later "improvements" included two coats of wall paint. Ironically, Althea's wallpaper *preserved* the drawings beneath the paint. The excised drawings—each a hefty chunk of plaster—are mounted and framed in the university's archives. And, no, no one involved with the Thurber archives has a clue as to the identity of the members of the gang or the band.

From 1969 to 1970, William Windom starred in twenty-six episodes of NBC's *My World and Welcome to It*, based on Thurber's work, in particular "The Secret Life of Walter Mitty." Both Windom and the series were presented with Emmy Awards. (A linguistic lark that would have delighted Thurber's mischievous ear is that the awards were presented by actress Eva Gabor in her peerless Hungarian accent: "And the vinner is Villiam Vindom for *My Vorld and Velcome to It*.")

Windom went on to present one-person theatrical evenings, acting as Thurber for well over a decade, performing some fifty evenings in a year.

This photo is a studio promotional photo from NBC's television series *My World and Welcome to It*, with John Monroe (William Windom) at the easel with two of his Thurber-inspired characters. The episodes offered an original way in which live actors inhabited and engaged with animated drawings.

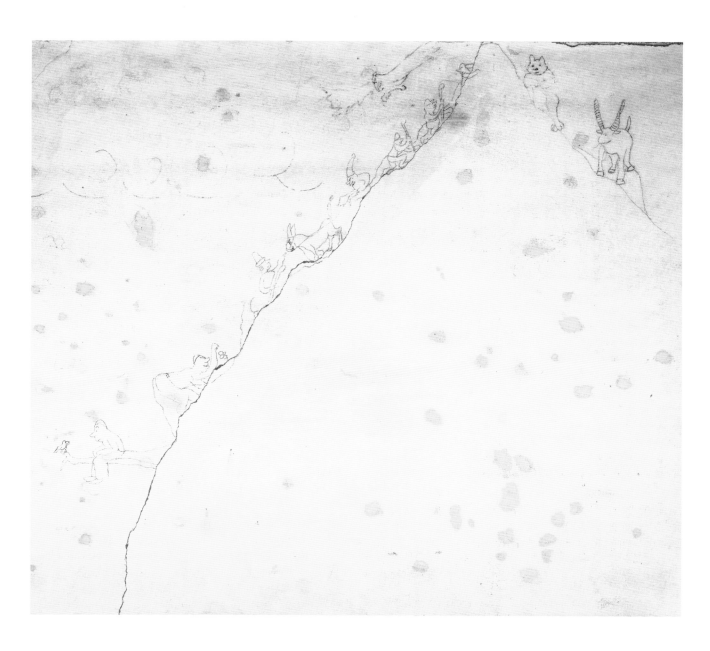

A crack-inspired mountain with hikers, donkey, clown, eagle, bear, and long-horned goat.

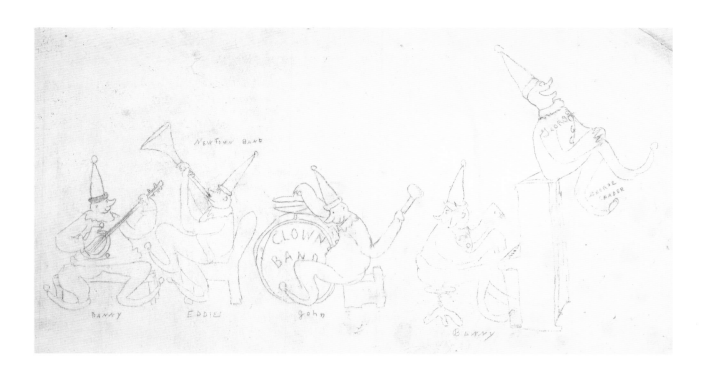

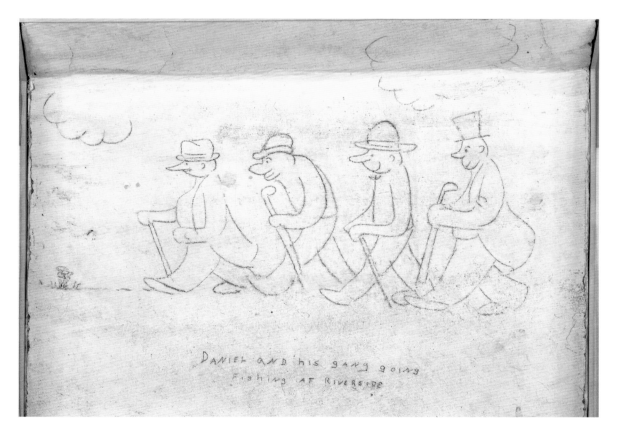

"Newtown Band" (top) and "Daniel and His Gang Going Fishing at Riverside" (bottom).

The Course of Thurber's Visual Decline and
His Ability to Write and Draw

Painting is the transcription of the adventure of the optic nerve.[25]
—PIERRE BONNARD (1867–1947), founding painter and print-
maker of *Les Nabis*, the avant-garde Post-Impressionist collective

1901

During a game of William Tell—it was James's turn to hold the apple on his
head; his brother William's turn to shoot—seven-year-old Jamie wondered
what was taking so long and turned to face the archer just as the bowstring
snapped. The arrow pierced his left eye.

The Thurbers had moved to Washington, DC; his father, Charles Thurber,
was serving as secretary to Ohio congressman Emmett Thomkins. James
received medical treatment from Swann Burnett, MD, who removed the boy's
left eye and replaced it with a glass prosthesis. The time between injury and
subsequent medical attention likely caused the sympathetic ophthalmia in
his right eye.

In an article in support of the National Blindness Council, Thurber wrote,
"If my own left eye had been removed in time it is likely that I would have
normal vision in the other eye today."[26]

1935

Nighttime driving became a harrowing ordeal. In a letter to his close friends
the Millers, Thurber talked of how the glare of oncoming headlights cause
him to weave and swerve, and how "flecks of dust and streaks of bug blood
on the windshield look to me often like old admirals in uniform, or crippled
apple women, or the front end of barges, and I whirl out of their way, thus
going into ditches and fields and up on front lawns." Thurber then enu-
merated other, earlier driving incidents, and concluded by mentioning that
his newly wedded Helen will be taking the driver's seat, lest she wake some
morning to a news story like this:

Police are striving to unravel the tangle of seven cars and a truck which
suddenly took place last night at 9 o'clock where Route 44 is crossed
by Harmer's Lane and a wood road leading to the old Beckert estate.
Although nobody seems to know exactly what happened, the automo-
bile that the accident seemed to center about was a 1932 Ford V-8 oper-
ated by one James Thurberg. Thurberg, who was coming into Winsted

at eight miles an hour, mistook the lights of Harry Freeman's hot-dog stand, at the corner of Harmer's Lane and Route 44, for the headlight of a train. As he told the story later: he swerved out to avoid the oncoming hot-dog stand only to see an aged admiral in full dress uniform riding toward him, out of the old wood road, on a tricycle, which had no headlights. In trying to go between the hot-dog stand and the tricycle, Thurberg somehow or other managed to get his car crosswise of all three roads, resulting in the cracking up of six other cars and the truck. Police have so far found no trace of the aged admiral and his tricycle. The hot-dog stand came to a stop fifteen feet from Thurberg's car.[27]

1937

The onset of more significant problems for Thurber's right eye began. In a letter to a fraternity brother, obstetrician Dr. Virgil Damon, he explained: "I have just had three separate pairs of glasses made, none of which I seem to be able to stand wearing. . . . I can promise any eye man one of the remarkable clinical eyes of the country. All oculists agree on that. They start out by deciding I should be able to see anything but moving shapes, end up with me reading two lines before normal on the chart, and finally discover a tiny hole left on a lens which otherwise is covered with 'organized oxidation.'"[28] Damon recommended Dr. Gordon Bruce.

"Certainly I can make it out! It's three seahorses and an 'h.'"

For the next year, while Thurber drove, but less frequently, the roads and landscape blurred, and the glare from oncoming cars forced him to strain and squint.

A steady flow of concerned letters arrived from his readers: "Deluded people all over the country and all over the world have written me about fake 'cures' for cataract and for all other eye conditions.

"I have not only been told to use orange juice, but to rub my spine with a billiard ball; to put a hot flatiron against my temple; to watch jumping beans; to swallow the scrapings of church bells, and even to become emotionally involved with an Apache princess."[29]

1940–1941

In June, Thurber underwent an iridectomy, a partial removal of the iris often preliminary to a cataract surgery, which then occurred in October. Thurber described himself and his wife Helen in a letter to the Millers, dear Columbus friends: "[We] both went to pieces at once, nervously, and mentally too."[30] He attributed the breakdown to the surgeries; long, late hours rewriting a play, *The Male Animal*, with Elliott Nugent; and "staying up too late arguing and fussing, smoking too early in the day and too often, and drinking too much."[31]

Before Christmas, Thurber required a subsequent operation and hospitalization. In March of 1941, inflammation and secondary glaucoma brought a fourth surgery. Fluid pressure on the retina and optic nerve necessitated a fifth in April. Within eleven months, Thurber endured five eye operations—all under local, not general, anesthesia. He spent a total of thirty-one days in the hospital. Simply writing that these procedures left Thurber agitated and anxious only hints at the trauma. (Nor did the year bring much relief: In September, Thurber contracted pneumonia; in November, his appendix ruptured.)

A nervous breakdown and a deep depression persisted for six months.

In the summer, in Martha's Vineyard, his writing helped him rally. He found it difficult to make legible handwriting on his favored yellow sheets of paper, so he often tried white typing paper and covered them with a heavy, slanted scrawl of perhaps fifteen or thirty words per page. Later, his wife Helen would type the dozen or dozens of pages, read the draft aloud, and wait for Thurber to call out revisions. Thanks to his nearly photographic memory, he could hold hundreds of words in his mind, tumble a given passage over and over to polish the sound and bring forth the clarity, and then recite the new passage verbatim.

How Law and Order Came to Aramie.

Big John Oakes, called
Big because bigness wasa quality
of his nature, and the lack of it,
of his physique, was asleep,
grotesquely doubled up on the
antique couch of his living room,
a vast depression in the center
of which made any peaceful dis-
position of one's person on it im
possible. He awoke when the
outside door opened, with a
swift, instinctive reach toward
his hip; but his revolver was in
the gun belt flung across the
back of a chair at his side. The
sheriff grinned as Slim Mason
playfully covered him with his
own six-shooter and drawled,
"I reckon the drop's on you,
sheriff.
"Didn't know you was partial

Before the vision in his right eye diminished, Thurber's penmanship was a small, legible script. Its loopy aspect would eventually loosen into barely decipherable flourishes. This page is from a short story, "How Law and Order Came to Aramie," written in his senior year in high school, 1912.

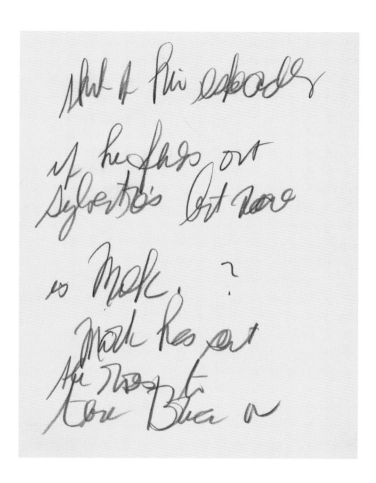

No longer able to see well enough to use the typewriter, Thurber wrote in longhand—fluid, hurried, oversized letters—on canary-yellow sheets of paper. This page is from a draft of "The Beast and the Dingle," published in 1948. The text reads: "'Oh, oh,' this accomplished, Miss Tighte began, 'I quite see it all—the figure in the tower, the figure across the pond!' He caught her, as who should say, in mid air. 'My dear young lady, . . .'"

From 1960, a sample manuscript page from *Make My Bed*, an unfinished play about the *New Yorker*. The scrawl of letters has slackened, the lines touch or tangle with other lines, and the number of words on any given page drops to a dozen or perhaps twenty. The text is too illegible to offer an accurate transcription.

1943

A goggle-like headband with a magnifying lens similar to ones that jewelers use—but for both eyes—allowed Thurber to draw his figures on twenty-four-by sixteen-inch sheets of paper. With the aid of this Zeiss loupe, he produced his second collection of drawings, *Men, Women and Dogs*; it had been ten years since the publication of his first collection, *The Seal in the Bedroom and Other Predicaments*.

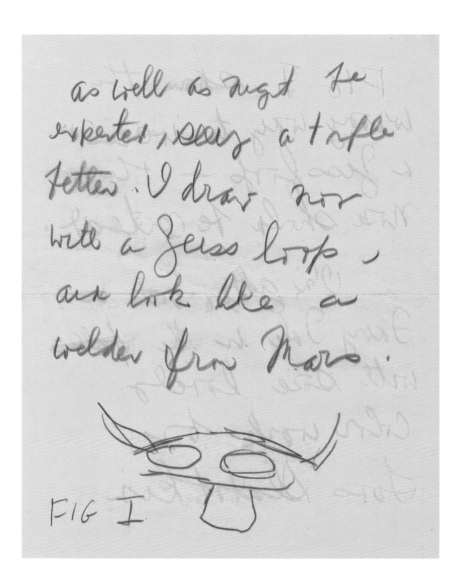

A self-portrait with a Zeiss loupe. The letter reads: ". . . as well as might be expected, seeing a trifle better. I draw now with a Zeiss loop [*sic*], and look like a welder from Mars."[32] From a letter to Herman and Dorothy Miller, May 28, 1943.

1945

Using the Zeiss loupe, Thurber produced forty-five drawings to illustrate a children's book, *The White Deer*. "This is Exhibit A in the strange case of a writer's switch from eye work to ear work,"[33] wrote E. B. White in his letter regarding the new book.

Thurber also managed to create two other suites of drawings that appeared in the *New Yorker*: "The Olden Time," Thurber's perennial depiction of the tension between men and women but staged in Arthurian days (see page 94), and "A New Natural History," colloquialisms and clichés turned into the common names of various plants and animals (see page 152).

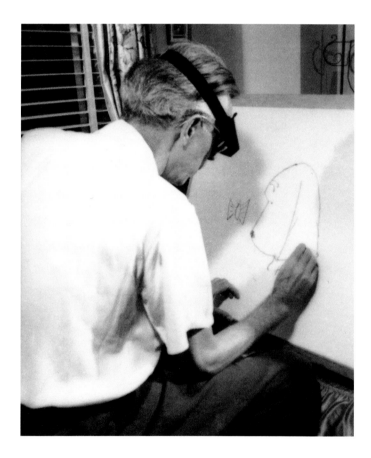

With the loupe's magnification, Thurber managed very large drawings that could be reduced for publication. Photo from a Connecticut news service, 1943.

"[THURBER'S] OTHER means of escape is simply by taking off his glasses. Because his vision is defective, the whole world thereupon assumes a different shape for him."[34]—Malcolm Cowley, literary critic and historian

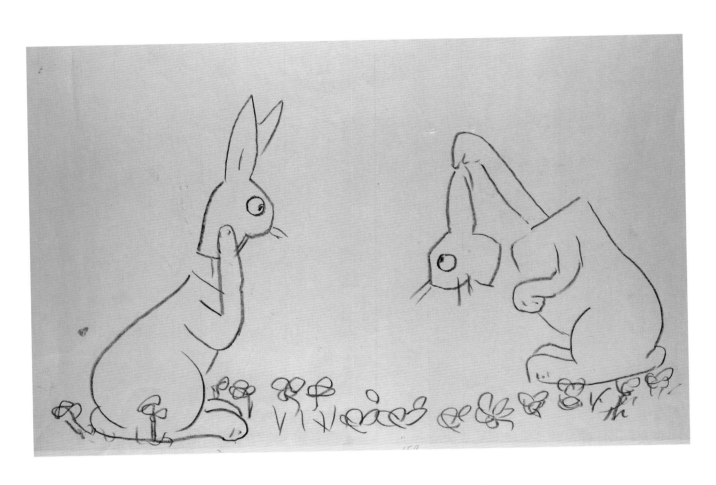

"In the enchanted forest that lies between the Moonstone Mines and Centaurs Mountain . . . rabbits here can tip their heads as men now tip their hats, removing them with their paws and putting them back again."[35]—from *The White Deer*

November 1, 1947

The *New Yorker* published a final drawing by Thurber. His work had been a central aspect of the magazine's identity for twenty years. At this point, Thurber attempted to draw in black chalk on sheets of yellowish paper. He struggled to use a custom-made, illuminated drawing board created for him by General Electric. He tried a pencil with a neon-glowing tip.

While this particular drawing is unpublished, these white-on-black drawings would be reversed during the layout stage so that they would appear black-on-white when printed.

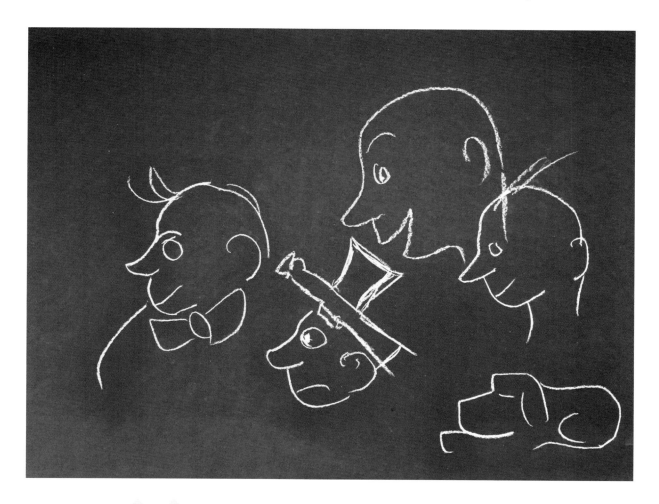

"A FEW WEEKS AGO Tom Bevans of Simon & Schuster brought me some sheets of flat black paper and a handful of white pastel chalk and, after three years, I have started plaguing the *New Yorker* with drawings once more. The men and the dogs are the same and so are the women, except that they have plunging necklines. By reversing the cuts, the drawings come out black on white."[36]—James Thurber

Frequently asked about how his diminished sight was affecting his writing and drawing, Thurber answered with versions of the headline the *Detroit Times* ran with their interview in March of 1950: "Writer Is Thankful for His Bad Eyesight. It Keeps Him from Being Distracted."[37] Eleven years later, Thurber was still being asked the question. His reply to the *Manchester Guardian* (London): "My one-eighth vision happily obscures sad and ungainly sights, leaving only the vivid and the radiant, some of whom are my friends and neighbors."[38]

The letter reads: "This is the best I can do with a dog now. Love in haste, Jamie."

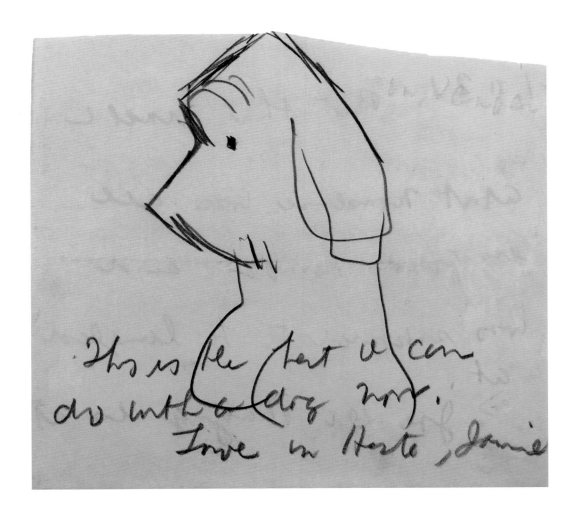

"WORDS WERE THINGS to Thurber, and this became more and more evident as blindness descended on him during the last quarter of his life. He could see the whole thing hanging up there in his mind, he just went on restlessly choosing his words. Perfectly fashioned pieces came out, showing an innocent dreamland, where there was no confusion or inaccuracy, only joy."[39]—Paul Jennings, *The Observer* (London)

July 9, 1951

The last of his drawings—a self-portrait with four dogs rendered in yellow chalk on black paper—appeared on the cover of *Time* magazine. In the issue, Thurber recounted how he once challenged a friend to come up with a better title for his autobiography than *Long Time No See*.[40]

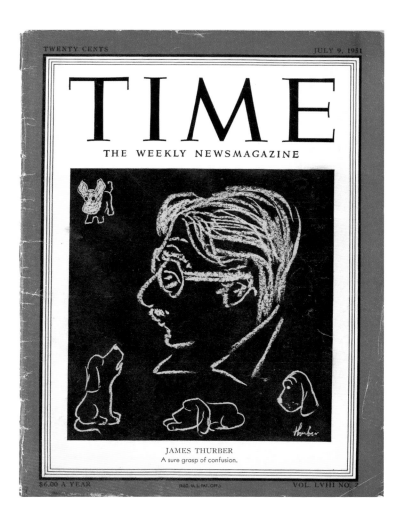

In its July 9, 1951, feature story, "Priceless Gift of Laughter," *Time* quotes T. S. Eliot, one of the most influential poets of the twentieth century: "There is a criticism of life at the bottom of it [Thurber's work]. It is serious and even somber. . . . His writings and also his illustrations are capable of surviving the immediate environment and time out of which they spring."[41]

1951–1961

The Thurber Album, *Thurber's Dogs*, and *The Years with Ross* appeared, in addition to six other books where Thurber's writing relied more and more on sentence sounds, alliteration, puns, neologisms, and other clever ways that words and their nuances could tether and stretch as he revised in his head. Thurber frequently bragged that he was capable of composing upwards of 3,500 words before dictating the manuscript to his wife or a secretary. Mid-decade, Thurber's agitated and angry behavior was traced to a worsening thyroid condition.

64

Signs of the Hard Times

"Well, you can't wait for the upturn in here!"[1]

Sign of the Times

Thurber "poured out his hundreds upon hundreds of drawings, stories, fables, memoirs, and essays—many of them among the funniest any writer or artist has ever produced—and turned them over to us in the warranted expectation that they would make us laugh, instruct us, shake us up, and keep us going."[2] So wrote the *New Yorker* in its obituary. These four expectations, at least in Thurber's mind, are particularly tethered to the times in which he lived. And to the present moment. He ruminated on this in his introduction to the 1950 edition of *The Seal in the Bedroom and Other Predicaments*:

> The last drawings for the original edition of this book—a small, lonely edition—were finished in the summer of 1932. That was only eighteen years ago, according to our obsolete system of measuring time, but we who were in our thirties then and are in our fifties now can't be fooled by the false accuracies of clocks and calendars. We know that several eras have gone by since 1932, a year that stood in the recession phase of the depression era, marked the end of the Prohibition era, and preceded, by a matter of months, the advent of the Hitler era. We find it hard to recall days and months and years, as we did in the old clock and calendar period, but we remember eras sharply since we have lived through so many of them. We know that the old-fashioned decade, with its gradual changes, has gone forever, leaving us stuck with a new and terrible calculation of time.
>
> I trust that future social historians, bearing in mind that we lived through several concentrated lifetimes in one, will not pass too severe judgment on the middle-aged manners and morals of the so-called Lost

Generation, grown gray and ulcerous and jumpier than ever. Surely few other generations in history had so little to look back on in peace and serenity, and so much to look forward to with fear and trembling.[3]

Thurber and those around him often spoke of the eclectic, ecstatic processor of his mind. Continuously gathering and composing and reacting. I'd say it's akin to someone paying attention to all that the media streams to us in this year in which Thurber would have turned 125. Even in 1960, a year before his death, in a new preface to *In a Word*, a book he illustrated in 1939, "the year all hell broke loose,"[4] he wrote, "We seem to be entering what might be called an Oral Culture, at six hundred miles an hour, the modern American speed in most fields of activity and endeavor. It is an era of babble . . . and the written word, the word that enchants the eye instead of disturbs the ear . . . [seems] in danger of losing its shape and sense."[5] What Thurber might have written almost sixty years later, we can only imagine.

Thurber frequently amused himself and others by charting or diagramming a complicated subject . . . such as a heart or a mind. Or, in two of the drawings here, the state of the country, the tumult of the times.

For the "Lost Generation," just how to get from the past, through the present, and into the future often felt like a crooked, directionless journey. Thurber "erected" a variety of visual signposts along his meanderings.

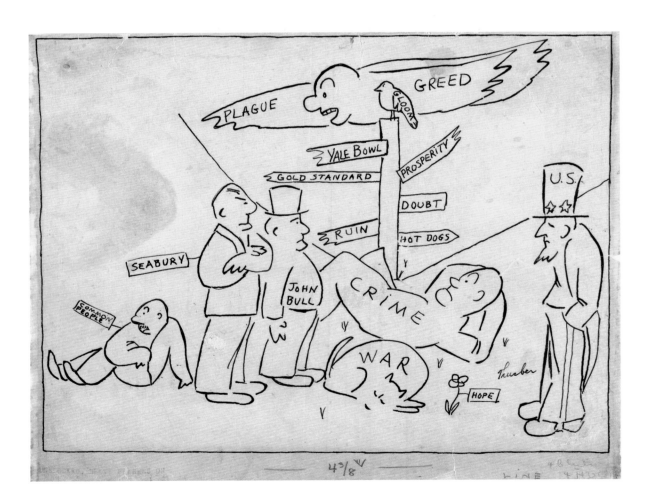

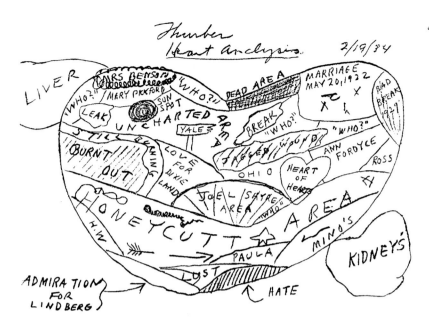

"Thurber Heart Analysis," dated February 19, 1934. This drawing accompanied a letter to Ann Honeycutt, in which Thurber describes his nature, his worries, his anxieties, and his burdens as a "Nervous Talker" from an psychiatrist's point of view. The "analysis" concludes with the doctor offering the chart "of that great heart which, if I were you, I would hesitate to break again."[6]

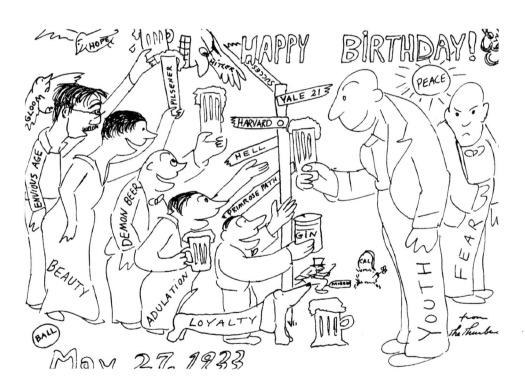

On the occasion of Vincent Price's twenty-second birthday, Thurber drew his friend a card that "profoundly, humorously was the story of that time of wondering if the American dream was for real. It showed me and my roommate as blobs beneath the signpost of our education—Yale, 21, Harvard, 0, with Hitler as a winged ogre prophetically hanging over our heads. J. P. Morgan is high-silk-hatted, creeping toward the grave occupied already by Calvin Coolidge. My dachshund represents loyalty, another blob is named 'Youth' and a self-portrait of Thurber is called 'Envious Age.' Althea, Jim's wife at the time, is proposing a toast, and an enigmatic circle in one corner seemed to tell by its label, 'Ball,' that that was just what life could be if you used your talents to the fullest."[7]—Vincent Price

The Lost Generation

"You are all a lost generation," modernist author Gertrude Stein overheard the displeased owner of a garage in France tell the young veteran working on her truck. Disillusioned with the world, its values, and empty promises, Stein felt this phrase perfectly described herself. As did many other writers who came of age after World War I: Ernest Hemingway, F. Scott Fitzgerald, T. S. Eliot, Hart Crane, and many Americans living in Paris.

Many of their writings dove headfirst into tides of self-pity and indulgence, frivolity, and impotence. And yet, when they were not writing, they figured if the world is doomed, why not blow the savings and party until the end?

Thurber had a clear view of this wallowing covey of writers: "The sense of doom that they had was more legendary than real."[8] "We knew where we were, all right, but we wouldn't go home. Ours was the generation that stayed up all night."[9]

THE CRUDER, more jagged lines of these ten small drawings suggest they were drawn in 1938 and 1939. The images, roughly five by seven inches, were hewn on scraps of a light-brown cardstock—quite possibly what the *New Yorker* used: "My rejected pictures were returned with a piece of brown cardboard that didn't hold its color so that the top drawing arrived looking like a platter from which a cat had just eaten beef liver."[10]

Author of more than fifty books, Cabell (1879–1958) is most known for his 1919 novel *Jurgen*, a provocatively suggestive tale of a smug, medieval pawnbroker who indulges in sexual liaisons with a vampire, a fertility goddess, and Arthurian girls before accepting the harmonious justness of a wedded bliss. The New York Society for the Suppression of Vice declared *Jurgen* obscene, seized the printer's plates, and banned the book. Overnight, Cabell became a cause célèbre—the trial dropped all charges in 1922—a best-selling author, and then a cult figure to those looking to doff their American provincialism.

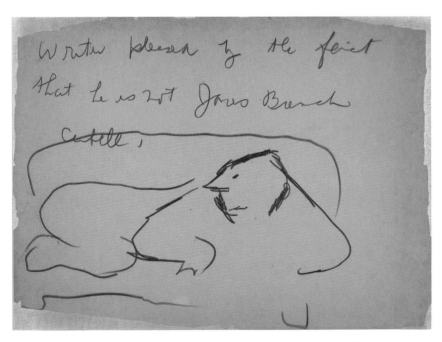

Writer pleased by the fact that he is not James Branch Cabell.

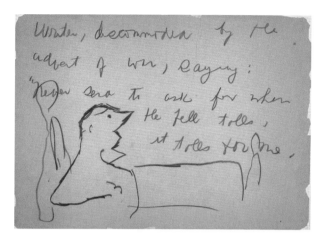

Writer, discommoded by the advent of war, saying:
"Never send to ask for whom the bell tolls, it tolls for thee."

The quote is from John Donne's poem "Devotions Upon Emergent Occasions," "Meditation XVII," which considers our nature: what happens to one, happens to all. "No man is an island," is included in this, Donne's most famous meditation.

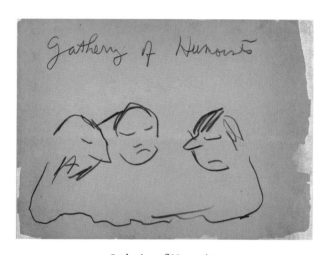

Gathering of Humorists

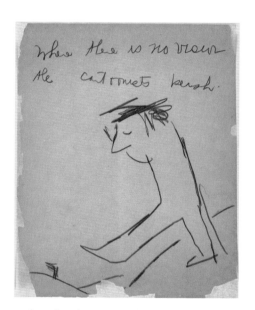

Where there is no vision the cartoonists perish.

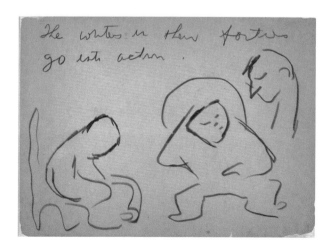

Writers in their forties go into action.

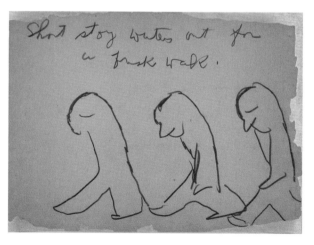

Short story writers out for a brisk walk.

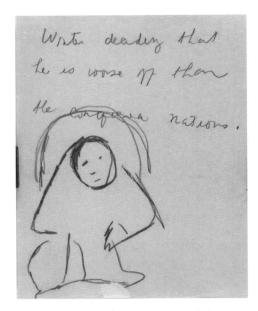

Writer deciding that he is worse off than
the conquered nations.

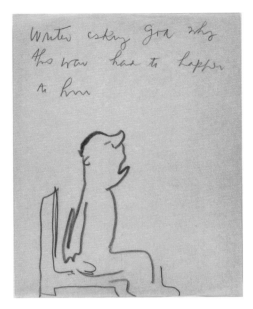

Writer asking God why this war
has to happen to him.

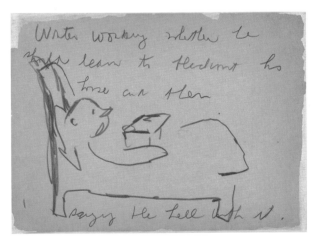

Writer wondering whether he should learn to blackout
his house and then saying the hell with it.

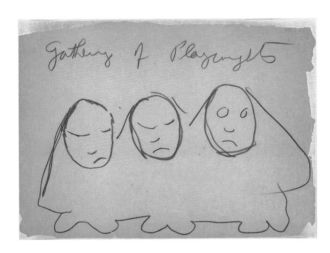

Gathering of Playwrights

Europe spent many nights in the dark during both world
wars. Lights were switched off or dimmed. Black curtains
were drawn across windows. The goal was to eliminate
targets enemy airplanes and boats could see. At the start of
the Second World War, New York City was considered a prime
target for German attacks. Manhattan's skyline turned eerily
dark. Baseball games were confined to daylight hours. Even
the Statue of Liberty, typically illuminated with 13,000 watts,
was dimmed to a mere 400.

War and Peace

It's easy to see why Thurber measured his times not in nameless years but in eras. Every few of those years, some enormous topic overshadowed everything. First the Great Depression clobbered the country. Along came FDR, promising "Happy Days Are Here Again." Next, Prohibition was overturned, so *huzzah!* Plus the New Deal gave hope, jobs, and electricity. But then disturbing world news smothered cheer. Hitler. Mussolini. Japan. Invasions and atrocities flooded the news, yet these events felt more like a movie than real life for many Americans. A divided country debated about entering the war as the military prepared . . . again. But on December 7, 1941, the United States was given no choice.

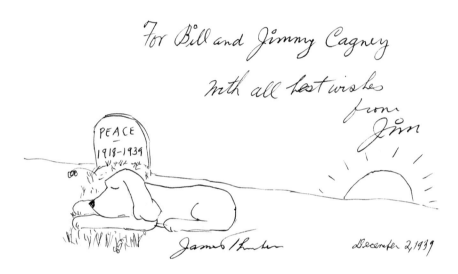

Thurber inscribed this copy of *The Last Flower* to his friends James and Frances (known to her friends as "Bill") Cagney. (James Cagney, whose acting career spanned the 1920s through the 1980s, starred in comedies, musicals, and dramas with equally remarkable talent. Many of his acclaimed roles portrayed charismatic criminals and gangsters.) The dates on the tombstone where the perennial dog dozes suggest the span of peace (inescapably delivered, in part, as the Great Depression) between the end of the First World War and the escalation of the Second World War.

Unique in his canon for two reasons, *The Last Flower* is the one book Thurber wrote and drew in a long, single night. Published at the start of World War II—Germany invaded Poland in September of 1939 and *The Last Flower* appeared in November—this shorthand "graphic novel" is likely Thurber's most succinct and celebrated work of faith. "His faith in the renewal of life," wrote E. B. White, "his feeling for the beauty and fragility of life on earth."[11] Subtitled *A Parable in Pictures*, the fifty spare drawings trace the relentless cycles of civilization, conflict or peace, hate or goodness, that reshape the world. The book is dedicated to Rosemary, his eight-year-old daughter, "in the wistful hope that her world will be better than mine."[12]

Today, Rosemary writes, "I don't know if that message is what my father would write me today. Would he even write and draw *The Last Flower* today? I'm not unappreciative of my father's hope in 1939. We had not yet, as my father, worried about my generation, said to me: 'unzipped the world' with atomic bombs and started the Nuclear Age."

The Bomb

The thicker, brush-and-ink line of this drawing was never used for Thurber's cartoons or illustrations for ads or others' books. He did a series of similar works in Paris (see page 240), likely in the summer of 1937, and other random drawings have appeared in this bolder, simpler brushstroke. Typically, Thurber used a smaller point to create that inimitable swiftness and unstudied line.

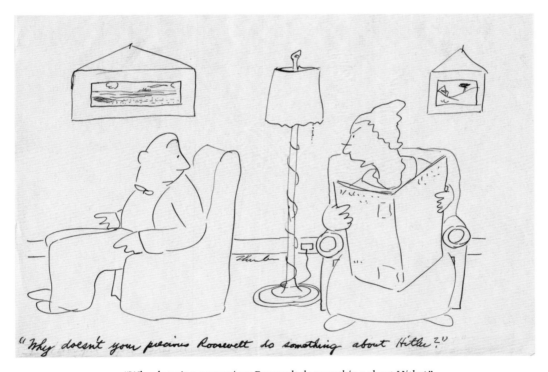

"Why doesn't your precious Roosevelt do something about Hitler?"

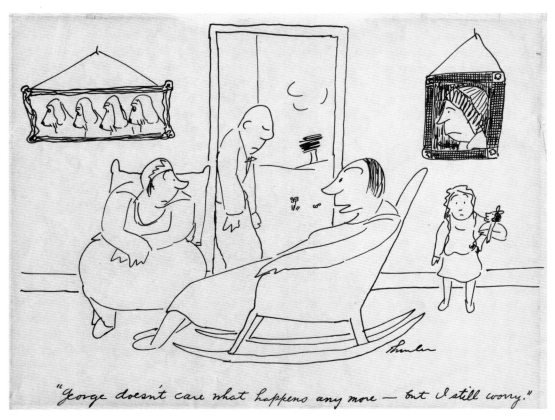

"George doesn't care what happens any more—but I still worry."

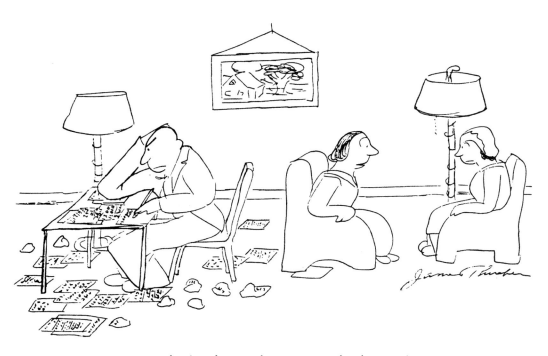

"He says he's just about got the government where he wants it."

The Machine Age

The Machine Age in America (1918–1941) was viewed as a mixed bag of helpful and harmful hardware. Travel became faster and more affordable. Telephones were installed in homes and offices. It made the world feel a little smaller. It made Thurber feel a little battier. Any gadget or appliance, everything from cigarette vending machines to a card table that, with the push of a button, transformed into an ironing board, filled Thurber with frustration—at least on the page. "Every person carries in his consciousness the old scar, or the fresh wound, of some harrowing misadventure with a contraption."[13]

As the Machine Age progressed, many Americans found themselves with something they hadn't experienced before: leisure time. But worries, like storm clouds, countered some of the sunny glee: Will mechanized warfare lead to our doom? Will free time lead to moral decline? Do monotonous factory hours deaden the workers? And Thurber's prevailing question: How does this thing work, anyway?

Ultimately, the age's progress and prosperity led to substantial improvements, valuable new skills, fewer work hours for better pay, rising life expectancies. And, people could smile at each other as they passed on the streets—in their newfangled automobiles.

For Thurber, there was a wellspring of humor in our "dread heritage of annoyance, shock, and terror arising out of the nature of mechanical contrivances."[14] There's a haplessness. A bafflement. An innocence daunted by technologies. The first Thurber biographer, Robert E. Morsberger, suggests that much of Thurber's work is "a counterpart to Chaplin's *Modern Times*, and his pathetic protagonists are upper middle-class cousins of Chaplin's little tramp."[15]

In 1941, Thurber published a story, "I Break Everything I Touch," in which he discusses how he essentially inherited his "ineptitude with contraptions." It ends with his stating, "This is not the world for me, this highly mechanized world. I can only hope that in Heaven there is nothing more complicated than a harp and that they will have winged mechanics to fix mine when I get it down and break its back."[16]

Thurber's cover coincides with the opening of the 1939 World's Fair. Its theme, "Building the World of Tomorrow," focused on the future with such innovations as the television, nylon, the View-Master, fluorescent lighting, electric typewriters, and, with 1,200 acres of experimental architecture, most remarkably, the iconic, all-white structures commonly known as "the ball and spike": the eighteen-story Perisphere (the left half of Thurber's cover), which housed an enormous exhibit of the future city some 44 million visitors viewed from two rotating balconies, and—connected by the longest electric escalator ever created—the 610-foot-tall Trylon (the right side of the cover).

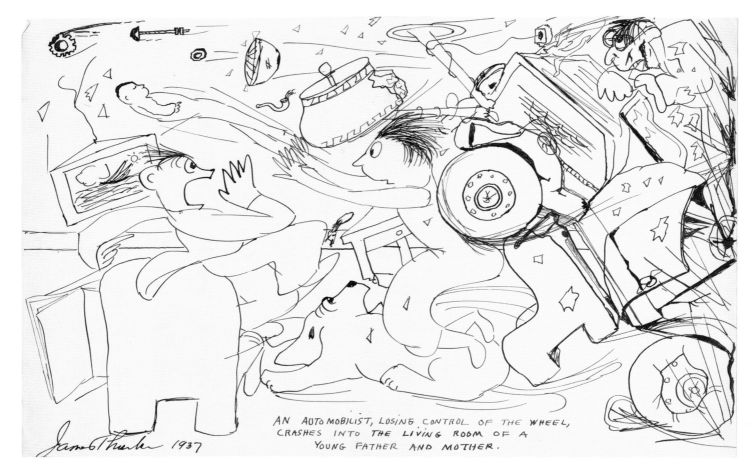

An automobilist, losing control of the wheel, crashes into the living room of a young father and mother.

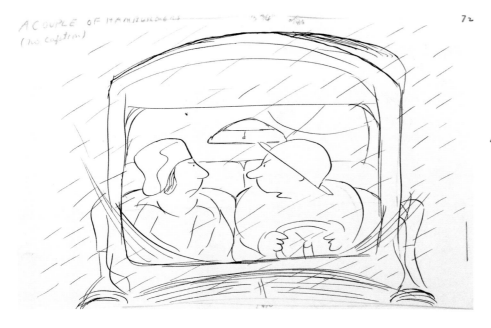

"She enjoyed bringing up the subject of the burned out bearing [what holds the crankshaft in a car's engine] whenever he got to chortling. . . . 'All engines make a noise running, you know.' 'I know . . . it sounds like a lot of safety-pins being jiggled around in a tumbler.' He snorted 'That's your imagination. Nothing gets the matter with a car that sounds like a lot of safety pins.'"—from "A Couple of Hamburgers," from *Let Your Mind Alone*.

These two undated, caption-less drawings did not appear in print during Thurber's lifetime.

The Great Depression

The first decade of Thurber's work coincides with the Great Depression: approximately 1929, "the black, memorable year," as Thurber described it, to 1939, the year "The Secret Life of Walter Mitty" appeared in the *New Yorker*. Publishing humor in such an era challenged everyone: None were eager to poke fun at poverty, unemployment, and financial ruin, including Thurber. Instead, folks continued their fixation with happiness—"Happy Days Are Here Again" was FDR's campaign theme song—and the nation's hope for better times.

For writers and journalists, the question was *how* to write—or not write— about the Depression. Leftists sparred with the *New Yorker*, which they deemed a mouthpiece for rich businessmen who undervalued the common worker. Thurber found their writings and ramblings to be disingenuous and pretentious. In return, these humorless fellows accused him of being, basically, a silly man in an ivory tower, out of touch with real American life.

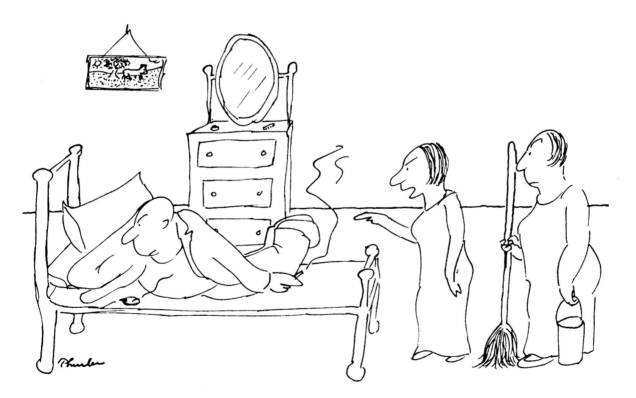

"Well, you can't wait for the upturn in here."

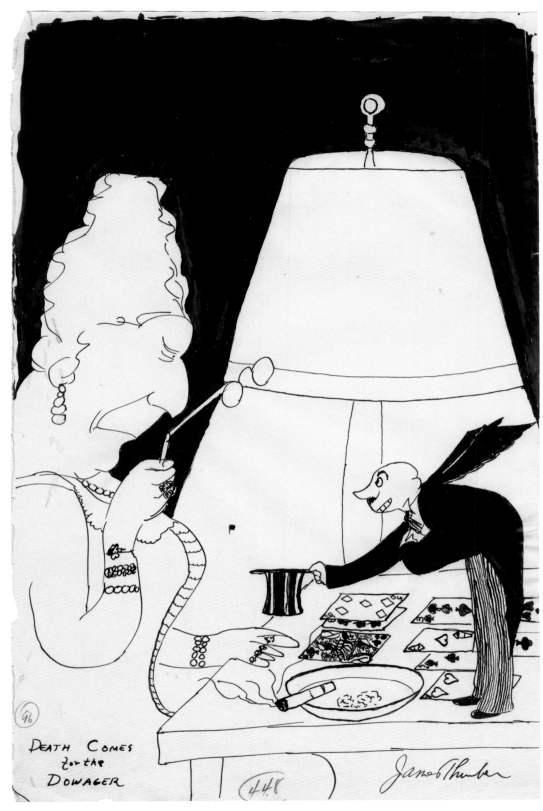

Death Comes for the Dowager

Don't offer money you printed yourself.

Don't shout over the phone.

"Don'ts for the Inflation," a series of six drawings, includes four others with the captions "Don't run," "Don't lie down," "Don't keep saying 'Hark!,'" and "Don't scream."

The Speakeasy and Prohibition

New York City, "Satan's last stronghold" (the *New York Times* joked), "the city on a still,"[17] may have been the wettest place in the United States during Prohibition, an era lasting from 1920 until 1933, during which temperance unions, the Anti-Saloon League, ministries, pietistic Protestants, and other "Drys" sought to cure society with a legislative ban on everything involving alcoholic beverages—selling, distilling, importing, serving . . . and even possessing alcohol, in some states.

Irish whiskey, German beer, Italian wine, and even home-brewed or bootleg—so democratic, how every class and ethnic group found its beverage of choice. Well over 30,000 speakeasies and nightclubs served thirsty Manhattanites. Secret passwords, whispered at the door, added a splash of excitement and a garnish of naughtiness. Those sophisticates who shared Thurber's happy—and not-so-happy—hours missed not a drop of their martinis and Scotches.

On the occasion of the publication of the first volume of Thurber's letters, critic Wilfred Sheed defines Prohibition more succinctly: "a plot brewed up by women and Protestant ministers while our soldiers were overseas, in order to end America's men-only culture and bring the boys all the way home, not just as far as the nearest saloon. Later, Thurber would draw a cartoon of a man returning to a house that had actually turned into his wife"[18] (see page 111).

New Yorker readers of the era clearly noticed what a contemporary viewer of a cartoon might need biographer Morseberger to point out: "In the early 1930s, Thurber's cartoons were often aimed at the then daring practice of ladies' frequenting bars and engaging in public drinking bouts. . . . The bar, after all, is traditionally man's domain, as one slightly inebriated male asserts; surveying the Sapphire Bar, filled entirely with women, he snarls, 'You gah dam pussy cats!'"[19]

In a letter to Wolcott Gibbs from September 1936, Thurber alludes to a casual, a short piece of prose, that he's submitting to the magazine:

> This represents two days and a night's work in the cool September air.
> I don't want you guys to get the notion that I just tear these off like
> my drawings, and reject them the way you do the drawings (of which
> "There's something in the air here tonight," is one of the best five I
> ever did).[20]

"You gah dam pussy cats!"

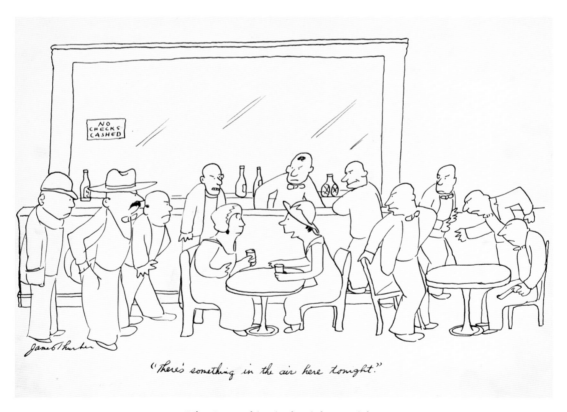

"There's something in the air here tonight."

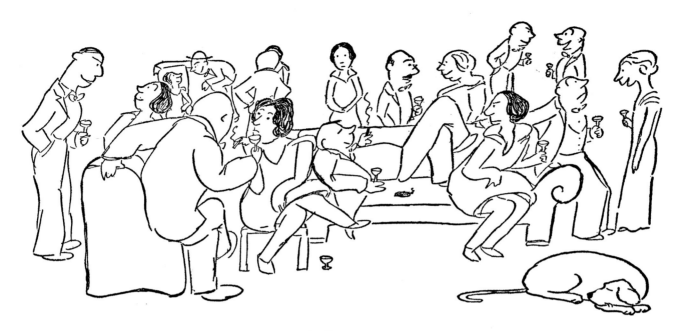

Cocktail Party, 1937

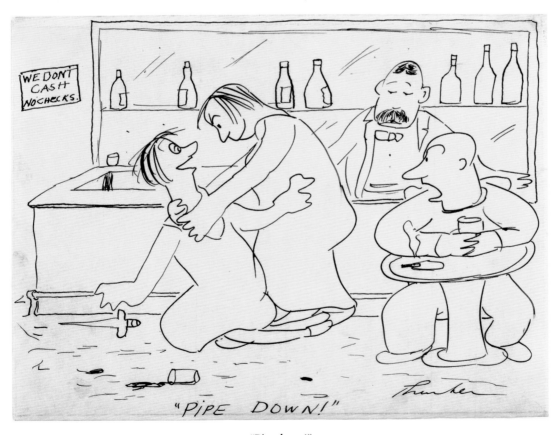

"Pipe down!"

Gangsters

Call it escapism, but during the Depression, following the antics of bank robbers, mobsters, and murderers was something of a pastime. And Thurber exploited readers' shock and fascination by including guns and violence—none of which brought harm in his bloodless world (see page 116). In New York City and Chicago, mobsters—men associated with "the Mob," aka the Mafia—were likewise both feared and revered. Gangland slayings, arrests, and manhunts became real-life dramas played out and eagerly followed on the radio and in the newspapers. In addition to gambling, prostitution, burgling, and murders, Prohibition offered organized crime another profitable pastime: bootlegging.

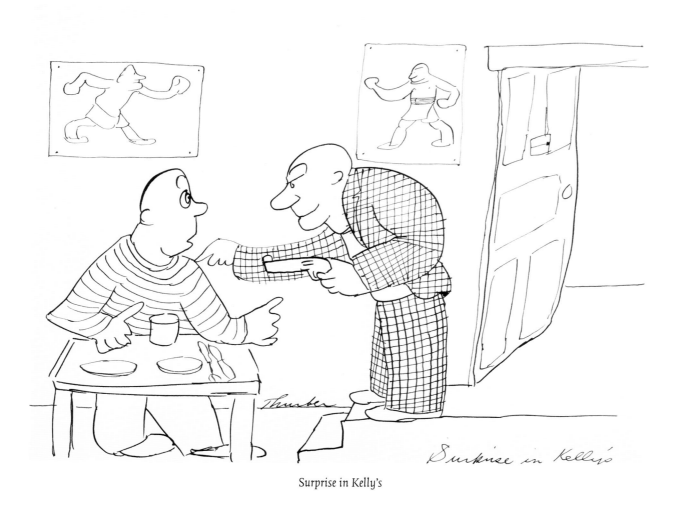

Surprise in Kelly's

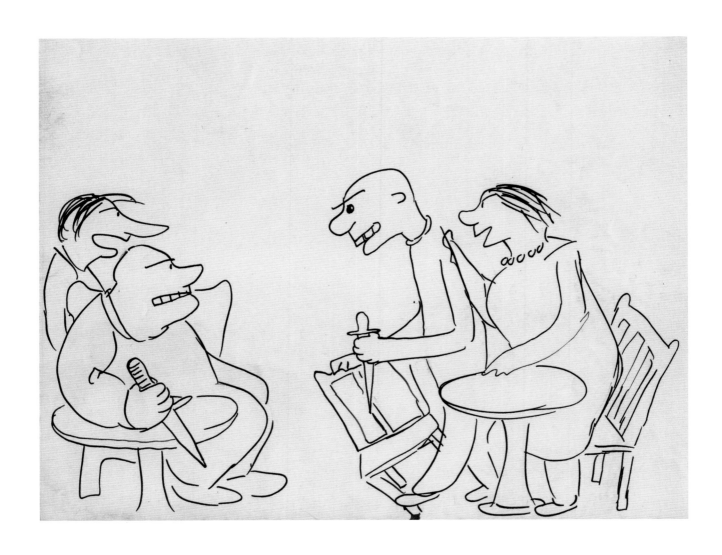

"Surprise in Kelly's" (overleaf) and the drawing above are two
of eight works in the "Tenth Avenue Series." A note from Helen
Thurber states that the drawings were "never published or
submitted to anyone. Done in the gangster era, late '20s, early '30s."

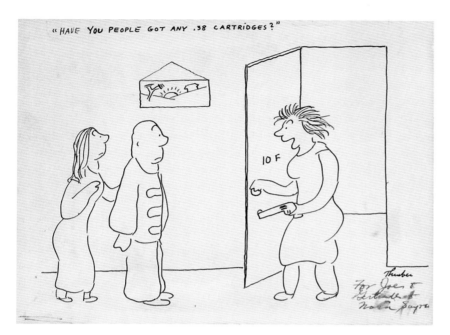

"Have you people got any .38 cartridges?"

The inscription, bottom right, is to Thurber's dear friends Joel, Gertrude, and their daughter Nora Sayre.

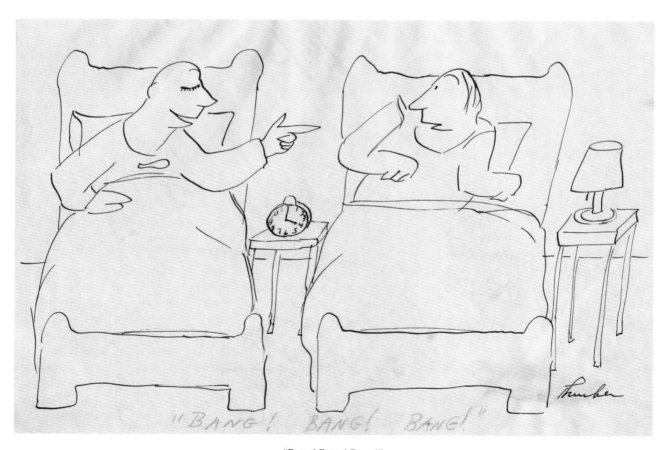

"Bang! Bang! Bang!"

85

Nudism

The Victorian era and industrial age nearly smothered the life out of humanity, and it took a new century for the uptight to explore the undressed. The era of nudism began in Europe—not that some American freethinkers such as Benjamin Franklin and Henry David Thoreau hadn't extolled the practice much earlier. The sophisticated readers of the *New Yorker* blushed and balked at the notion of collective nakedness—even though it purported to bring better health. The idea was received more calmly in the countryside, where fresh air, clean water, and fewer eyes more easily provided grounds for skinny-dipping and naked strolls.

Nudist camps (later called colonies) sprang up all along the East Coast—the very first in *New Yorker* readers' home state. Sure, they were raided regularly

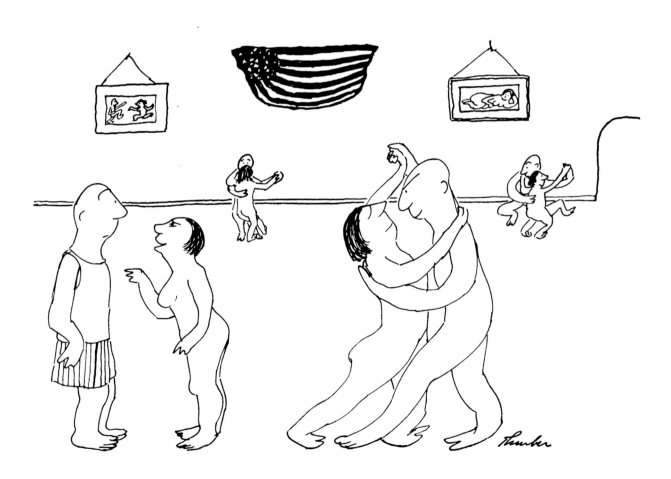

"See how beautifully your wife caught the spirit of nudism, Mr. Spencer."

until a landmark court case acquitted the bare-bottomed bunches: As long as their private parts remained behind privacy signs and privet hedges, assembly was permitted.

As the movement grew, marketing flyers became pamphlets became magazines, eventually featuring even full-frontal photography. As a humorist, Thurber found society's alternately amused, mortified, and titillated attitude an ideal theme. Besides, he had already been drawing his men and women naked; clothing, for the most part, was too fussy and time-consuming.

Often it's the presence of children that heightens a Thurber situation. Another cartoon from a gathering of naked men, women, and children bears the caption: "I bring the children because I don't want them to get the idea that there is anything horrible about nakedness."

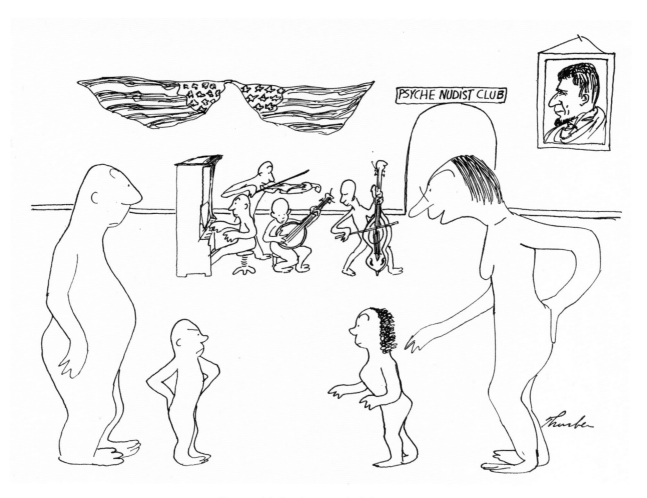

"Dance with the nice man's little boy, dear."

This drawing was featured on the cover of a tent-folded card that was mailed from Rankin & Young, a printing company in New York City. Thurber provided the "Foreword" on the inside. In a letter to Theodore Rousseau of December 18, 1952, he explained that "I did that nudist camp drawing solely for Ross about 1933, but he went ahead without authority and had two hundred copies made, which he sent to everybody."[21] In 1939, while living in Los Angeles to collaborate with Elliott Nugent on their play, *The Male Animal*, Thurber re-created the drawing at Hollywood's most fabulous Chasen's restaurant, where he frequently enjoyed cocktails with Humphrey Bogart, James Cagney, and even the young Ronald Reagan. The topic clearly entertained him.

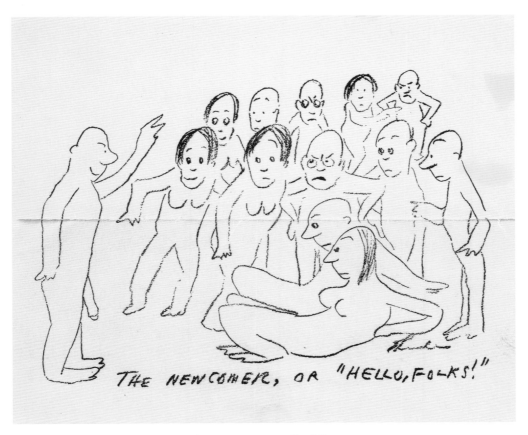

The Newcomer, or "Hello, folks!"

The interior of the card reads: "I have long wondered just how even the most sincere and impersonal nudists must react when a terribly well-hung gentleman appears in the colony. Many lady nudists' experiences of a gentleman's physique must be quite limited indeed, and I should imagine that it would be rather difficult to keep one's poise in that first moment of shock and revelation. My drawing shows the first moment as I visualize it, just before everybody settles down to the proper mood of indifference and nonchalance again.—Thurber"

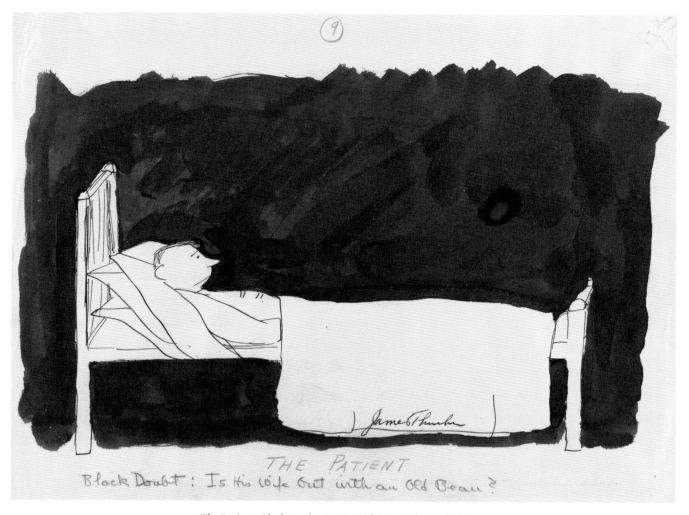

The Patient. Black Doubt: Is His Wife Out with an Old Beau?

Men, Women, and the Troubles Between

Prior to World War I, fewer than three out of a thousand marriages ended in divorce. Those who undertook the difficult separation process were ostracized; they were morally suspect. But after the Great War, many of the soldiers' hastily arranged marriages proved untenable, contributing to a rising divorce rate.

The concept of marriage was changing with the times: Couples began to consider their unions companionships, not contracts. If the husband and wife agreed that things just weren't working, divorce provided an available option. Personal happiness in the 1920s and 1930s gave people, especially women, new permission to end disappointing marriages. When James and Althea's marriage ended in 1935, divorce had lost some of its stigma. By

One in a series of nine drawings Thurber published in the short-lived magazine *Night and Day*, in the last months of 1937. He was becoming something of a hospital veteran at that point . . . and would only endure more and more distressing stays as his eyesight and health disrupted his life.

1940, the divorce rate tripled as Americans wanted not just to be married, but happily so. As Rosemary Thurber recalls:

> Yes, it *was* hard to be the child of divorce because it was an oddity—an aberration in the late 1930s. It was hard to have one last name, Comstock, until I was nine, and then to change to my *real* last name, Thurber. By then my mother, who had remarried, had a different name from mine, and that was embarrassing, friends calling her "Mrs. Thurber" when her name was then "Mrs. Gilmore."
>
> One thing about kids of divorce in the old days in Cornwall was that a group of us hung out together. At Rose Algrant's house. She was divorced and her son, Rolly, had two friends from divorced parents. There, no one had to explain divorce stuff all the time. Rose was my hero: She welcomed stray kids and stray animals! Dogs and cats were everywhere. That's just one of the reasons I loved spending time there.

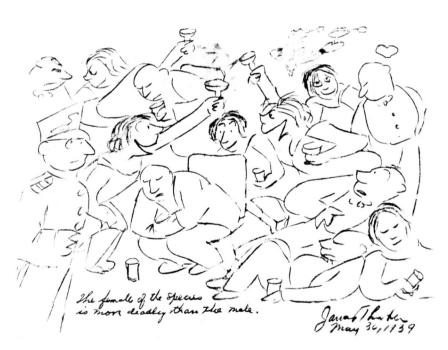

An unpublished drawing dated May 30, 1939. Thurber was actively engaged in the writing of *The Male Animal* at this point with his collaborator, Elliott Nugent.

The female of the species is more dangerous than the male.

The War Between Men and Women

Here is Thurber's grandest showdown between the ladies and the gents. The unassuming pleasantries and innocent jabs and unintentional barbs from the sofa or the café are escalated into a theater of battle. Heavy objects are hurled. Damage is done. Momentary truce is achieved, maybe. But what's the conflict here? Is it really between the sexes?

What's a couple often do when the parties can't find a solution together?

They battle between themselves. So I'd suggest Thurber enlists the sexes to engage with what lies before and beyond them: the future. The unknowable and unstoppable future that's out of reach, even the combined reach of a chain of women and men linking arms. In these drawings in particular, the awareness that more and more is out of one's control (or even comprehension) underlies the goofiness of the warfare. This is one of Thurber's tonic chords: The "little man"—or anyone else, for that matter—dealing with all that's OUT OF ORDER, and that includes everything from an appliance to a wartime alliance, from a failing body part to a bastardization of English usage.

The Battle on the Stairs

Zero Hour—Connecticut

The Battle of Labrador

Surrender

The Olden Time

An oddity in Thurber's canon, the eight drawings of "The Olden Time," which appeared once a month in the *New Yorker* from June 1946 to January 1947, are glimpses of the Middle Ages through a distinctly Thurber lens.

The comparison to the house-woman likely won't escape you (see page 111). But Thurber frequently drew men and women in various states of mitosis, joining together, sharing a common structure, pulling apart (see page 101).

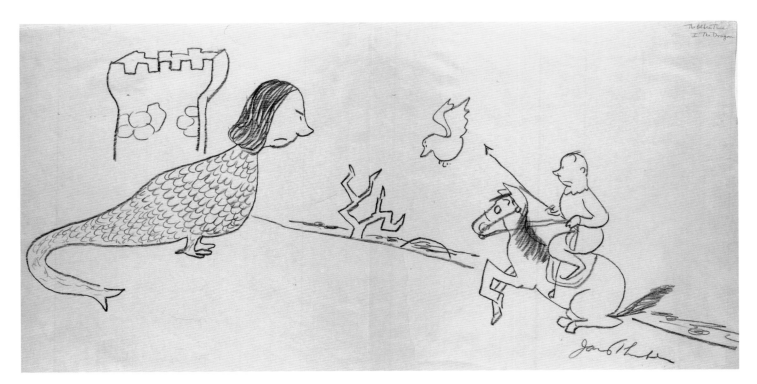

The Dragon

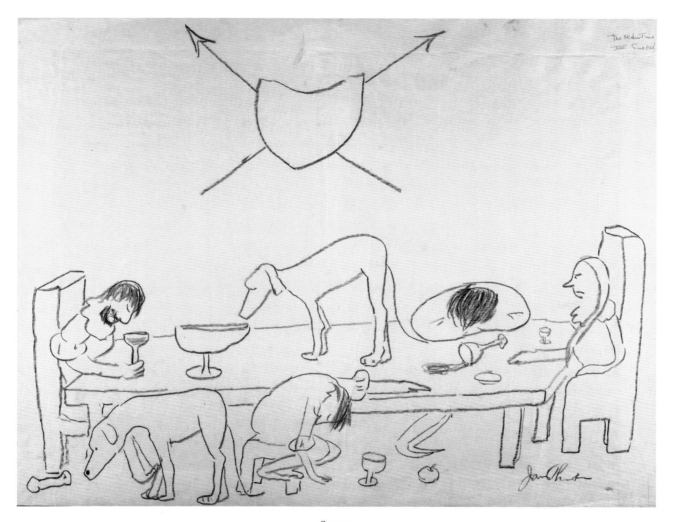

Supper

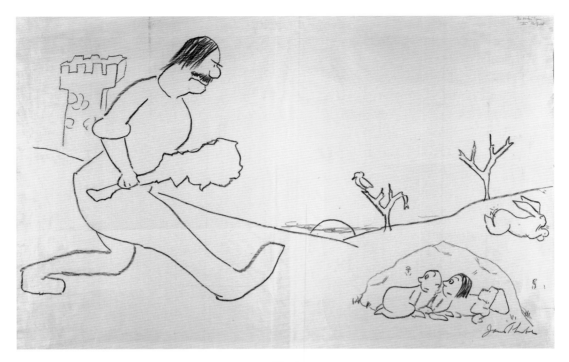

Giant

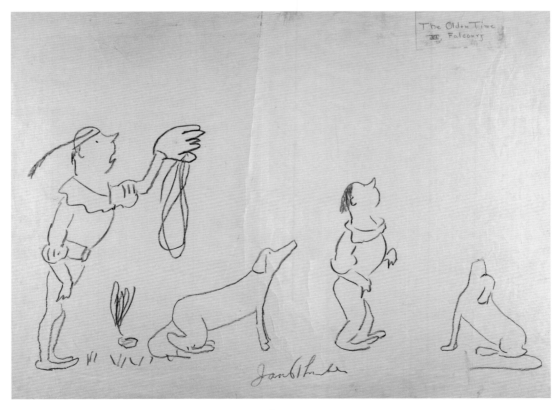

Falconry

The Stages of a Relationship

The theme of a relationship's stages is a bittersweet deck that Thurber drew, shuffled up, and dealt out on many occasions. Other variations of amorphous, once amorous, couples bear titles: "The Last Farewell," "The Enigma," "The Dance of Life," "Surrender," "The Sick Wife," and "The Good-bye Drink." The suite of thirteen images below is unpublished and undated, but the rounder figures with fewer background elements relate them to the 1930 drawings for *Is Sex Necessary?*

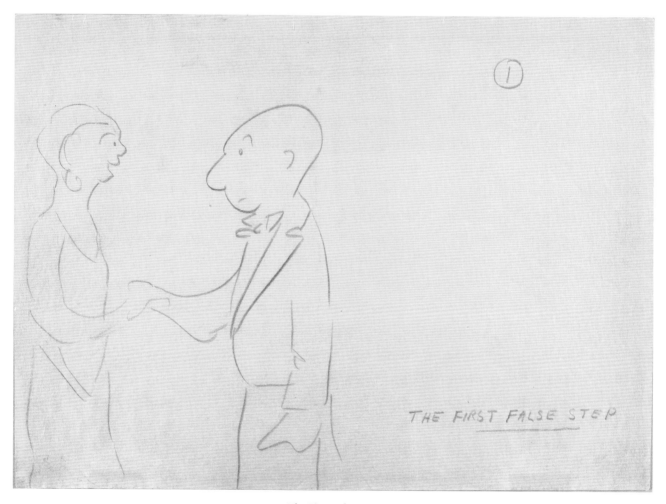

The First False Step

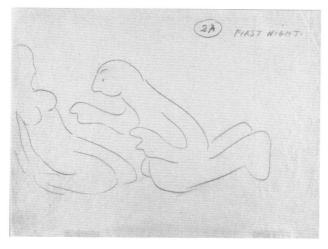

First Night

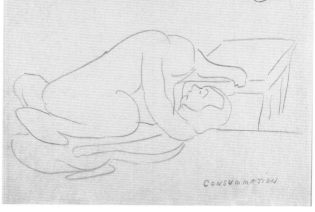

Consummation

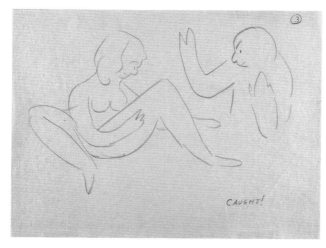

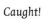

Caught!

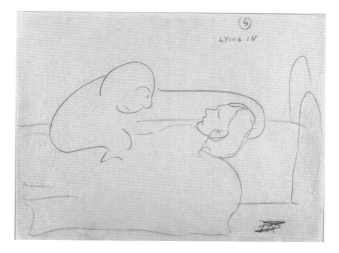

Lying In

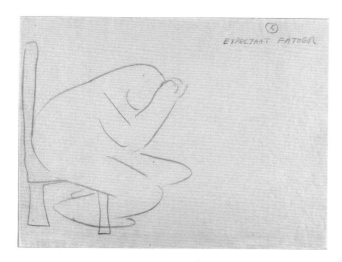

Expectant Father

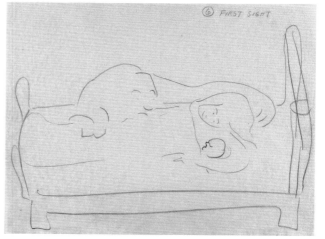

First Sight

98

Play Time

Suspicion

The Quarrel

Recalling Happy Days

Temporary Peace

Alone at Last

Thurber's Additions to William Steig's About People

Perhaps most known today for his *Shrek!* series of children's books, over a course of seventy years William Steig (1907–2003) published 121 covers and 1,676 drawings in the *New Yorker*. In Steig's first book for adults—pen-and-ink drawings entitled *About People: A Book of Symbolical Drawings* (Random House, 1939)—Thurber penciled fifteen more drawings among the 105 states of mind printed in the book. In addition to these six, he depicted "First Love," "First Affair," "Marriages Are Made in Heaven," "Impotence," "Duty," "End of a Love Affair," "Just Missed," "Disease," and "Art and Marriage."

Regret

Disillusion

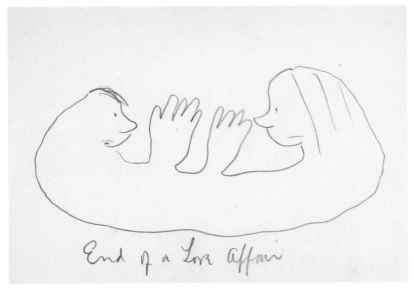

End of a Love Affair

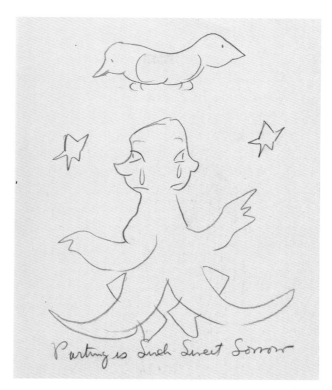

Parting Is Such Sweet Sorrow

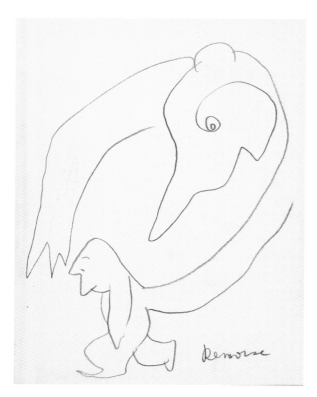

Remorse

Stomach Ulcer

Mind Games

Office mates E. B. White and Thurber wrote alternate chapters of a book that would be the first book for each of them: *Is Sex Necessary? Or Why You Feel the Way You Do*. As White relates in the preface to the twenty-first anniversary edition, they "somehow managed, simultaneously, to arrive at the conclusion that . . . the heavy writers had got sex down and were breaking its arm. We were determined that sex should remain in high spirits. So we decided to spoof the medical books and, incidentally, to have a quick look at love and passion."[22] Various editions of the book have remained in print for ninety years.

Thurber followed this book with *Let Your Mind Alone*, a further spoofing of various pop psychology themes of the day.

"Many men have told me that they would not object to sex were it not for its contactual [sic] aspect. (One such man is shown in the background.)"—from *Is Sex Necessary?*

"Unconscious Drawing: Plate 1. Unconscious drawings, as they are called in psychoanalytical terminology, are made by people when their minds are a blank. This drawing was made by Floyd Neumann, of South Norwalk. It represents the Male Ego being importuned by, but refusing to yield to, Connecticut Beautiful."—from *Is Sex Necessary?*

Ladder Phobia

This illustration from *Let Your Mind Alone* is from "Miscellaneous Mentation," a chapter in which Thurber considers choice passages in the "mental technique" books of the era. His first example: Dr. Louis E. Birch, author of *Be Glad You're Neurotic*, sets forth how to overcome problems in much the same way as learning that walking under ladders is superstitious. Thurber counters: "If you keep looking for and walking under ladders long enough, something is going to happen to you, in the very nature of things. Then, since your defiance of 'all the demons that may be' proves you still believe in them, you will be right back where you were, afraid to walk under a ladder again."[23]

STROLLERS [OSU's theater group] put on an evening of one-act plays. . . .
Jim appeared in *A Night at the Inn*, and I played the husband in a short satirical
comedy by Susan Glaspell. They treated the new 'science' of psychoanalysis
with good-natured derision, and so far as I remember, no other American
playwright even mentioned the subject. . . . Neither Thurber nor I considered
psychiatry a science in those days; even psychology . . . seemed vague and full
of unproved theories. We had vastly greater respect for Henry James than for
his brother William."—Elliott Nugent, playwright, actor, and coauthor with
Thurber of the Broadway hit *The Male Animal* [24]

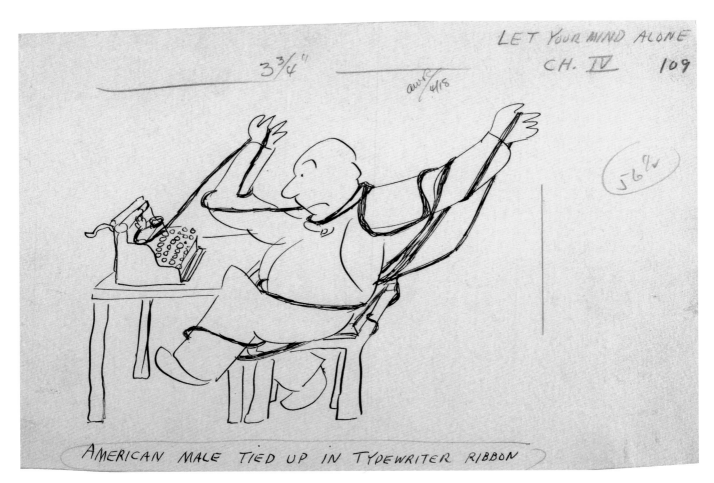

American male tied up in typewriter ribbon

This drawing is from *Let Your Mind Alone*, but Thurber drew other images of man
versus typewriter ribbon. In each case, the ribbon appears to be winning.

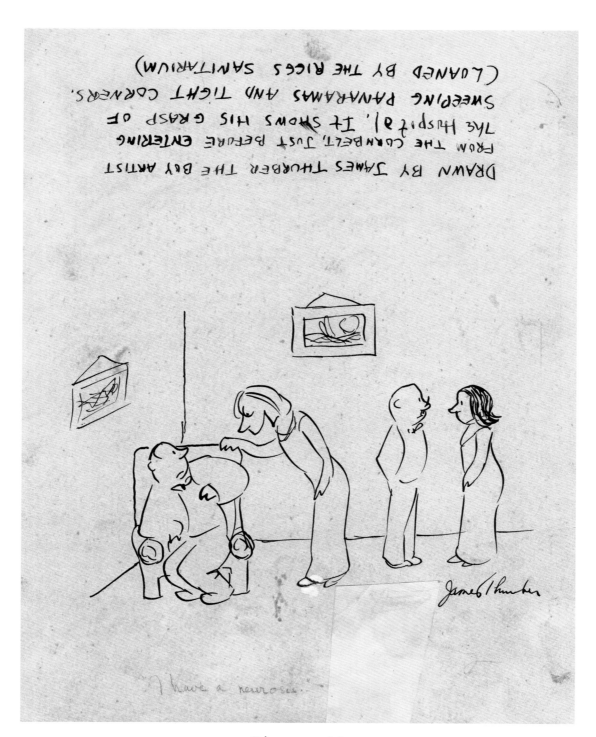

"I have a neurosis."

The cartoon appears in the *New Yorker*, February 15, 1941, but without Thurber's additional text penned upside down: "Drawn by James Thurber the boy artist from the corn belt, just before entering the Hospital. It shows his grasp of sweeping panaramas [sic] and tight corners. (Loaned by the Riggs Sanitarium)."

Thurber's Pre-Intentional Compositions

"My psychoanalyst could cure him of these drawings in six weeks."[1]

Thurber's drawing may as the legend goes have started as a cross between neurasthenia and doodling, but by now it is a full-fledged style, capable of anything and secure in its authority.[2]
—OTIS FERGUSON, *The New Republic*

What first attracted me to a Thurber cartoon was that there was so little of it. Then as I began to study his cartoons (and who "studies" a cartoon?), I realized that the idea (and the writing) was more important than the drawing.

The magazine's cartoon editor Bob Mankoff validated my suspicions when he told me, "It's the think, not the ink." Thurber was all think.
—MICHAEL SHAW, a cartoonist for the *New Yorker*

WHEN THURBER PUBLISHED and reprinted the only authoritative piece possible on how he draws what he draws, a piece that half-kiddingly provides insights into his methods/madness, it makes no sense for an "editor-itative" and less astute version. Thus, here is Thurber's complete text and drawings for "The Lady on the Bookcase," an essay from *The Beast in Me*, first published in 1945 as "Thurber as Seen by Thurber," in the *New York Times Magazine*.

The Lady on the Bookcase

One day twelve years ago an outraged cartoonist, four of whose drawings had been rejected in a dump by the *New Yorker*, stormed into the office of Harold Ross, editor of the magazine. "Why is it," demanded the cartoonist, "that you reject my work and publish drawings by a fifth-rate artist like Thurber?" Ross came quickly to my defense like the true friend and devoted employer he is. "You mean third-rate," he said quietly, but there was a warning glint in his steady gray eyes that caused the discomfited cartoonist to beat a hasty retreat.

With the exception of Ross, the interest of editors in what I draw has been rather more journalistic than critical. They want to know if it is true that I draw by moonlight, or under water, and when I say no, they lose interest until they hear the rumor that I found the drawings in an old trunk or that I do the captions while my nephew makes the sketches.

The other day I was shoving some of my originals around on the floor (I do not draw on the floor; I was just shoving the originals around) and they fell, or perhaps I pushed them, into five separate and indistinct categories. I have never wanted to write about my drawings, and I still don't want to, but it occurred to me that it might be a good idea to do it now, when everybody is busy with something else, and get it over quietly.

Category No. 1, then, which may be called the Unconscious or Stream of Nervousness category, is represented by "With you I have known peace, Lida, and now you say you're going crazy," and the drawing entitled with simple dignity, "Home." These drawings were done while the artist was thinking of something else (or so he has been assured by experts) and hence his hand was guided by the Unconscious which, in turn, was more or less influenced by the Subconscious.

Students of Jung have instructed me that Lida and the House-Woman are representations of my *anima*, my female essence or directive which floats around in the ageless universal Subconscious of Man like a tadpole in a cistern. Less intellectual critics insist that the two ladies are actual persons I have consciously known. Between these two schools of thought lies a discouragingly large space of time extending roughly from 1,000,000 BC to the middle 1930s.

Whenever I try to trace the true identity of the House-Woman, I get to thinking of Mr. Jones. He appeared in my office one day twelve years ago, said he was Mr. Jones, and asked me to lend him "Home" for reproduction in an art magazine. I never saw the drawing again. Tall, well-dressed, kind of sad-looking chap, and as well spoken a gentleman as you would want to meet.

Category No. 2 brings us to Freud and another one of those discouragingly large spaces—namely, the space between the Concept of the Purely Accidental and the Theory of Haphazard Determination. Whether chance is capricious or we are all prisoners of pattern is too long and cloudy a subject to go into here. I shall consider each of the drawings in Category No. 2, explaining what happened and leaving the definition of the forces involved up to you. The seal on top of the bed, then ("All right, have it your way—you heard a seal bark"), started out to be a seal on a rock. The rock, in the process of being drawn, began to look like the head of a bed, so I made a bed out of it, put a man and wife in the bed, and stumbled onto the caption as easily and unexpectedly as the seal had stumbled into the bedroom.

The woman on top of the bookcase ("That's my first wife up there, and this is the *present* Mrs. Harris") was originally designed to be a woman crouched on the top step of a staircase, but since the tricks and conventions of perspective

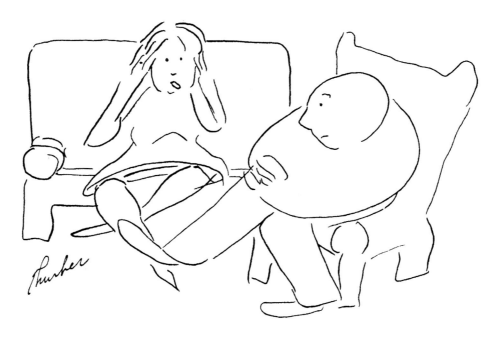

With you I have known peace, Lida, and now you say you're going crazy.

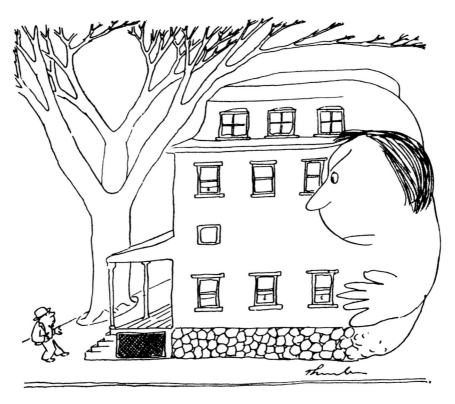

Home

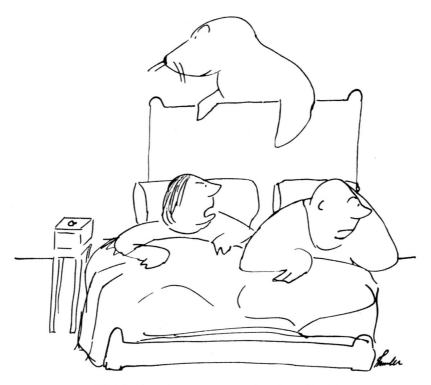

"All right, have it your way—you heard a seal bark."

"That's my first wife up there, and this is the present Mrs. Harris."

and planes sometimes fail me, the staircase assumed the shape of a bookcase and was finished as such, to the surprise and embarrassment of the first Mrs. Harris, the present Mrs. Harris, the lady visitor, Mr. Harris and me. Before the *New Yorker* would print the drawing, they phoned me long distance to inquire whether the first Mrs. Harris was alive or dead or stuffed. I replied that my taxidermist had advised me that you cannot stuff a woman, and that my physician had informed me that a dead lady cannot support herself on all fours. This meant, I said, that the first Mrs. Harris was unquestionably alive.

The man riding on the other man's shoulders in the bar ("For the last time—you and your horsie get away from me and stay away!") was intended to be standing alongside the irate speaker, but I started his head up too high and made it too small, so that he would have been nine feet tall if I had completed his body that way. It was but the work of thirty-two seconds to put him on another man's shoulders. As simple or, if you like, as complicated

"For the last time—you and your horsie get away from me and stay away!"

as that. The psychological factors which may be present here are, as I have indicated, elaborate and confused. Personally, I like Dr. Claude Thornway's theory of the Deliberate Accident or Conditioned Mistake. [Editor's note: The good doctor and the theory are both Thurber's invention.]

Category No. 3 is perhaps a variant of Category No. 2; indeed, they may even be identical. The dogs in "The father belonged to some people who were driving through in a Packard" were drawn as a captionless spot, and the interior with figures just sort of grew up around them. The hippopotamus in "What have you done with Dr. Millmoss?" was drawn to amuse my small daughter. Something about the creature's expression when he was completed convinced me that he had recently eaten a man. I added the hat and pipe and Mrs. Millmoss, and the caption followed easily enough. Incidentally, my daughter, who was two years old at the time, identified the beast immediately. "That's a hippotomanus," she said. The *New Yorker* was not so smart. They described the drawing for their files as follows: "Woman with strange animal." The *New Yorker* was nine years old at the time.

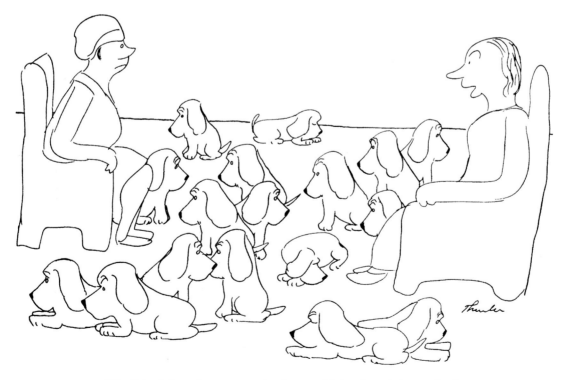

"The father belonged to some people who were driving through in a Packard."

"I ALWAYS LOVED *New Yorker* cartoons as a kid and at an early age borrowed collections from the library. It was in one of those that I must have discovered the James Thurber cartoon where a man's first wife is on top of a bookshelf. It blew my mind. It was so hilarious and full of surprise and more importantly, emotional truth. And the drawing was so primitive, yet so beautiful and stylish. ¶ Many years later, when I started submitting cartoons to the *New Yorker*, I often thought about Thurber. I aspired to my id as deeply as he seemed to. And when I would get frustrated by being a self-taught artist, I would comfort myself that Thurber seemed to be one, too, and was still able to create stunning images."—Bruce Eric Kaplan (BEK), cartoonist for the *New Yorker*

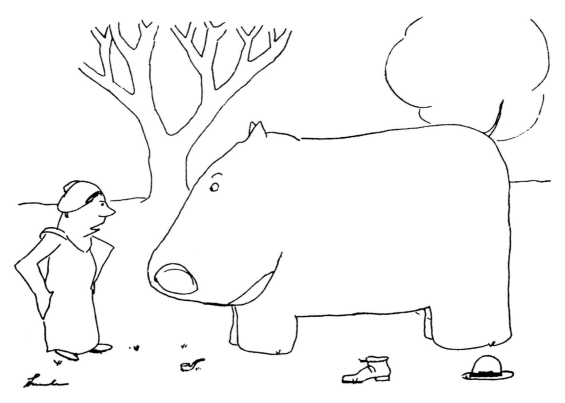

"What have you done with Dr. Millmoss?"

Category No. 4 is represented by perhaps the best known of some fifteen drawings belonging to this special grouping, which may be called the Contributed Idea Category. This drawing ("Touché!") was originally done for the *New Yorker* by Carl Rose, caption and all. Mr. Rose is a realistic artist, and his gory scene distressed the editors, who hate violence. They asked Rose if he would let me have the idea, since there is obviously no blood to speak of in the people I draw. Rose graciously consented. No one who looks at "Touché!" believes that the man whose head is in the air is really dead. His opponent will hand it back to him with profuse apologies, and the discommoded fencer will replace it on his shoulders and say, "No harm done, forget it." Thus the old controversy as to whether death can be made funny is left just where it was before Carl Rose came along with his wonderful idea.

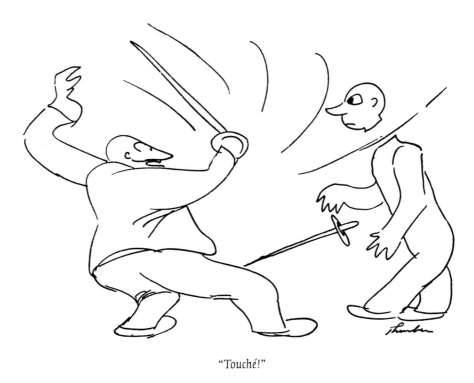

"Touché!"

Category No. 5, our final one, can be called, believe it or not, the Intentional or Thought-Up Category. The idea for each of these two drawings just came to me and I sat down and made a sketch to fit the prepared caption. Perhaps, in the case of "Well, I'm disenchanted, too. We're *all* disenchanted," another one of those Outside Forces played a part. That is, I may have overheard a husband say to his wife, on the street or at a party, "I'm disenchanted." I do not think this is true, however, in the case of the rabbit-headed doctor and his woman patient. I believe that scene and its caption came to me one night in bed. I *may* have got the idea in a doctor's office or a rabbit hutch, but I don't think so. "You said a moment ago that everybody you look at seems

to be a rabbit. Now just what do you mean by that, Mrs. Sprague?" If you want to, you can cut these drawings out and push them around on the floor, making your own categories or applying your own psychological theories; or you can even invent some fresh rumors. I should think it would be more fun, though, to take a nap, or baste a roast, or run around the reservoir in Central Park.[3]

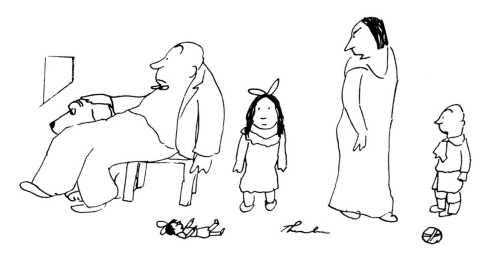

"Well, I'm disenchanted, too. We're all disenchanted."

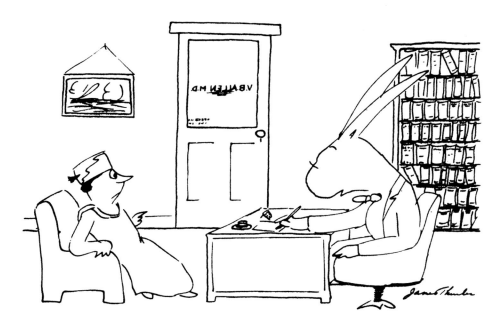

"You said a moment ago that everybody you look at seems to be a rabbit. Now just what do you mean by that, Mrs. Sprague?"

◗ MICHAEL MASLIN

Maslin and Millmoss

THE FIRST THURBER drawing I ever saw could barely be simpler: a hippopotamus, a hat, a shoe, a pipe, a woman, a tree, and a cloud. Nearly fifty years have passed, and I am still overwhelmed by its hilarity and its perfection—its cartoon perfection (see page 115). But "Millmoss" is not alone in the Thurber canon of perfection. It is definitely not alone—I could easily name a dozen more. But you know what they say: You always remember your first.

How often does one drawing change one's life? I don't mean change in some minor way, as in you appreciate an artist's work more or less, or somehow differently than you saw it before. I mean change in the trajectory of one's life. Thurber's Millmoss drawing changed mine.

I'd been drawing since age four. By the time I was sixteen, I was under the influence of R. Crumb and M. C. Escher, drawing pages thick with complex lines. Millmoss appeared under my nose courtesy of a friend who opened up *The Thurber Carnival* and pointed to it. Right then and right there, life changed. When describing this moment to others, I've said it was if I'd been struck by cartoon lightning. In that moment, I fell into a world and a humor completely new to me, yet somehow entirely familiar. It felt like home, like the way I felt about the world, about the way I saw things. This brilliant drawing lit the way.

"Hm. Explorers."

Millmoss emboldened me to draw for fun. Not to worry about how "right" the work looked, but how it felt, *how I felt*, putting something down on paper. Look again at Thurber's hippopotamus. It's almost a giant dog, but it clearly reads as a hippo despite its pointed ears and head shape. Here and now is an excellent opportunity to recall E. B. White's response to a criticism of the way Thurber drew a seal's whiskers: "This is how Thurber's seal's whiskers are drawn," White said. (See the quote on the right for Thurber's own recounting of this.)

And this is how Thurber's hippopotamuses are drawn. Somehow his hippo is—to me—more a hippopotamus than one rendered by a "fine artist."

Millmoss also educated me in the benefit of not giving the customers everything they want in a cartoon. By keeping his drawings sparse, everything in the drawing becomes more important. For instance: Notice there is just one shoe on the ground next to the hippo, not two. Most of us looking at the drawing might think the hippo wouldn't be interested in eating shoe leather. But Thurber, in his brilliance, left us with a little more something to mull over. ✦

Uneasy lies the head that wears the penguin.

[E. B. WHITE] tried to get the *New Yorker* to publish a drawing I had done with a pencil on yellow copy paper. It showed a seal on a rock staring at a distant group of human beings, and saying, 'Hm.' The magazine's art meeting rejected it and sent along, for my instruction and guidance, a professional's drawing of the head of a seal, with the message, 'This is the way a seal's whiskers go.' White sent my drawing back to the next art meeting with the message, 'This is the way a Thurber seal's whiskers go.' It was rejected again, without drawings or messages. White and I then wrote *Is Sex Necessary?* and he forced our shocked publishers to publish my illustrations for that book. The *New Yorker* then asked me to let them have another look at the seal on the rock, but I had destroyed it. I set about doing another one, and what came out of that, by accident and ineptitude, was the drawing in this book of the seal in the bedroom."[4]
—James Thurber, from *The Seal in the Bedroom and Other Predicaments*

A couple in bed with an aquatic creature nearby—my Thurber roots are showing.
—MM

Look Out!

Perhaps growing up in a household where one's mother, a frustrated actor, took her theatrical bent and bent over backwards with various voices and costume disguises, pranks, and assorted shenanigans she'd spring on relatives and neighbors . . . perhaps that, in combination with the shake-ups and shakedowns of one's country, seemingly endless heretofore unheard of inventions with minds of their own, dire economic plummets, dizzying reports of shootings and gangsters—perhaps this could lead to jumpiness. "Jumpy as tin toys with keys in their backs"[5] was a metaphor Thurber used to describe a youth baseball team, but it readily applies to Thurber and many of the characters that populate his cartoons and stories.

In the preface to *My Life and Hard Times*, Thurber generalized "jumpiness" as a quality humorists possess: "They lead . . . an existence of jumpiness and apprehension. They sit on the edge of the chair of Literature. In the house of Life they have the feeling that they have never taken off their overcoats."[6]

In 1939, Thurber chose to focus on this theme in his "Statement," a contribution to *I Believe: The Personal Philosophies of Certain Eminent Men and Women of Our Time.*

> The survival of almost any species of social animal, no matter how low, has been shown to be dependent on Group Co-operation, which is itself a product of instinct. Man's cooperative processes are jumpy, incomplete, and temporary because they are the product of reasoning and are thus divorced from the sanity which informs all natural laws.[7]

In her critical study, *Thurber's Anatomy of Confusion*, Catherine McGehee Kenney suggests that "there is perhaps no better explanation of the wildly chaotic scenes in Thurber's cartoons than that they are pictures of co-operative processes which are 'jumpy, incomplete, and temporary.' They freeze a moment in the confusion."[8]

Thurber restated this theme in a slightly more dire key, for a *New York Times* interview on the current state of humor:

> Americans must learn that humor, whatever form it may take, can be one of our strongest allies, but it cannot flourish in a weather of fear and hysteria and intimidation. Bravest of the brave in wartime, we are known abroad as the jumpiest of the jumpy in peacetime.[9]

Several of his drawings explore or expose the idea of a surprise, something or someone unexpectedly or inexplicably appearing.

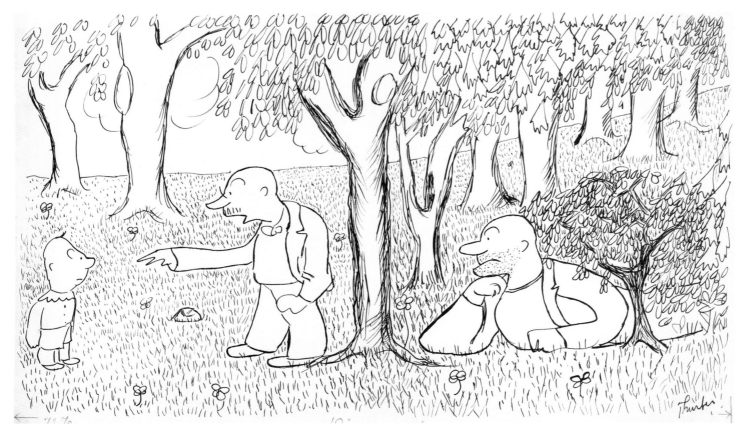

"No son of mine is going to stand there and tell me he's scared of the woods."

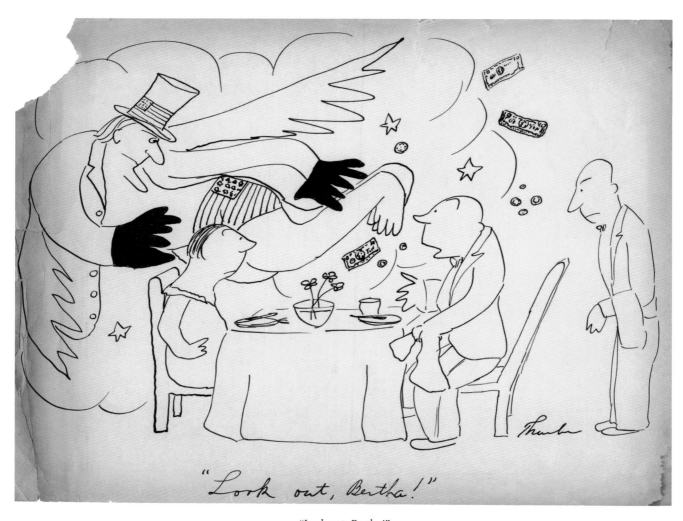

"Look out, Bertha!"

"You and your premonitions!"

"Well what are you staring at?"

One of several drawings Thurber created
on the walls of Costello's (see page 49).

"Oh, Doctor Conroy—look!"

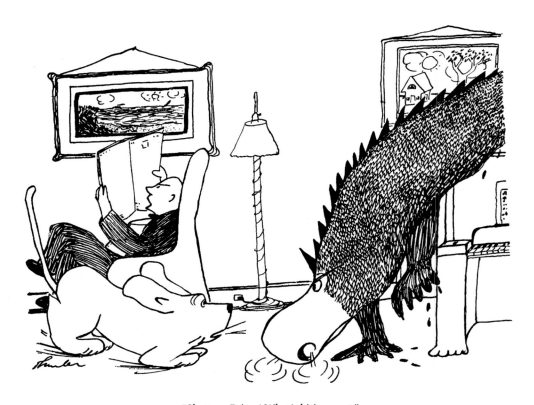

"Shut up, Prince! What's biting you?"

Less alarming and more alluring, this same scenario Thurber cast with a man and woman sitting opposite one another where a nude or half-dressed beauty stands in plain sight—of only the man.

That fortuitous doorway that frames the beauty with the Thurber-flower slip? The slump of the man in the seat-less chair (surely an example of Thurber's sketch-free inking directly on the page)? While there's no saying why, they ineffably add humor, invisible as helium, to the cartoon's atmosphere.

Thurber dashed off innumerable versions of this scenario—most of them passed to friends and framed, it's hoped, in homes nationwide. Mixed into *The Seal in the Bedroom*'s miscellany are six variations of this theme. All have the identical caption, but a Mr. Gardiner, a Mr. Griscom, a Dr. Garber, a Mr. Jaffe, and a Mr. Speaks each gets a turn on the couch.

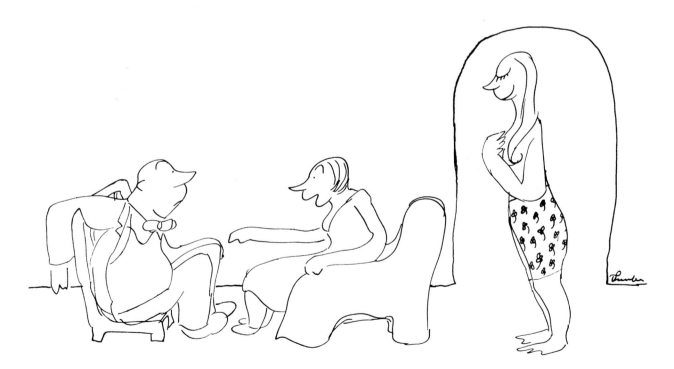

"A penny for your thoughts, Mr. Coates."

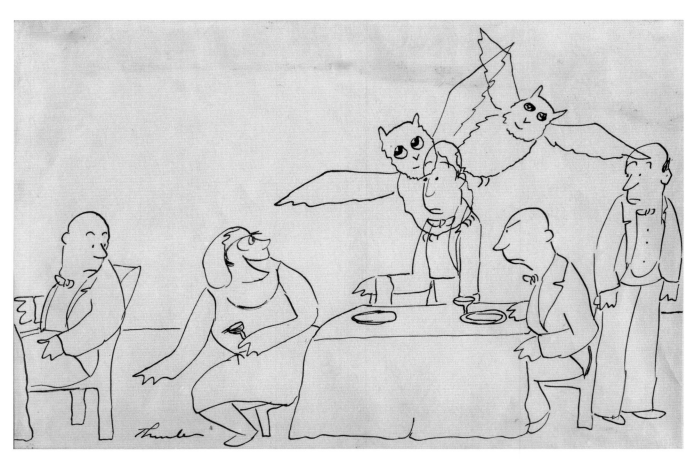

"Look out, here they come again!"

This work was featured at the Museum of Modern Art's exhibit *Fantastic Art, Dada, Surrealism*, curated by Alfred H. Barr, Jr., in 1936. Thurber's drawing of the couple at a restaurant where owl-bat spirits suddenly rise from the waiter was included in a section entitled "Artists independent of the Dada-Surrealist movements," which featured works by Alexander Calder, Walt Disney, Georgia O'Keeffe, and Arthur Dove, among others.

From *Los Caprichos*, this is one in the suite of eighty etchings that ridicules the corrupt and dissolute Spanish society. John Elderfield, of the Museum of Modern Art, suggests that Thurber is parodying Goya in this drawing.[10] Or that Thurber's response is a paraphrasing (see page 26 for other paraphrases) of Goya's etching *The Sleep of Reason Produces Monsters*. Goya's grotesque humor is unmistakably "batty," rather than "owlish." And the context is clearly different. Thurber's delivery of the cartoon, once again, is an open-ended invitation to supply what we will: What just happened? What's just about to happen? And why was the "ghost" of Goya invited to this bizarre dinner/séance?

The Sleep of Reason Produces Monsters, Francisco Goya, c. 1799. The artist explains: "Fantasy abandoned by reason produces impossible monsters: united with her (reason), she (fantasy) is the mother of the arts and the origin of their marvels." Image courtesy the Metropolitan Museum of Art.

Animal Artist

CHAPTER FOUR

That Thurber Dog and Other Creatures

"There go the most intelligent of all animals."

THROUGHOUT MUCH OF HIS WORK, Thurber rued and ridiculed the unique "gift" of reasoning and rationality that people were handed—or greedily grabbed—in the evolution of the Animal Kingdom. His letters, essays, and interviews frequently allude to humankind's overthinking, conceitedness, and other fumbling, ill-fitted behaviors—particularly evident in contrast to the exquisite suitability, efficiency, and balance achieved by other creatures. They live in a version of homeostasis and harmony that men and women rarely achieve. And that's only a hint at the anxieties and aggressions

"There go the most intelligent of all animals."

posed by humans assembled in political parties, ethnic groups, countries, or any number of other subsets of the population. And Thurber turned his humor to many of these troubling subjects.

Thurber's profound sense of the world's injudicious and wayward state is frequently contrasted with members of the animal world. In some instances, their very presence in a cartoon is the "natural world" staring back—or even looking away—at "human nature." In other pieces, such as his many fables, animals are stand-ins, agents that occupy a simpler, less complicated domain where they can illuminate an absurdity, foible, or weakness. Whether the "unregistered" hybrid, "the Thurber Dog," or a seal, penguin, bird, or any number of other real—or in his books for children, imagined—creatures, each offers a soundness in an unsound world.

That Thurber Dog

> I had a friend who was on the telephone a great deal and while he talked was always tapping the pages of his memo pad and writing things down. I started to fill up the pad with drawings so he'd have to work to get to a clean page. I began to draw a bloodhound but he was too big for the page. He had the head and body of a bloodhound; I gave him the short legs of a basset. When I first used him in my drawings, it was as a device for balance: when I had a couch and two people on one side of a picture and a standing lamp on the other, I'd put the dog in the space under the lamp for balance. I've always loved that dog. Although at first he was a device, I gradually worked him in as a sound creature in a crazy world. He didn't get himself into the spots that human beings get themselves into. Russell Maloney stated once that I believe animals are superior to human beings. I suspected he wanted to get me sore. If I have run down the human species, it was not altogether unintentional. They say that Man is born to the belief that he is superior to the lower animals, and that critical intelligence comes when he realizes that he is more similar than dissimilar. Extending that theory, it has occurred to me that Man's arrogance and aggression arise from a false feeling of transcendence, and that he will not get anywhere until he realizes, in all humility, that he is just another of God's creatures, less kindly than Dog, possessed of less dignity than Swan, and incapable of becoming as magnificent an angel as Black Panther.[1]
> —JAMES THURBER
> [Editor's note: Russell Maloney was contributor of many cartoons, profiles, stories, and "Talk of the Town" pieces during his eleven years at the *New Yorker*.]

In the spring of 1940, Thurber was asked to contribute to an "old timers" issue of the Ohio State University monthly humor magazine, the *Sundial*, to which he contributed a variety of poems, drawings, and prose during his college years. His final year at the university, 1917–18, he essentially rose to impresario of the *Sundial*'s circus. As he wrote in 1936 to his Columbus friend Herman Miller, "Because all the artists went to war or camp and left me without any

artists . . . I drew pictures rapidly and with few lines because I had to write most of the pieces, too, and couldn't monkey long with the drawings."

His contribution as a renowned alumnus, "How to Build a Rabbit Cage," included this unpublished cartoon and text:

People have frequently asked me to 'explain' my drawings, that is, tell what they are 'about,' and although I never have, I might as well begin with this one. The scene is in a room in the house of one Bryon O. Merriwell, aged 46, a manufacturer of gypsum board. He has asked a number of people to a party, including Mr. and Mrs. Claude Wenfle. Mr. Wenfle is the man dancing. Mrs. Wenfle is behind the vase holding the ball bat. She has long (say two hours) been jealous of Miss Corabelle Clester, the woman dancing with Wenfle (or Wenfel). Miss Clester, a Southern girl, aged 35, daughter of Mrs. Belle Clester and the late Gordon J. Clester, of 2436 Mayberry Avenue, Natchez, having had a couple of drinks of a wine made from oleander blossoms, put up by Mrs. Minna ('Mother') Merriwell, at first had her eye on George Vennish, sales manager for a big *toile de jouy* concern, who, however, went to sleep shortly after the rug was rolled up and the people began to dance. Miss Clester thereupon asked Wenfel to dance, which he is shown doing. The actual 'point' of the drawing is that Miss Clester's desire and hope of 'going on this way' with Wenfel forever is bound to be frustrated, like so many things in life. For one thing, she cannot maintain her balance very long owing to her precarious list; for another, she is almost certain to be crowned by Mrs. Wenfel. The dog does not know exactly what is going to happen, but he knows that something is, and thus becomes one of the two figures in the drawing who has a sense of 'awareness,' the other being Mrs. Wenfel. It seems to me that this is simple enough.

—From the Ohio State University *Sundial*, April 24, 1940

"I could go on like this forever!"

James Thurber

Thurber's original drawing for the magazine's cover (opposite), intended to coincide with the Westminster Dog Show held in Manhattan since 1877, and the colored drawing on the cover of the February 9, 1946, issue.

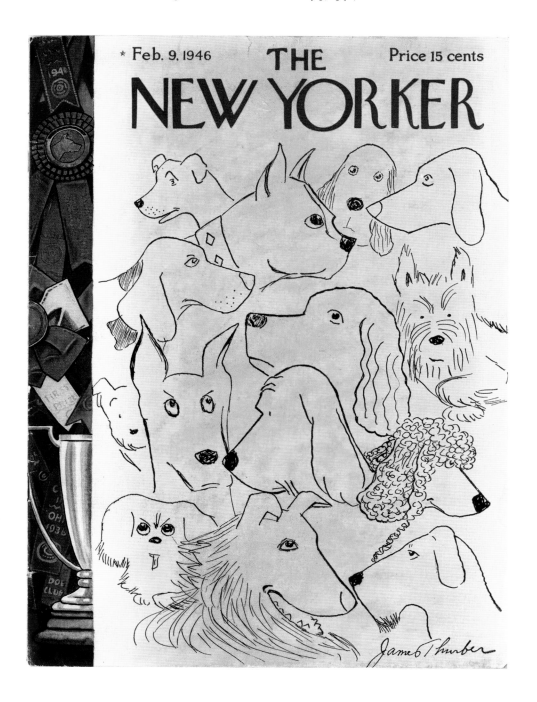

Five of the seventeen panels that comprise a Thurber dog's encounter with a beetle, "The Bloodhound and the Bug." The *New Yorker* ran the series February 6, 1932.

"NOTHING IS LESS NECESSARY than a pet dog, or more needed. Thurber's theme is that a dog's life is spent, as a man's life should be, doing pointless things that have the solemnity of inner purpose. ¶ The most memorable images of the dog that Thurber left us are contained within his wonderful, mysterious series called 'The Bloodhound and the Bug.' The bloodhound tracks the bug, finds the bug's hideout in a mouse hole, and then leaves the bug alone. It's not that the pleasure is in the pursuit so much as that the wisdom lies in the knowing when it doesn't matter. The deep wisdom of permanent inaction is one Thurber's men take from their dogs."—Adam Gopnik, "A Note on Thurber's Dogs," the *New Yorker*, November 1, 2012

THESE ARE THREE of the thirty-two illustrations, all featuring "that Thurber dog," created for James R. Kinney, DVM, and Ann Honeycutt's book, *How to Raise a Dog in the City and in the Suburbs* (Simon & Schuster, 1938). Honeycutt, who was romantically "involved" with Thurber for some eight years, frequently enjoyed sharing her friend's remark: "Thurber used to tell me it was really his book, and that my text was simply the captions for his drawings."[2] While it did become a best-selling book, the illustrations were far and away its biggest draw.

The man was a pushover.

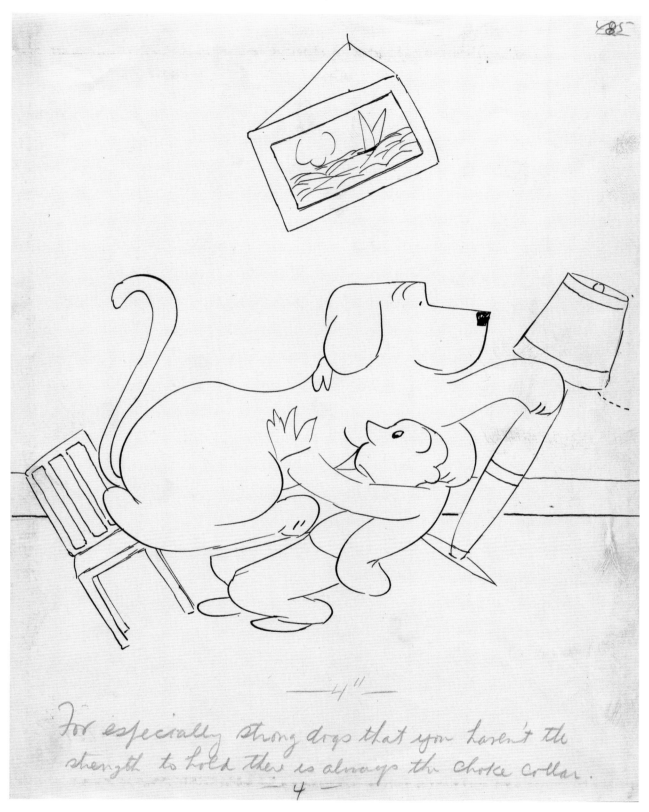

For especially strong dogs that you haven't the strength to hold there is always the choke collar.

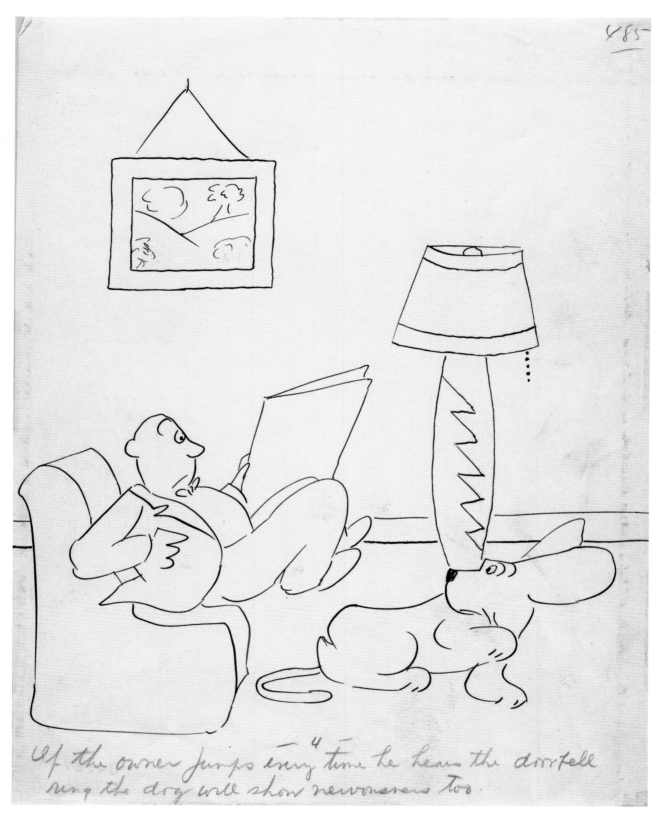

If the owner jumps every time he hears the doorbell ring the dog will show nervousness too.

138

Merry Christmas,
Happy New Year!

Many of the books and holiday cards sent from the Thurbers included drawings, often of "that Thurber dog." In this more carefully inked one, a pack of Thurber dogs have replaced Santa's reindeer. It was sent to Eva Prout, Thurber's Douglas Elementary School crush. (Meeting her again in their mid-twenties, still smitten with her, Thurber wrote his buddy Elliott Nugent: "Eva, the Girl of Dreams. . . . The Girl of movie stories. . . . The girl of Browning gondolas, of Lee Robert's songs. . . . The one, after all, we marry."[3]) Perhaps, dog person that he was, he remembered Eva as the one guest at the Thurber household who pet the Airedale, "Muggs, the dog who bit people," and *wasn't* bitten. (Mame Thurber *still* sent her the family's typical apology: a box of her homemade chocolates.)

"The Hound and the Hat," a sequence from the *New Yorker*, August 25, 1934. Thurber's art for panel six has been lost. That image printed here has been reproduced from a slide of the original.

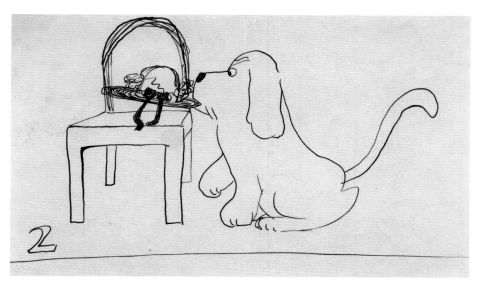

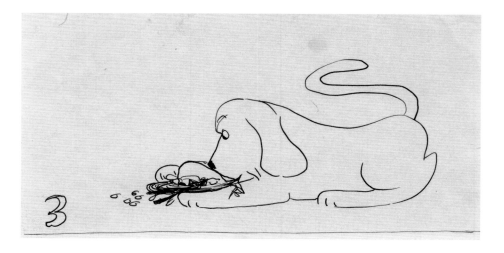

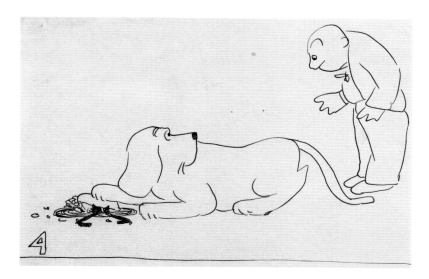

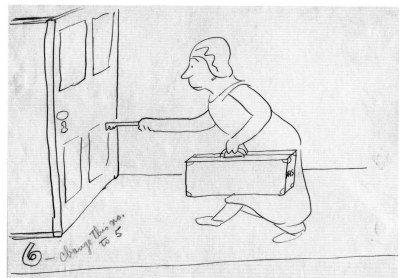

This unpublished suite of eight drawings was likely created in 1937, the period in which Thurber prepared the illustrations for *How to Raise a Dog in the City and in the Suburbs*.

"May we share that bench?"

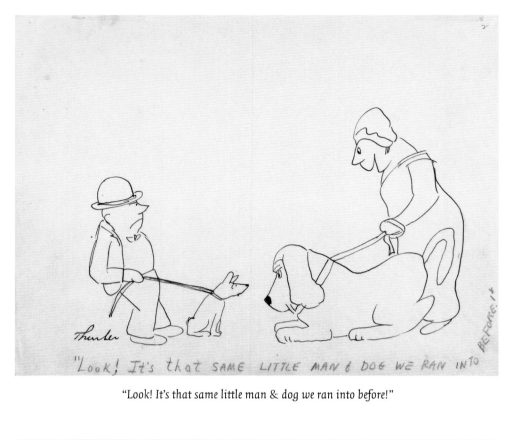

"Look! It's that same little man & dog we ran into before!"

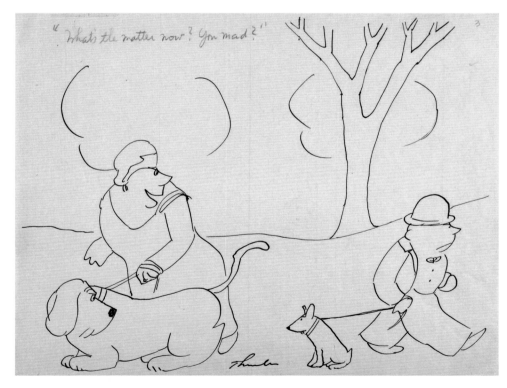

"What's the matter now? You mad?"

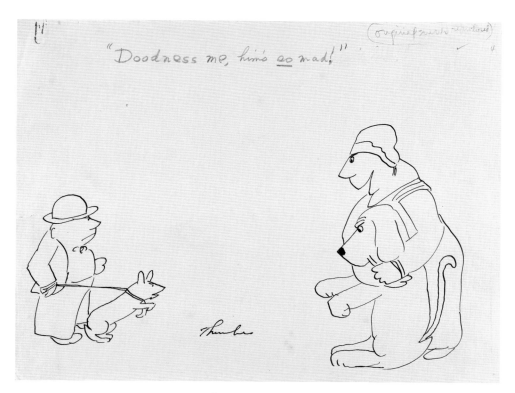

"Doodness me, him's so mad!"

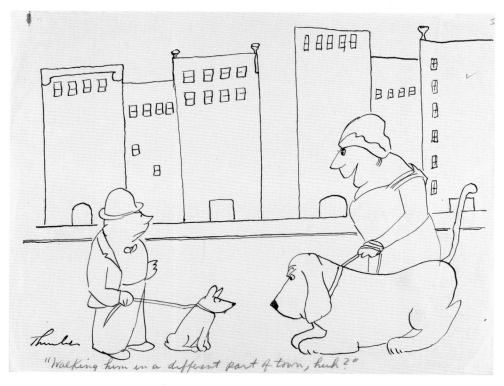

"Walking him in a different part of town, huh?"

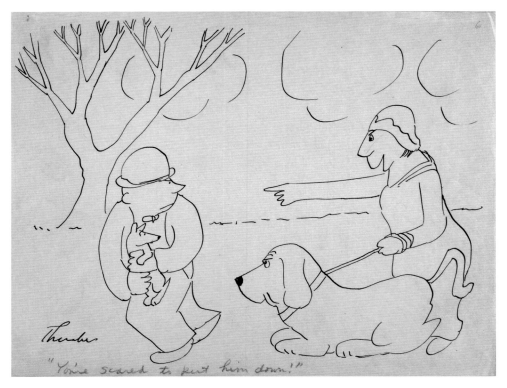

"You're scared to put him down!"

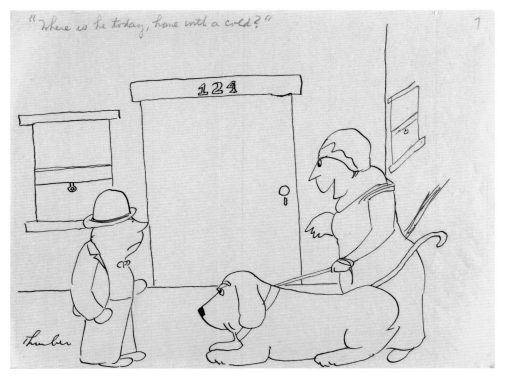

"Where is he today, home with a cold?"

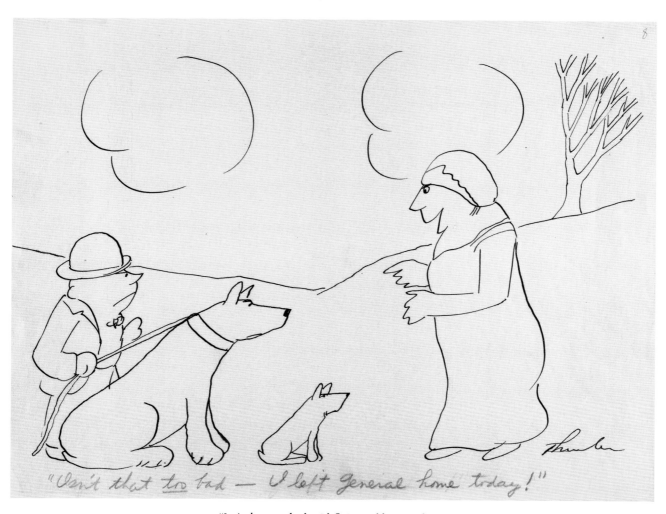

"Isn't that too bad—I left General home today!"

The Bestiary Years of My Life

Be they creatures that uniquely prowl the realms of Thurber's imagination or actual representatives of the Animal Kingdom, beasts, both big and little, cut the widest swath across Thurber's canon. (Scholars have enjoyed scouting along that path. Darwin asserted that humans, being animals, must exhibit versions of what is clearly animal behavior. Thurber asserted that animals, being not-human, must be clearly superior in many ways.)

The English scientist, essayist, and author J. B. S. Haldane, whose studies pioneered the relationship of genetics to evolution—hardly a humorist by trade—echoes much that Thurber claimed: "The change from monkey to man might well seem a change for the worse to a monkey. But it might also seem so to an angel. The monkey is quite a satisfactory animal. Man of to-day is probably an extremely primitive and imperfect type of rational being. He is a worse animal than a monkey."[4]

In *I Believe: The Personal Philosophies of Certain Eminent Men and Women of Our Time*, a compendium edited by Clifton Fadiman in 1939, Thurber wrote:

> Abstract reasoning, in itself, has not benefited Man so much as instinct has benefited the lower animals. In moving into the alien and complicated sphere of Thought and Imagination he has become the least well-adjusted of all the creatures on the earth and, hence, the most bewildered.[5]

So whether as companions or co-conspirators, naysayers or soothsayers, elusive or invented beasts appear in the majority of Thurber's work. The off-balance chairs, the thumbnail paintings, the catawampus lamps—perhaps they do outnumber the animals. But throughout his work, it's the beasts that illuminate the "animal" in our own animal nature. "The Beast in Me and Other Animals" became the title of his 1948 collection, although he considered "The Bestiary Years of My Life," as an alternative.

The Beast in Me and Other Animals contains two bestiaries. The first, "A Gallery of Real Creatures," showcases sixteen more vigilantly drawn portraits of animals inspired by Thurber's "beloved, though occasionally cockeyed, Lydekker's *New Natural History*."[7] Still, the character and acuteness of each line choice are identifiably Thurber . . . even as the resemblance to Alexander Calder's wire-form circus may also come to mind.

The other, "A New Natural History," features species that occupy the verbal realm, creations idly born from popular idioms or peculiar words that Thurber acutely heard as nomenclature—as common names for one or another newly discovered beastie. Thurber is the first to identify "the qualm," "the glib," and "the moot"—three freshwater creatures we can add to our life lists. Or three new prehistoric creatures, "the Thesaurus," "the Stereopticon," and "the Hexameter," that surely roamed the Earth. Other species are shown on pages 149 to 155.

"THE POWER that created the poodle, the platypus, and people has an integrated sense of both comedy and tragedy."[6]
—James Thurber

A part of the menagerie of species Thurber depicted in "A Gallery of Real Creatures."

Northern Lynx

Cynogale

Tarsier

Gorilla

From "A New Natural History," these colloquial creatures exemplify the kind of synesthesia that wove into Thurber's "writing in his head"—revising, memorizing . . . and then dictating or hurriedly penciling large words across a page, rather than composing on a typewriter or by hand on a page. As his sight vanished, words became more creature-like: Their vocalizations (the vowel sounds and alliterative qualities and rhythmic patterns) and their behaviors (the grammar, misuse, and connotations) provided a menagerie of familiars in his fables, children's tales, and essay-reveries.

The Early and Late Riser

A Gloat near a patch of I-Told-You-So

153

An Upstart rising from a clump of Johnny-Come Lately. The small rodent is a Spouse.

The White-faced Rage. At right: A Blind Rage.

The Hopeless Quandary

Fables

Thurber wrote some eighty-five fables that were published in two volumes: in 1940, *Fables for Our Time*, and in 1956, *Further Fables for Our Time*. Among the lavish praise afforded these books, the *Manchester Guardian* (London) wrote, "These are true fables. It was Whitman who wanted to turn and live with the animals; it is Thurber who has succeeded in the only possible terms, by enlisting them in the endless battle for human sanity."[8] *Collected Fables*, which includes unpublished fables, was published in 2019.

Thurber's illustration from "The Unicorn in the Garden," one of twenty-eight fables in his 1940 collection, *Fables for Our Time and Famous Poems Illustrated*. The cover of the first edition (above).

"Here, unicorn," said the man, and he pulled up a lily and gave it to him. The unicorn ate it gravely.[9]

REDUCE TO 8½"

Cover artwork for Thurber's *Fables for Our Time*. Various editions used all or part of this image, supplemented with the fables' original illustrations in the *New Yorker* and portions of the twenty-nine new illustrations created for the book.

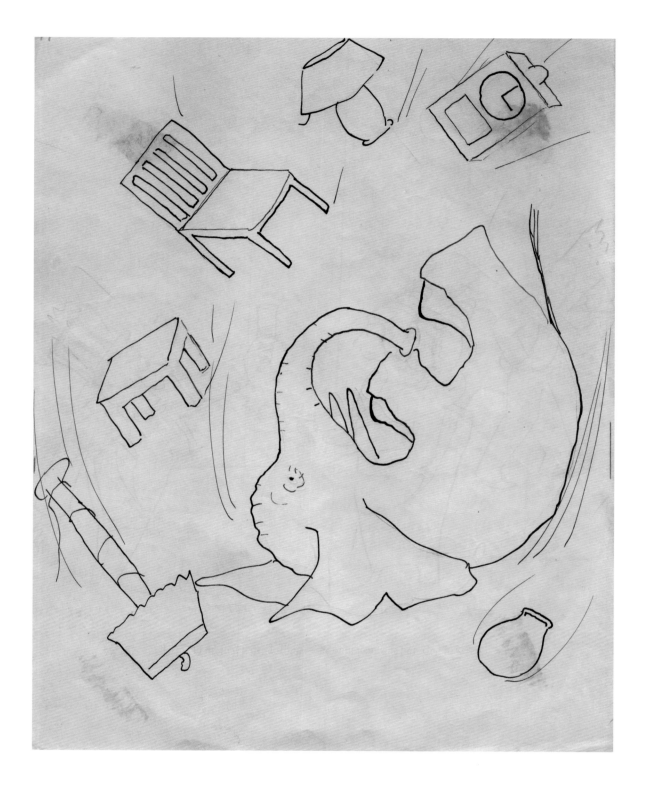

"At exactly three o'clock the house began to tremble and quiver as if an earthquake had it in its paws. Pillars and beams bent and broke like reeds, for they were all drilled full of holes. The fifth floor gave way completely and crashed down upon the fourth, which fell upon the third, which fell upon the second, which carried away the first as if it had been the floor of a berry basket. The elephant was precipitated into the basement . . ."[10]
—from "The Elephant Who Challenged the World"

"He made some notes on a piece of paper (which a spy should never do) and he headed them 'My Twenty-Four Hours in Wolfland,' for he had decided not to be a spy any longer but to write a book on Wolfland and also some articles for the *Sheep's Home Companion*."[11]
—from "The Sheep in Wolf's Clothing"

The Enormous Rabbit

The Race of Life

"The Race of Life" is a folio of thirty-five pages Thurber created for his first collection of drawings, *The Seal in the Bedroom and Other Predicaments*. In his introductory note to this suite, he explains that the sequence "represents the life story of a man and his wife; or several days, a month, or a year in their life and in that of their child; or their alternatively interflowing and diverging streams of consciousness over any given period."[12]

Escape

Thurber continues his introduction, "the Enormous Rabbit . . . calls for
a few words of explanation. It can be an Uncrossed Bridge which seems, at
first glance, to have been burned behind somebody, or it can be Chickens
Counted Too Soon, or a ringing phone, a thought in the night, or a faint
hissing sound. More than likely it is an Unopened Telegram which when
opened . . . proved not to contain the dreadful news one had expected but
merely some such innocuous query as: 'Did you find my silver-rimmed glasses
in brown case after party Saturday.'"[13]

Dogs in the Blizzard

Thurber concludes his introduction by mentioning, "The snow in which the bloodhounds are caught may be either real snow or pieces of paper torn up."[14]

While not exactly a race of "two thousand people . . . in full flight,"[15] "The Day the Dam Broke," from *My Life and Hard Times*, offered Thurber a chance to depict the flood of 1913, a "frightful and perilous afternoon in 1913 when the dam broke, or, to be more exact, when everybody in town *thought* that the dam broke."

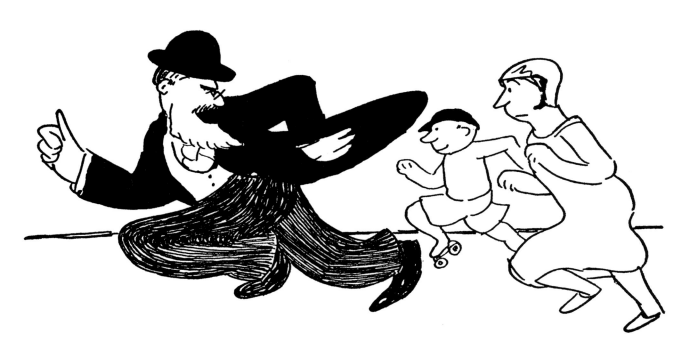

"It's got us!"

"When I reached Grant Avenue, I was so spent that Dr. H. R. Mallory
. . . passed me. 'It's got us!' he shouted, and I felt sure that whatever
it was *did* have us. . . . I didn't know at that time what he meant,
but I found out later. There was a boy behind him on roller-skates,
and Dr. Mallory mistook the swishing of the skates for the sound of
rushing water."[16]—from "The Day the Dam Broke"

The Masculine Approach

This theme, antiquated and even inappropriate as it will seem to contemporary notions of gender and partnership, is one that Thurber reworked many times, either as single images or in a series. One suite of twenty drawings was published in *Men, Women and Dogs*.

"Yoo-hoo! It's me and the ape man!"

The Thurber archives hold other variations on this general theme; clearly the subject either pleased or plagued Thurber to no end. While some entries are riffs on the same text, the images themselves are distinct.

The Candy-and-Flowers Campaign
The I'm-Drinking-Myself-to-Death-and-Nobody-Can-Stop-Me Method
The Strong, Silent System
The Pawing System
The Strange-Fascination Technique
The You'll-Never-See-Me-Again Tactics
The Heroic, or Dangers-I-Have-Known, Method
The Let-'Em-Wait-and-Wonder Plan
The Unhappy-Child Story
The Indifference Attitude
The Letter-Writing Method
The Man-of-the-World, or Ordering-in-French, Maneuver
The Sweep-'Em-Off-Their-Feet Method
The Her-Two-Little-Hands-in-His-Huge-Ones Pass
The Sudden Onslaught
The Continental-Manners Technique
The I'm-Not-Good-Enough-for-You Announcement
The Just-a-Little-Boy System
The Harpo Marx Attack
The I-May-Go-Away-for-a-Year-or-Two Move

"The lion had his mane . . . but man found himself in a three-button sack suit."—from *Is Sex Necessary?*

165

The Masculine Approach Series. This unpublished series of fifteen drawings tackles—or buckles under—the topic of courtship and exists only in archived photographs. Once again, the morays and "immorays" of 1930s gender roles are more than evident here.

The War Hero Method

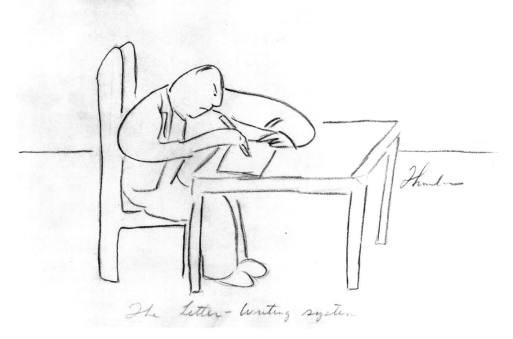

The Letter-Writing System

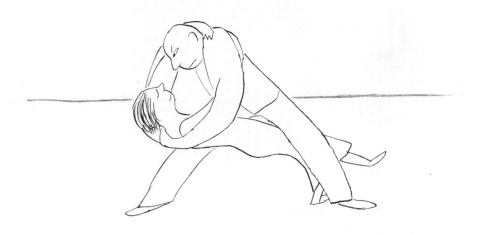

The Movie Kisser

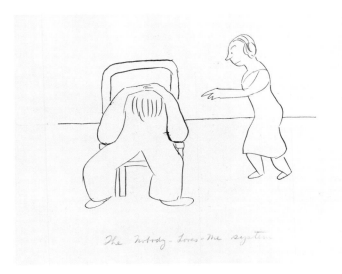

The Nobody-Loves-Me System

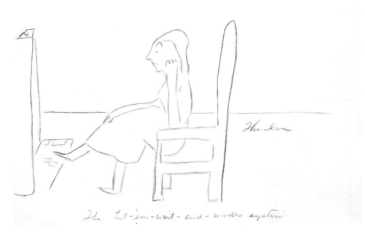

The Let-'Em-Wait-and-Wonder System

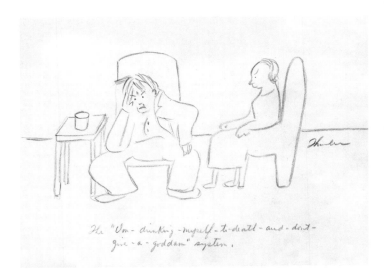

The "I'm-Drinking-Myself-to-Death-and-I-Don't-Give-a-Goddam" System

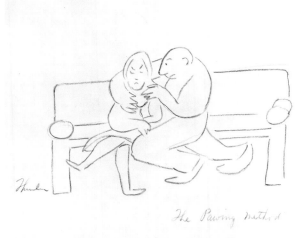

The Pawing Method

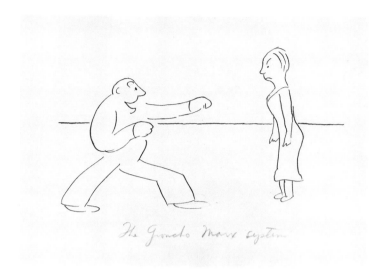

The Groucho Marx System

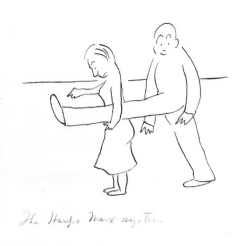

The Harpo Marx System

The Tear-Off-Their-Clothes Attack

The Strong Silent Approach

The Continental-Manners Method

The Candy-and-Flowers Campaign

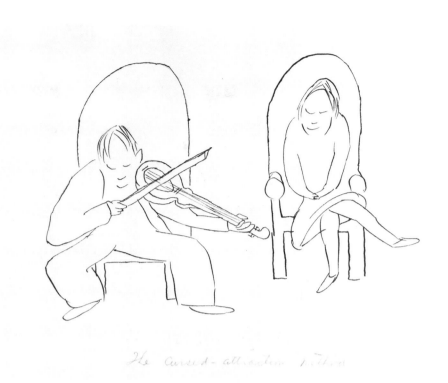

The Cursed-Attraction Method

The "I'm-Through!" System

●✿ LIZA DONNELLY

Without Saying a Word

I FIRST ENCOUNTERED James Thurber's cartoons when I was seven. With typing paper and pencil, I would trace his cartoons and I quickly discovered it would make my mother laugh. She was the primary audience of my initial efforts, but after my success in making her laugh, I sought to amuse my father and then all my classmates. That's what made me become a cartoonist: the fact I could make someone happy without saying a word.

Thurber's people were alive to me. I could feel who they were. The minimal lines Thurber used to depict them had energy and expression. When looking at a Thurber drawing, it's clear that he had drawn it quickly, but in the quickness, he grabbed the essence of whatever it was he was drawing. Be it a lampshade, a bookshelf, a man, woman, or dog, he tells you all you need to know about it.

As a child who was "always drawing," I was attracted to cartoons. My parents had the *New Yorker* around the house, and our bookshelves had all the collections of cartoons from the magazine. Most *New Yorker* cartoons seemed complicated to me and, combined with a caption, made me not want to look at them (I was suspicious of words); I didn't understand them. They seemed "adult." Thurber, on the other hand, created drawings that were childlike and accessible to a young girl. I didn't understand his captions, either, but it was almost like he drew the pictures *for me*. And since I knew my mother loved the *New Yorker*—she first handed me *The Thurber Carnival*, paper, and pencil—it was an easy choice: Trace Thurber and make her happy.

However, the women he drew confused me. I was at an impressionable age, trying to understand the adults around me and what I might become. I did understand the amorphous people's expressions. But Thurber's women were either angry, massive, powerful battleaxes . . . or they were demure, flowering waifs. With just one simple line over the eye, he could make a woman absolutely terrifying.

And the men that accompanied these angry women? They were inevitably short, wide-eyed, mustached, and balding. I actually worried for the men and wondered why they were with these horrible women (see page 164).

The waifs in Thurber's world were my other worry: innocent smiles, clasped hands, heads bent in kindness and submission. My young mind was concerned that they would be made fun of (my personal fear), their innocence mindlessly trampled on. As I traced these characters, I tried to understand them. Drawing something brings greater understanding of the thing in myriad ways; as an idealistic college student, I used to draw animals in order to "connect" with their soul.

Even though Thurber drew simply, he put meaning into the quality of the line (he would probably scoff at me saying this, and in fact probably make fun of me). Also, I believe the quicker you draw an impression, the more "real" a response/depiction it is to the subject. Many of us cartoonists believe the first drawing you do is the best. Cartoonist Ed Sorel used to encourage me to try to draw without drafts. Thurber may have not personally known any of the people he drew, but one feels like he did. He makes us hate or love or desire his cartoon characters.

So as a child, while looking at Thurber's cartoons I wondered, "Is this what adulthood is?"

I don't know if Thurber ever intended to make people happy with his drawings, as I had when I traced his work. It wasn't until many years later that I understood his captions and began to see that not all of his cartoon women were one or the other, as I had first sensed. Adulthood brought to me an understanding that the world is not black and white, in gender or in anything. Humor sometimes does that—makes the world bilateral—particularly humor of a certain time period, as Thurber's cartoons inevitably were. His work reflected the time in which he lived, a time when women were secretaries, mistresses, and wives and not much else, rarely seen in bars or speakeasies, let alone boardrooms. Men and women in Thurber's world were often at odds with one another, they were polar opposites; when not in bed, they were fighting. And even in bed they were fighting!

Cartoons reflect a society trying to understand itself through laughter. One can only imagine what/who Thurber would have drawn in the 1960s, let alone today. We now are aware of many genders and many variations within genders. Thurber would have had a field day, distilling it for us in a few lines and making us laugh. And think. ◆●

As in so many of Thurber's drawings, there's vibrant energy in the line and dry, mocking humor with a complicated subtext; one wonders about the dancing couple and their marriage . . . as well as the couple talking about them. It's a little short story in a drawing.—LD

"I hear their marriage is in trouble."

Rosemary Thurber on This "Men vs. Thurber's Women" Thing

Why do people—*still!*—latch onto this? I remember being so irritated as a kid by friends asking, "Why does your father hate women?" If that's where people stop their understanding of Thurber—and the rest of men and women—so be it.

What I know and see is that captions alternate between the man speaking in the drawing and the women and, just so, their roles. But "bossy," "henpecked," "sweet," "meek," "glum," "annoyed"—the key word for me in all of this—for both his men *and* women—is "baffled." They're startled. They're confused. Walter Mitty, for example, isn't "henpecked." He's a creative survivor.

In "The War Between Men and Women," the sides look pretty equal to me. The women finally surrender? That has been The Way for centuries. But does anyone ever actually win? Personally, too much analysis and explanation spoil the Thurber fun . . . rather like taking the wings off butterflies to see how they fly. In the words of my father's creative Aunt Gracie Shoaf: "This is all I have. Please take it . . . as this is all I *have*."

Now my mother *was* a formidable force and I do recognize her in many drawings. We were all a bit scared of Althea . . . sadly for her. When she was seven, her father died. Subsequently, she never did figure

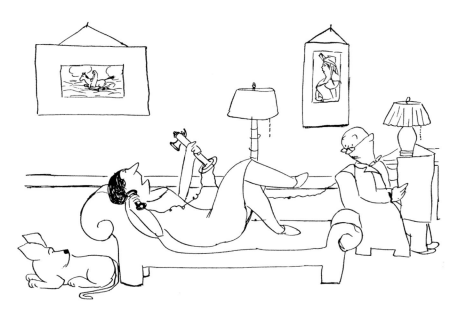

"Well, if I called the wrong number then why did you answer the phone?"

out how to be successful in relationships with men. Not that my father did any better figuring out how to be with women.

One of my favorite Thurber women is lying on the sofa with the phone in her hands.

She looks like my mother, *not* an ogre. And look at the face on the man: He's not "meek" or scared, he's *startled and baffled!* Too bad he can't just laugh, but then, that's *our* job.

Rosemary Thurber with her father, her grandmother, Mame Thurber, and Poodle, 1946.

IN A PIECE from 1936, "The Case Against Women," published in the *New Yorker*, Thurber met this accusation head-on—at least, in a humorous essay: At an afternoon gathering, a woman approached him and asked, "Why do you hate women, Mr. Thurberg?"[17] And he reveals that, in fact, he does hate women for reasons as follows: They know where things are; they like to spend time looking at old photographs; they never have anything smaller than a ten-dollar bill whenever there's a sign that reads "Please have exact change ready";[18] and the consummate reason: "They invariably lose one glove. . . . I have spent some part of every day or night hunting for a woman's glove."[19]

●◆ LIZA DONNELLY AND MICHAEL MASLIN

Isn't That Sweet?

WAY BACK IN THE pre-email days, the phone rang. Our friend Anne Hall, assistant to Lee Lorenz, art editor of the *New Yorker*, said, "A woman just called the office. She has a Thurber original . . . that needs a good home. I suggested she call you two."

Anne knew Thurber was—and is—central to us: a cartoon-marriage couple who bonded over a mutual love of his work. (On our first unofficial date, we traveled to see, but not buy, a Thurber original being auctioned.)

Although money was tight—we were just starting a family—we decided we'd empty the piggy bank for the drawing. But at the tail end of the phone conversation—when the subject of money was finally brought up—the owner said she wanted to give us the drawing.

That it's a lovely drawing, you can see. But it's the extra history we particularly value: It once belonged to Thurber's good friend—and his playwright/ collaborator on *The Male Animal*—Elliott Nugent.

Thurber put a lot—for Spartan line-man Thurber—in this drawing: a bookcase (actually, a secretary); a bust (a man? a woman?) sitting atop a box-like base; and a framed mountainous landscape with one large cloud.

You also can't see the back of the drawing. Upper right, there's the letter "R," indicating publisher Harold Ross's okay to purchase it.

In recent years, we've collected many more drawings by other cartoonists, yet it is always the Thurber drawing to which we lead visitors first. ◆●

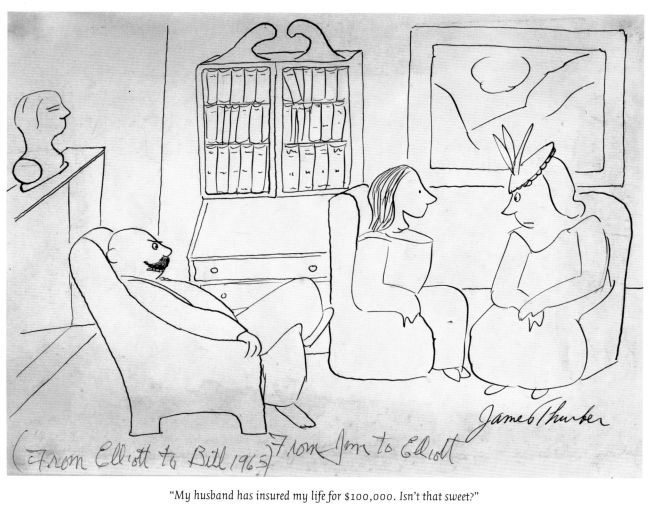

("From Elliott to Bill 1965) From Jim to Elliott

"My husband has insured my life for $100,000. Isn't that sweet?"

The Draw of Columbustown

"The clocks that strike in my dreams are often the clocks of Columbus."[1]

My Life and Hard Times

Historicity lies so close to legend in my world that I often walk with one foot in each area, with side trips, or so my critics declare, into fantasy. This is because of my unenviable talent for stumbling from one confusion into another.[2]
—JAMES THURBER

Written in the midst of a great economic depression, the ironically titled *My Life and Hard Times* confines its attention to a world of midwestern culture, school days, and family life—the idiosyncratic world above and beyond the genuine problems of a nation, Columbustown, which, as biographer Robert Morseberger points out, "is located in time rather than place."[3]

Thurber much admired Clarence Day—they both drew, they both found animals a distinctive means of revealing human character, they both published in the *New Yorker*—and Day's short memoirs of his own family had just begun to appear in magazines (and were later collected in his books such as *Life with Father*). These emboldened Thurber to embrace the eccentricities of his own family in his first attempt at autobiography-inspired stories. For years, Thurber, an effervescent raconteur, had been rehearsing bits of these stories at dinner parties, honing memory into the even more memorable guise of fiction. As Thurber's first biographer, Charles Holmes writes that those comedic figures of his youth—assorted maids, illiterate ball players, elders stuck in Civil War visions, frail aunts—"represent freedom, independence, the irrepressible stuff of life which refuses to be caught in formulas and conventions."[4]

In each story, Thurber took an illogical assumption or wayward predica-

ment and naturalized it through his own quirky logic. It's not that the family members or situations are intrinsically comical or irrational. It's the attempts to provide reasonableness that provide the comedy.

His sentences are gems of clarity and composition. The reader delights in and trusts such polish and authority with the language . . . even as the irrational has been passed off as the rational. The stories' escalating plots finally impose an odd calm amid the calamity, an assurance of sorts, as though amid the surprises of Thurber's far-fetched goings-on, the reader feels the sigh and pleasure of recognition. Clifton Fadiman, speaking of Thurber, identifies what it is that "true humor" provides:

> [It] changes your feelings, usually in the direction of greater well-being and general expansiveness. Instead of tensing you, it relaxes you. It works not on the nerves and the brain but on the heart and the imagination. It does not have a "point" which is a hard, direct thing. It suffuses an atmosphere, which is a soft and subtle thing. That is why good humor is enjoyable again and again. Once you have "got the point" of something that has only "point" to offer, you are through, but an atmosphere is no more exhaustible than a fine landscape.[5]

Certainly *My Life and Hard Times* is Thurber's best effort at providing the releasing laughter of hindsight, the lifesaving relief of storytelling.

> "*The [Thurber] Album* was kind of an escape—going back to the Middle West of the last century and the beginning of this, when there wasn't this fear and hysteria. I wanted to write the story of some solid American characters, more or less as an example of how Americans started out and what they should go back to— sanity and soundness and away from this jumpiness."[6]
> —James Thurber

Opposite: This illustration is from the chapter "The Car We Had to Push." "She [my mother] came naturally by her confused and groundless fears, for her own mother lived the latter years of her life in the horrible suspicion that electricity was dripping invisibly all over the house. It leaked, she contended, out of empty sockets if the wall switch had been left on."[7]

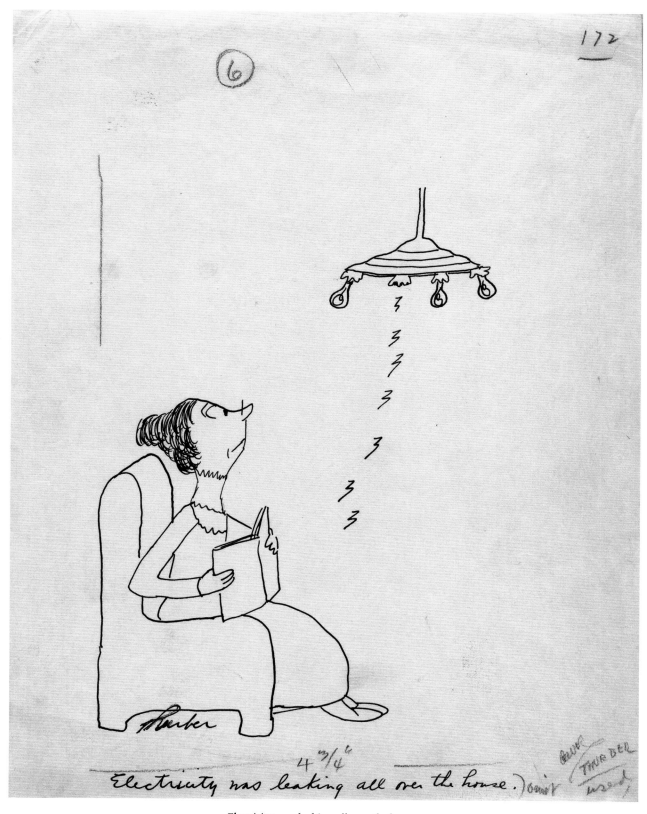

Electricity was leaking all over the house.

One woman climbed up into the "These Are My Jewels" statue.

"Though Thurber was skilled at melding the apocryphal with the actual happenings for the best comic effects,"[8] as his biographer Harrison Kinney writes, Thurber maintained that there *was* a ghost who lived at 77 Jefferson Avenue. The gist of "The Night the Ghost Got In": A boy hears footsteps coming from downstairs one night. A burglar! His brother won't help. Dad isn't home. His mother gets a neighbor to call the police. They check out every room, including the attic—where Grandpa sleeps and believes the police are Civil War deserters and shoots one in the shoulder. The cops find nothing and leave. Was that burglar a ghost? Even if his brothers were the only two who saw the apparition, which Thurber believed was a "Columbus jeweler [who] is said to have shot himself after running up those steps,"[9] both Thurber and his mother, who delighted in and even planned things based on the occult, perpetuated the tale's veracity.

Opposite: On the lawn of the Ohio statehouse, seven stone-faced men encircle a towering base. Actually, they're bronze-faced. The grouping of Ohio sons—Ulysses S. Grant, William T. Sherman, James A. Garfield, Philip Sheridan, Salmon P. Chase, Edwin Stanton, Rutherford B. Hayes—is known as "These Are My Jewels." The sculpture's title is based on the words of Cornelia, a wealthy lady of ancient Rome, who spoke of her sons, both military and political leaders, as "her jewels." In his story "The Day the Dam Broke," Thurber juxtaposes this imposing, serious monument with a silly woman who clambers up the statue to escape a coming flood. A flood, by the way, that never comes.

Take one more look: The naked woman on top of the statue? Not her. She's supposed to be there . . . part of the sculpture, even though Thurber unrobed her. The panicking woman is wedged between Stanton and Sherman.

To his publisher, Thurber added this note with his sketches for the cover of *My Life and Hard Times*: "Here are six or eight trys [*sic*] at a cover design. Somewhere among them you may find something you can use. A ghost plays a considerable part in one chapter of the book and I have worked it into several of these. There is also much running—in the broken dam chapter—which would justify the riot border, or whatever it is.—Cordially yours, Thurber, the boy artist."[10]

However many Thurber actually sent, only these five, previously unpublished variations, exist in the archive of his work.

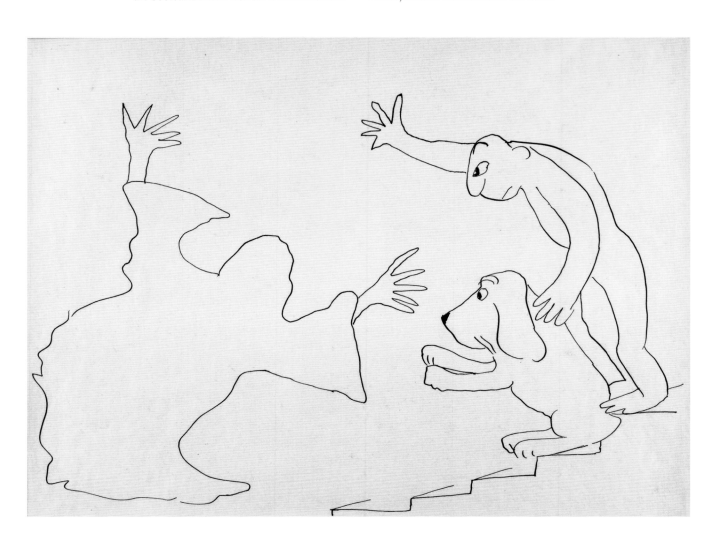

188

Sports

One of my favorite summer-sound memories with my father are those
warm afternoons we'd listen to radio broadcasts of baseball games. (In
so many ways, much better than television!) Mostly I think of games with
the Yankees . . . New York Yankees vs. Brooklyn Dodgers. I remember
my father stomping upstairs one afternoon muttering, "Even the damn
pigeons are on the Yankees' side!" (As I recall a possible home run was
lost because the ball hit a pigeon.) This is where I learned to root against
those who always win (especially the Yankees!). I'm all for the underdog.
—ROSEMARY THURBER

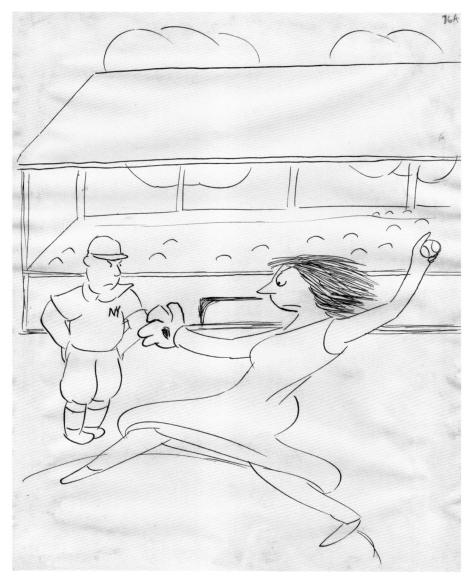

Dexterity

One of the sixty-three drawings
Thurber created for *In a Word*, an
etymological romp by Margaret
Ernst.

This trio of self-portraits accompanied a letter to the E. B. Whites from April of 1936. While in Bermuda, Helen and Jim played "ten sets in two days, me cursing every second stroke, for I never played before. . . . Helen is really very good . . . she used to win cups and things. . . . Once in a while I got in a fine forehand drive down the line. But in making a backhand I look and act like a woman up under whose skirts a bee has climbed."[11]

"Look out, Harry!"

"Hey, Joe. How d'ya spell 'rhythm'?"

Thurber published several tennis drawings as well as fourteen columns on the subject of tennis for the *New Yorker* between 1935 and 1938. Many were signed "Foot Fault." (*New Yorker* writers often used their initials, nicknames, or other noms de plume when signing pieces.)

"You don't understand. The mascot isn't supposed to participate in the game."

Drawing for the official program, Michigan vs. Ohio State Homecoming, November 12, 1936. (The score, Buckeye fans? OSU 21; Michigan 0.)

Before 1916, football at Ohio State University was just a game. Over the next three years, it became a religion. Charles "Chic" Harley, a fellow student with Thurber at both East High School and OSU, was a gridiron phenomenon. Chic could pass, he could run, and, once at a 6–6 tied game with Illinois, with no kickers in the game, he stepped up and kicked the winning extra point. For a New York tabloid started by *New Yorker* colleague Ralph Ingersoll, Thurber still thought to tout the unsung (enough) football hero from his college days: "If you never saw him run with a football . . . it was kind of a cross between music and cannon fire, and it brought your heart up under your ears."[12] A three-time All-American, Harley still holds the highest-scoring game in the history of the college: 128–0. He lit the fire of excitement for football at OSU, a tradition that burns still hotter today.

Drawing for the official program of the Ohio State vs. Northwestern game, October 23, 1937. (Once again, Buckeye fans, the final score: OSU 7; NW 0.)

Place Kick

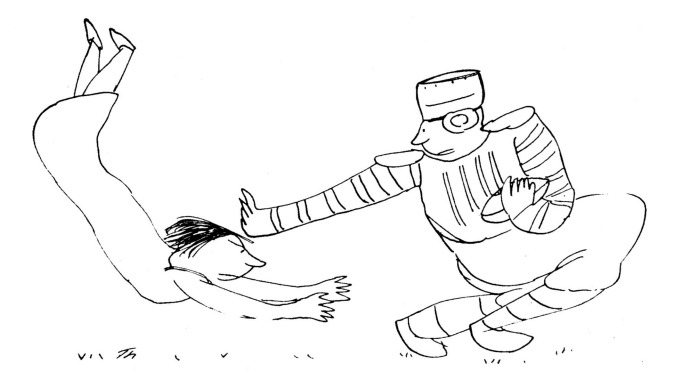

This drawing of a woman tackling the runner appeared in the *New Yorker*, November 30, 1935. This topic clearly amused Thurber. Another version he added to the walls of Costello's bar in Manhattan, offering a final score of "Wellesley 42, Harvard 13." Another appeared in the Mt. Holyoke 1948 yearbook with a score of "Mt. Holyoke 11, Yale 3." (His wife Helen did attend Mount Holyoke.) The yearbook's text reads, "In a Walter Mitty Dreamworld, it is pleasant indeed to contemplate [the college's founder and a female-fitness advocate] Mary Lyon's beating up Eli Yale [Yale is named for Elihu Yale, a governor with the British East India Company] as thousands cheer . . . and receiving a million dollar stadium in the next morning's mail from alumnae gone mad with victory.

"But in the real world, Mount Holyoke and all her sister colleges echo President Ham's famous ejaculation, 'I sometimes thank God we have no football team.'"

The Male Animal

Friends since college, Thurber and Elliott Nugent coauthored a full-length play some two decades after their shared time at Ohio State. In 1939, they wrote *The Male Animal*. Set in an unnamed midwestern football-loving college town (Columbus), the story's conflicts arise as a hapless college professor reads a text to his English class to show how an uneducated person—the apolitical prof chose a letter by the infamous traitor Vanzetti—can still be an exceptional writer. While backlash from that riles the college, the lovely woman married to the play's academic main man unexpectedly hears from her former boyfriend, a storied athlete of the college who is now a rich man . . . still sweet on his old flame. Brain versus brawn plays out on the campus alongside freedom of speech versus censorship.

The *New York Times* touted the successful Broadway play: "Although Mr. Thurber's satire is subtle, the humor . . . is as plain as the nose on a comedian's face."[13] Further success followed on the big screen: In 1942, a motion picture starred Henry Fonda and Olivia de Havilland.

One of several drawings Thurber created to highlight key moments in his play *The Male Animal.*

"Touchdown!" Sc I, Act II.

"All the male animals fight for the female."

A similar set of drawings for *Life* include a caption for this scene that reads: "Husband gets drunk at home while wife goes to football game with ex–football hero. Here with his friend he resolves to fight for his wife like all the other male animals which he pictures in the cloud above him."[14]

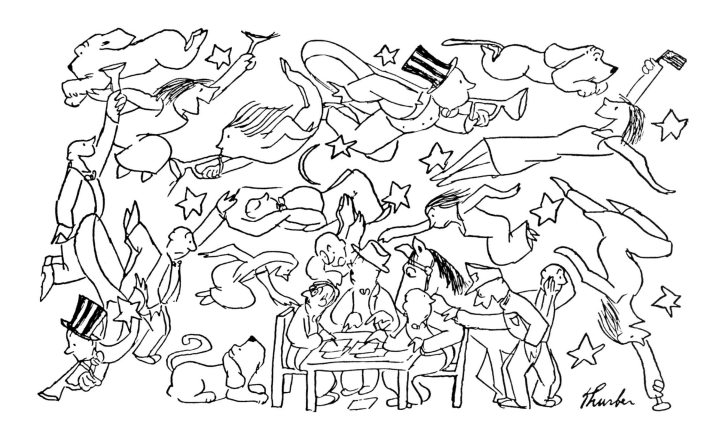

An illustration that accompanied the *New York World-Telegram*'s story,
"Thurber Finds Revising His Play for Broadway Is 'A Great Ordeal.'"

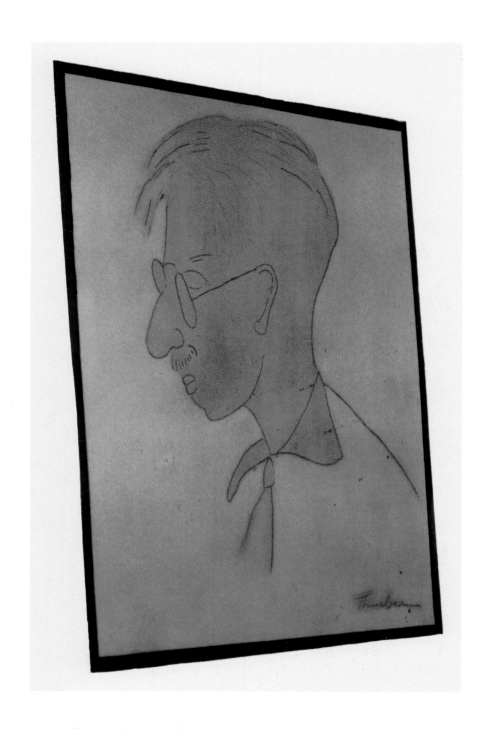

Self-portrait from the walls of the *New Yorker* offices at 25 West 43rd Street, which has traveled with the staff to 20 West 43rd Street, then 4 Times Square, and to its current location at One World Trade Center.

Thurber's Walls

An Afterword by Ian Frazier

WHEN I STARTED WORKING at the *New Yorker* I was twenty-three and Thurber was dead, but his presence still hung around the offices so palpably that he might have just stepped out. A lingering smell of cigarette smoke, the sound of his dog's toenails skittering down the hall in the wake of his slow-moving, almost completely sightless passage, and a lingering reverence for the great writer who might never have been discovered were it not for the magazine, and vice versa—all these informed the place's atmosphere. The office decor had nothing fancy about it: pale walls in a drab, tan-ish institutional color, doors with opaque glass windows, an actual water cooler, and, next to it, a couch someone may have scavenged off the street. One or two weird touches, like the fish-eye mirrors here and there on the walls (installed originally, it was said, so that the magazine's founder, Harold Ross, would not turn a corner and suddenly bump into a writer or staffer he'd been trying to avoid), let you know that unusual people worked here.

I felt comfortable in the *New Yorker* offices but didn't grasp their hidden meaning until I saw the Thurber House in Columbus. In its state of restoration to the period when the Thurbers lived there, its parlor reminded me of my great-aunts' house in Tiffin, Ohio, and of that house's nervous-making (to me) interior. Lace doilies, some of which my aunts had crocheted themselves, covered many surfaces without lightening the weightiness of the dark-brown rococo wainscoting and molding and walnut chair backs and varnished cabinetry full of keepsakes acquired on my aunts' not-extensive travels. The *New Yorker* office, like modernism itself, represented an erasure of that kind of gimcrackery. For its habitués the office was a design slate wiped clean.

Thurber wrote and drew on the *New Yorker*'s walls not so much to beautify

as to claim them. His wall drawings didn't decorate, they yelled. With big slashes and swoops of carpenter's pencil Thurber had drawn dogs, football players, flowers, a man sitting in a chair, and a few odd objects I couldn't identify. Of course, the magazine had preserved the drawings—not hard to do, in a place where freshening up the work environment with a new coat of paint happened almost never. Some of Thurber's pencil marks had faded or blurred with age. Words appeared here and there; he liked to write "Too late" on the walls, but sometimes the "Too" would be on one wall and the "late" on another. The sight of these written words fascinated me; handwriting still had magic in those days. Thurber's "Too late" struck me as a piece of meta-editing, a marginal emendation as if added by fate, or life. The words could have been directed at those who would come after him. Thurber had been here; we had only just missed him.

One of Thurber's wall drawings showed the artist himself, swiftly sketched, with glasses and mustache.

I felt a retrospective awe when I looked at this, as if it were one of those seventeen-thousand-year-old paintings on the walls of the caves in Lascaux, France. Throughout my childhood I had heard about Thurber. Many fellow Ohioans, including my father, worshipped the guy. As a kid I tried often to make my father laugh and never succeeded. (When I asked my father why he never laughed at anything I said or did, he reminded me that he'd laughed that time I fell down the stairs.) But my father used to sit in the living room reading Thurber and laughing loudly, unguardedly. Hearing his laughter resounding through the house, I received my direction in life. Making someone laugh like that seemed to me an amazing achievement. That same Thurber self-portrait sketch, or one just like it, appears on the cut-glass trophy awarded with the Thurber Prize.

The gypsum wallboard and plaster that support Thurber's pencil lines, and the lines themselves, have proved to be pretty durable. In 1991, when the *New Yorker* moved to new offices, conservators cut out the wall sections containing the drawings (including, unfortunately, none of the "Too late"s). Then they covered the sections with high-strength, bulletproof, non-reflective glass and installed them in a place of honor at the new offices across the street. Since that time the drawings have been moved twice more, and they now reside on a wall in the magazine's latest home, on the thirty-ninth floor of One World

Additional drawings from the *New Yorker* offices—cut from
the walls, framed, and reinstalled each time the magazine's
headquarters has moved across Manhattan.

Trade Center, in a cubicle-filled, glass-enclosed office space that does not much resemble their original milieu. The magazine's current offices have an up-to-date, brushed-chrome stylishness, and the walls look as if they'd be difficult to draw on. And as far as I know, nobody does draw on them.

ADMIRERS OF THURBER may recall the story of his early collaboration with E. B. White, who insisted that Thurber's drawings accompany their coauthored 1929 satirical book, *Is Sex Necessary?* White used to ink in Thurber's pencil sketches, and he knew Thurber's genius intimately. Once, when Thurber decided to make his drawings better by adding shading and cross-hatching and other graphic conventionalities, White told him not to, adding, "If you ever became good [at that], you'd be mediocre."[1]

A few sayings of the *New Yorker*'s early days stay with me. Harold Ross's dictum, "Nothing is indescribable," is one of them; his question, "Was Moby Dick the man or the fish?" is another. For my money White's advice to Thurber on the subject of mediocrity is the most brilliant and lasting observation any *New Yorker* contributor of that generation made. If you want to produce real art—great art—don't do anything that if you got good at it you'd be mediocre.

Thurber understood the wisdom of this advice and followed it. His drawings have lasted, in the largest sense, because they're nowhere in the vicinity of mediocrity. Their boldness expanded the idea of what a cartoon is, just as abstract art redefined studio painting. In a way, Thurber took funny drawings back to their origins as pictures scrawled on a piece of notebook paper to make your friends laugh in study hall. Thurber drawings were full-arm, high-spirited gestures rather than careful renderings of some ordinary subject or other, and that's why they jump off a wall—why they have what art mavens call "wall power"—while more literal cartoon renderings don't.

When Thurber drew on a wall, it was almost as if he simultaneously crossed something out. The energy of the mark he made reminds me of a graffiti scrawl done on top of other graffiti in order to stake out territory or dis a rival. It's hard for us today to understand how fed up those we think of as our distinguished elders were when they were young. Thurber and his intimates like White and Ross did not like a lot of what they had inherited. When Ross said the *New Yorker* would not be edited for "the little old lady in

Dubuque," he was rejecting the mediocrity of established journals of the time like *Collier's* and the *Saturday Evening Post* (a publication that Ross's mother wished he would work for). Like Ross's *New Yorker*, Thurber's drawings made an all-or-nothing bid for artistic authority. They hedged none of their chips on mediocrity just in case. A colleague of mine, George W. S. Trow, always spoke with scorn of those in the media world whose goal is "to be first to be second"—to discover an idea or trend or story always a step just behind those who'd found it first, and just a step ahead of everybody else. In whatever Thurber wrote or drew he was first to be first.

As I was thinking about Thurber's wall drawings the other day, a spring snowstorm appeared out of nowhere and bedecked all the tree branches and telephone wires and rooftops in the neighborhood, and I remembered Thurber's remark when a similar snowfall descended on his rural Connecticut town. He couldn't really see the wintry result, having lost most of his vision by then, but he growled to whoever he was with, "Oh, no! Not another god-dam fairyland!" I can never see a snow-covered tree-scape without his "Not another goddam fairyland!" superimposing its hilarious dyspepsia on the scene. Thurber was one of those rare artists—rarer still among cartoonists—who change how we see the world. His defiantly un-mediocre un-drawings knocked visual conventionality back into the first-to-be-second-rate category where it belongs.

I no longer have an office at the *New Yorker*, and have not had one for thirty-six years, but I still occasionally stop by the magazine once in a while to be interviewed for the magazine's radio show (!) or to record a reading for their web page (!!). I often make a point of stopping at the Thurber drawings in their glassed-in cases near the elevators. I'm glad that the great man's claim-marker drawings still survive, up here in this unexpected World Trade Center aerie. But when I look at them, I can't help also remembering the penciled memento mori, "Too late."

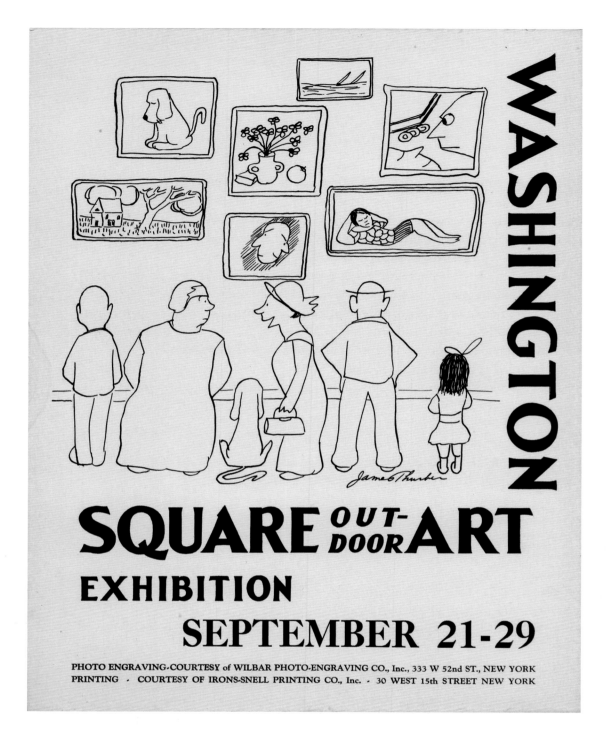

Thurber's is one of four eleven- by fourteen-inch posters for the Washington Square Outdoor Art Exhibition, a 1932–33 sidewalk art show that also included work by William Steig, George Grosz, and Otto Soglow. The exhibits have continued for more than eighty years. They began "in the midst of the Depression Era, [when] Jackson Pollock, desperately in need of funds . . . took a few of his iconoclastic paintings down several flights of stairs and set them up on the sidewalk near Washington Square Park. His friend and fellow Village artist, Willem de Kooning, in equally desperate financial straits, soon joined him."[1]

A Chronology of Solo and Group Exhibitions of James Thurber's Art

GIVEN PRESENT RECORDING, promotional, and archiving technologies—from video cameras to simple photocopies—it may be difficult to appreciate that details about Thurber's artwork in museums and galleries are rather hit and miss. Many of the galleries that featured his work have closed or moved. Many had no means or staff or space to photo-document and preserve all the ephemera, correspondence, and press material from the various exhibits that rotated through their rooms. Likewise, even as we may be accustomed to seeing museum monographs and exhibit catalogs, or even a gallery's smaller booklets and brochures, these were not commonly produced during Thurber's lifetime.

Solo exhibits are designated with an asterisk.

1932 *James Thurber and Georg Grosz*
TYRAN GALLERY
NORTHAMPTON, MASSACHUSETTS

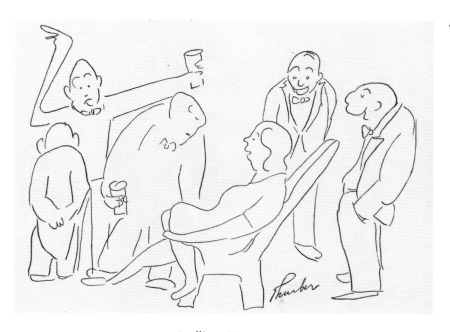

Intelligent Woman

"This one, called 'Intelligent Woman' I had left half-finished and had thrown upon the floor where Rae Irvin picked it up . . . asking me to complete it. It had on it, plainly, the mark of a dusty rubber heel. . . . I did complete it, in a few minutes, and it was bought, and used. Three or four years ago I was asked to submit one picture to be hung at a show in Vienna of the work of comic artists of all nations. This was the picture they wanted."[2] —letter to Herman Miller, December 1936

1934 *Forty Original Drawings by James Thurber★*
 VALENTINE GALLERY
 NEW YORK, NEW YORK

From Thurber's comments in the exhibit leaflet: "He never plans out an idea nor sketches one in; he merely gets mad or bewildered and begins to draw. He draws for pleasure but with almost grim intent. He strives to catch the humor, sometimes fantastic, sometimes grotesque, but always a little sad, that appears upon the surface of the simple or elaborate involvements in which men and women, husbands and wives, constantly find themselves entangled. He sees no brave new world in which men and women, as such, are at all different from what they have always been—be they patrician or proletarian. His nature and his technique are such that he cannot draw a wholly pleasant or attractive person, nor a wholly unpleasant or unattractive animal."[3]

The Three Wise Men

"Since 1930, his scrawls of impotent men and women and sad-eyed hounds have gained him international fame. They are enormously funny, and like most lasting humor, are the products of an unhappy mind. Three Thurber drawings that his associates on the *New Yorker* would never print were on view. . . . Two were blasphemous: 'The Thurber Madonna' and 'The Three Wise Men' (three goggle-eyed oldsters smirking behind their hands at something that might be the Virgin). The third was 'The Gates of Life.' Glum pedestrians hustled by in the background; sprawled on the grass in the foreground was a horrid little girl hoisting her skirts before a legless War veteran, with tears rolling down his cheeks."—*Time*, December 31, 1934[4]

"Sic her!"

"The picture frames, the chairs, and the lamps may wiggle uncertainly
like the drawings of a seven-year-old, but every up and down stroke
counts tremendously in the faces and bodies that uncomfortably
remind us of some of our friends and relatives in their off moments."[5]
—*American Art News*

1936 COLUMBUS GALLERY OF FINE ARTS★
COLUMBUS, OHIO

Twenty-eight drawings, including a cartoon of a man looking through his
dresser's drawers and asking a woman holding a newspaper in one hand that
shields the gun in her other hand, "Have you seen my pistol, Honey-bun?"

"Columbus is the first city, outside of New York, to have a comprehen-
sive exhibit of his cruelly amusing sketches."[6]—*Columbus Dispatch*

"Verging on complete lunacy as his drawings often do . . . they form a
satirical commentary as keenly alive to our times as were the cartoons
of Hogarth, Rowlandson or Daumier to theirs."[7]—*Columbus Citizen*

Fantastic Art, Dada, Surrealism
THE MUSEUM OF MODERN ART
NEW YORK, NEW YORK

Included the drawing "Look out, here they come again!" (see page 126).

1937 *Forty Original Drawings by James Thurber*★
STORRAN GALLERY
LONDON, UNITED KINGDOM

Among the works presented were:
"All right, have it your way—you heard a seal bark" (see page 112).
"Well, *I'm* disenchanted, too. We're *all* disenchanted" (see page 117).
"Have you seen my pistol, Honey-bun?"
". . . and keep me a normal, healthy girl."
"This gentleman was kind enough to see me home, darling."
"I say it's a damnable illusion and I want it stopped!"

In a letter to Roland and Jane Williams, Thurber writes, "My London show of pictures—which ran for three weeks—was a tremendous success, much greater than all my US shows put together. They sold 30 pictures, many of them for 18 guineas each. I was only counting on making a hundred dollars or so out of it but have already got a check for 130 pounds, with another of the same size to come."[8]

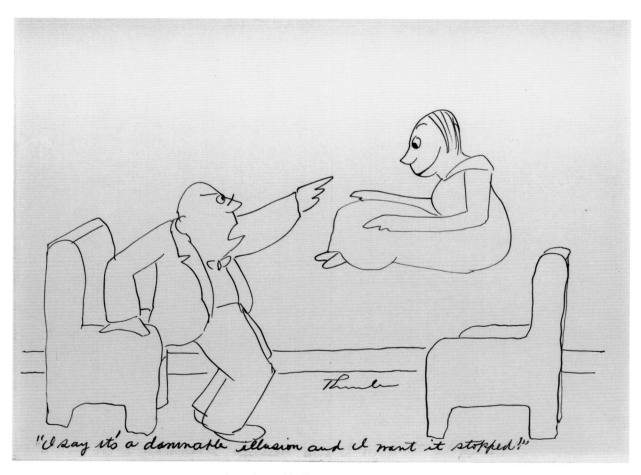

"I say it's a damnable illusion and I want it stopped!"

208

HOWARD PUTZEL GALLERY★
HOLLYWOOD, CALIFORNIA

GUMP GALLERIES★
SAN FRANCISCO, CALIFORNIA

"And despite Mr. Thurber's protestations about his work, we call it art.
(Yes, Mr. Thurber, it is a flower of art grown upon the wasted energies of
human love, hate, greed, and inertia.)"[9]—*San Francisco News*

Drawings included:
"I'd hate to fall under your spell, Mr. Shoaf."
"With a hey nonny, nonny and a nuts to you."
And three drawings Thurber told the *News* he liked especially, even though
each was rejected twice or even three times by the *New Yorker*:
"Good morning, my fine-feathered friends."
"There's something in the air tonight."
"The one in the middle is stuffed, poor fellow."

1939 *Paraphrases*
STORRAN GALLERY
LONDON, UNITED KINGDOM

Thirty-two artists were invited to create "free copies" from famous works in
the National Gallery. Thurber contributed a parody of Poussin (see page 26).

Salon of American Humorists
ADVERTISING CLUB OF NEW YORK
NEW YORK, NEW YORK

1940 VASSAR COLLEGE★
POUGHKEEPSIE, NEW YORK

Lines That Live
SALT LAKE CITY ARTS CENTER
SALT LAKE CITY, UTAH

MARIE HARRIMAN GALLERY
NEW YORK, NEW YORK

A group show of *New Yorker* artists Arno, Alajálov, Steig, and Thurber, who was represented with twenty-four drawings.

> "Thurber with a few lines gives us a catastrophic sense of the inanity
> of human behavior, the incongruity of motive and resulting action,
> the pretensions and humiliating exposures of our weak human race.
> If Thurber never had a legend for his drawings, they would speak for
> themselves."—*Sunday Journal & American*[10]

Original Drawings by American Humorists
CINCINNATI ART MUSEUM
CINCINNATI, OHIO

"Give a cartoon for Christmas" was the slogan for this show's poster. Works by Arno, Alan Dunn, Mary Petty, George Price, William Steig, Richard Taylor, and Gluyas Williams were shown, along with ten Thurber drawings. (The numbers following the titles below are prices.)

"How do you stand on the third term, buddy—right or wrong?" $25

"Have you no code, man?" $20

"Whatever has become of the Socialist Party?" $25

"It goes 'Build me some more stately mansions, oh my soul.'" $25

"He doesn't believe a single word he's read in the past ten years." $20

"I don't want him to be comfortable if he's going to look too funny." $25

"You may not be aware of it, but you are about to get a kick in the teeth." $25

"Don't keep saying 'God forbid' every time I mention Mr. Roosevelt." $25

"She's burning with a gem-like flame—it's something they learn in school." $25

"Now take you and me, Moffitt—we're both men of the world." $25

Living American Cartoonists
MUSEUM OF ART, RHODE ISLAND SCHOOL OF DESIGN
PROVIDENCE, RHODE ISLAND

American Humor in Prints and Drawings
WEYHE GALLERY
NEW YORK, NEW YORK

1941 *19th Annual Show of the Art Directors' Club of America*
GEORGE WALTER VINCENT SMITH ART GALLERY
SPRINGFIELD, MASSACHUSETTS

Animals in Art; Designing a Stage Setting
THE MUSEUM OF MODERN ART
NEW YORK, NEW YORK

Included two dogs from *Fables for Our Time*.

Lines that Live
CURRIER GALLERY OF ART
MANCHESTER, NEW HAMPSHIRE

SIOUX CITY ARTS CENTER
SIOUX CITY, IOWA

New Acquisitions: Fantastic Art, Dada, Surrealism
THE MUSEUM OF MODERN ART
NEW YORK, NEW YORK

Included the drawing "Just some of my husband's kickshaws."

[Editor's note: "Kickshaw" is an Anglicized spelling of the French *quelque chose*, or "something else." The word designates trinkets, geegaws, "something else"s.]

1943 POMFRET SCHOOL*
POMFRET CENTER, CONNECTICUT

Meet the Artist
M. H. DE YOUNG MEMORIAL MUSEUM
SAN FRANCISCO, CALIFORNIA

An exhibit of 188 self-portraits. Among the *New Yorker* artists who contributed were Thurber, Saul Steinberg, Otto Soglow, and Reginald Marsh. "Animal Artist" (see page 128) and another Thurber drawing were featured.

American Drawings & Prints
DAYTON ART INSTITUTE
DAYTON, OHIO

Arts and Crafts, Paintings and Drawings by Patients of Stark General Hospital
GIBBES ART GALLERY (NOW THE GIBBES MUSEUM OF ART)
CHARLESTON, SOUTH CAROLINA

A Gallery of American Women
ASSOCIATED AMERICAN ARTISTS GALLERIES
NEW YORK, NEW YORK

Sponsored by the Committee for the Care of Young Children in Wartime, the show was based on a feminist "war cry" by Elizabeth Hawes, clothing designer, *New Yorker* columnist "Parisite," and gender-equality advocate. *Why Women Cry: Or, Wenches with Wrenches* outlined eleven types of American women, and the exhibit engaged painters, sculptors, and cartoonists to portray them. Included Thurber's "The Forgotten Female."

1944 *James Thurber: Original Drawings*★
CORNELL UNIVERSITY
ITHACA, NEW YORK

From Thurber's introductory note: "Draughtsmanship is lacking, and that
lack is in itself, one of the points and purposes of the way I draw."

> "These Thurbers resemble, or are perhaps caricatures of, the kind of
> modern drawings which have caused so many people to exclaim angrily,
> 'Why a child could do that.' The only trouble is that a child can't do it.
> There is a cunning behind that crude, stabbing pen line which brings out
> the idea with stunning effect. No child could draw Thurbers; he would
> be as difficult to forge as any good artist."—John Hartell, *Ithaca Journal*,
> August 26, 1944 [11]

Some Original Drawings of James Thurber★
PRINCETON UNIVERSITY
PRINCETON, NEW JERSEY

"Why don't you let me know what it is, if it's so pleasant?"

Exhibition of Drawings by James Thurber ★
ARTS CLUB OF CHICAGO
CHICAGO, ILLINOIS

300 Modern Drawings
MUSEUM OF MODERN ART
NEW YORK, NEW YORK

Included the drawing "Ballet": Above a row of stars, a trio of shut-eyed men cross left. Above them, a trio of scowling women cross right. And above them, a trio of hound dogs pass to the left. The drawing is inscribed to Monroe Wheeler, the first director of exhibitions at the museum.

Prints & Drawings
PHILADELPHIA MUSEUM OF ART
PHILADELPHIA, PENNSYLVANIA

Contemporary American Artists
NEW YORK NATIONAL ACADEMY OF DESIGN
NEW YORK, NEW YORK

M. H. DE YOUNG MEMORIAL MUSEUM
SAN FRANCISCO, CALIFORNIA

Meet the Artist
PORTLAND ART MUSEUM
PORTLAND, OREGON

Included two Thurber self-portraits, including "Animal Artist" (see page 128).

CARNEGIE INSTITUTE
PITTSBURGH, PENNSYLVANIA

CITY ART MUSEUM
ST. LOUIS, MISSOURI

1945 *Some Ohio Moderns*
CINCINNATI MODERN ART SOCIETY
CINCINNATI, OHIO

DAYTON ART INSTITUTE
DAYTON, OHIO

COLUMBUS GALLERY OF FINE ARTS
COLUMBUS, OHIO

Drawings by Sculptors, Advertising Artists & Cartoonists
PHILADELPHIA ART ALLIANCE
PHILADELPHIA, PENNSYLVANIA

Your Rollicking Cartoons
SALISBURY, CONNECTICUT

Three Towns Art Exhibition
SHARON HOSPITAL
SHARON, MASSACHUSETTS

1946 *American Cartoonists*
EXHIBIT SPONSORED BY THE OFFICE OF WAR INFORMATION
PARIS, FRANCE

Prints & Drawings of Political Significance
CLEVELAND MUSEUM OF ART
CLEVELAND, OHIO

New Yorker Cover Designs
CITY MUSEUM OF NEW YORK
NEW YORK, NEW YORK

1947 *Drawings in the Collection of the Museum of Modern Art*
MUSEUM OF MODERN ART, NEW YORK

Included "Just some of my husband's kickshaws."

New Yorker Cover Drawings
CLEVELAND MUSEUM OF ART
CLEVELAND, OHIO

CINCINNATI TAFT MUSEUM
CINCINNATI, OHIO

1949 *Exhibit of Pen and Pencil Work of Artists from Renaissance to Present*
MATTATUCK HISTORICAL SOCIETY
WATERBURY, CONNECTICUT

1953 *American Drawings*
AMERICAN ACADEMY OF ARTS & LETTERS
NEW YORK, NEW YORK

1954 *Wit & Humor*
An annual exhibit from the Schmulowitz Collection
SAN FRANCISCO PUBLIC LIBRARY
SAN FRANCISCO, CALIFORNIA

Colorful Prints
METROPOLITAN MUSEUM
NEW YORK, NEW YORK

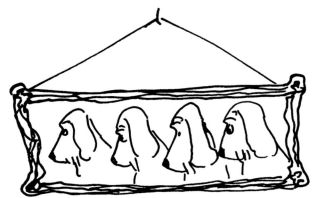

UK and US Laugh
NEW VICTORIA CINEMA
EDINBURGH, SCOTLAND

LA JOLLA ART CENTER
LA JOLLA, CALIFORNIA

1955 Thurber's art was included in a traveling exhibition through Latin America and Europe sponsored by the United States Information Agency and operated by the American Foundation for the Arts.

1956 *Authors as Illustrators*
UNIVERSITY OF CONNECTICUT STAMFORD LIBRARY
STAMFORD, CONNECTICUT

Included images from *The White Deer*.

1957 *Vincent Price Drawing Collection*
OAKLAND ART MUSEUM
OAKLAND, CALIFORNIA

See page 67.

1960 *New Yorker Artists Living in Connecticut*
WESTPORT CONNECTICUT LIBRARY
WESTPORT, CONNECTICUT

1962 *Thurber Drawings★*
SHARON PLAYHOUSE GALLERY
SHARON, CONNECTICUT

1963 *Friends of Rose Algrant*
COVERED BRIDGE HARDWARE BUILDING
WEST CORNWALL, CONNECTICUT

Included Thurber's illustrations of Shakespeare plays (see pages 30–32).

[Editor's note: Rose Algrant was a close friend of the Thurbers who hosted many parties in her home. Beginning in 1959, she arranged exhibits of area artists that featured Thurber and Marc Simont, a prolific illustrator of children's books including Thurber's *The Wonderful O* and *Thirteen Clocks*.]

1965 *Friends of Rose Algrant*
RAILWAY STATION
WEST CORNWALL, CONNECTICUT

1966 *James Thurber: An Exhibition of Books, Manuscripts and Drawings Selected from the Thurber Collection of the Ohio State University Libraries*★
THOMPSON LIBRARY, OHIO STATE UNIVERSITY
COLUMBUS, OHIO

1967 *Friends of Rose Algrant*
BEWITCHERY
WEST CORNWALL, CONNECTICUT

1971 *A Second Talent*
ARTS CLUB OF CHICAGO
CHICAGO, ILLINOIS

Twelve Thurber drawings were included in an exhibit of 200 images created by those best known as writers. Others included Günter Grass, Marcel Proust, Henry Miller, Marianne Moore, Mark Twain, and Vladimir Nabokov.

1974 *The Satirical Drawings of Thurber, Getz, Simont, and Osborn*
WEST CORNWALL, CONNECTICUT

1979 *The Wonderful Thurber*★
THOMPSON LIBRARY, OHIO STATE UNIVERSITY
COLUMBUS, OHIO

1987 *92 Drawings: A James Thurber Retrospective*★
GREAT SOUTHERN HOTEL
COLUMBUS, OHIO

*Thurber Revisited**

THE THURBER CENTER
COLUMBUS, OHIO

An exhibit of works donated to Ohio State University by essayist and film critic Nora Sayre.

[Editor's note: The only daughter of Joel Sayre, *New Yorker* war correspondent, reporter, and screenwriter, Nora and Joel both enjoyed a close friendship with the Thurbers.]

1996 *James Thurber: Selections from the Family Collection**
SOUTH HAVEN CENTER FOR THE ARTS
SOUTH HAVEN, MICHIGAN

2006 *Thurber in the House**
THE THURBER CENTER
COLUMBUS, OHIO

2019 *A Mile and a Half of Lines: The Art of James Thurber**
COLUMBUS MUSEUM OF ART
COLUMBUS, OHIO

*Thurber's Columbus**
THOMPSON LIBRARY, OHIO STATE UNIVERSITY
COLUMBUS, OHIO

*"The Last Flower" by James Thurber**
CARNEGIE GALLERY, COLUMBUS METROPOLITAN LIBRARY
COLUMBUS, OHIO

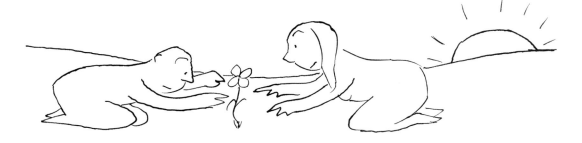

THE
NEW YORKER

July 5, 1941

Price 15 cents

James Thurber

Books by James Thurber

BETWEEN 1929 AND 1961, James Thurber published twenty-nine books, including two memoirs, two plays, six works for children, and sixteen unique collections of his writing and drawings. He is credited as illustrator for an additional three books. During and after his lifetime, various publishers have selected and arranged Thurber's work into a variety of other anthologies. Finally, ten other collections of primarily unpublished or uncollected works have been published posthumously, this volume being the latest.

Is Sex Necessary? Or Why You Feel the Way You Do (with E. B. White). New York and London: Harper & Brothers, 1929.

The Owl in the Attic and Other Perplexities. New York and London: Harper & Brothers, 1931.

The Seal in the Bedroom and Other Predicaments. New York and London: Harper & Brothers, 1932.

My Life and Hard Times. New York and London: Harper & Brothers. 1933.

The Middle-Aged Man on the Flying Trapeze. New York and London: Harper & Brothers, 1935.

Let Your Mind Alone! And Other More or Less Inspirational Pieces. New York and London: Harper & Brothers, 1937.

Kinney, James R., with Ann Honeycutt. *How To Raise a Dog in the City and in the Suburbs* (illustrated by James Thurber). New York: Simon & Schuster, 1938.

The Last Flower: A Parable in Pictures. New York and London: Harper & Brothers, 1939.

Ernst, Margaret S. *In a Word* (illustrated by James Thurber). New York: Alfred A. Knopf, 1939.

Hawes, Elizabeth. *Men Can Take It* (illustrated by James Thurber). New York: Random House, 1939.

Fables For Our Time and Famous Poems Illustrated. New York and London: Harper & Brothers, 1940.

The Male Animal (with Elliott Nugent). New York: Random House, 1940.

My World—And Welcome to It. New York: Harcourt, Brace and Company, 1942.

Many Moons (illustrated by Louis Slobodkin). New York: Harcourt, Brace and Company, 1943.

These "simple but perfect dresses to go a hundred places this Spring" were produced by B. H. Wragge for the department store Bonwit Teller to coincide with the release of *Men, Women and Dogs.* The ad ran in the *New Yorker,* April 8, 1944.

Men, Women and Dogs. New York: Harcourt, Brace and Company, 1943.

The Great Quillow (illustrated by Doris Lee). New York: Harcourt, Brace and Company, 1944.

The Thurber Carnival. New York and London: Harper & Brothers, 1945.

The White Deer (illustrated by the author, cover by Don Freeman). New York: Harcourt, Brace and Company, 1945.

The Beast in Me and Other Animals. New York: Harcourt, Brace and Company, 1948.

The 13 Clocks (illustrated by Marc Simont). New York: Simon & Schuster, 1950.

The Thurber Album: A Collection of Pieces about People. New York: Simon & Schuster, 1952.

Thurber Country. New York: Simon & Schuster, 1953.

Thurber's Dogs. New York: Simon & Schuster, 1955.

Further Fables for Our Time. New York: Simon & Schuster, 1956.

The Wonderful O (illustrated by Marc Simont). New York: Simon & Schuster, 1957.

Alarms and Diversions. New York: Harper & Brothers, 1957.

The Years with Ross. Boston: Little, Brown and Company, 1959.

Lanterns and Lances. New York: Harper & Brothers, 1961.

Credos and Curios. New York and Evanston: Harper & Row, 1962.

A Thurber Carnival (a script of the musical review). New York: Samuel French, 1962.

Thurber & Company. New York, Evanston, and London: Harper & Row, 1966.

Thurber, Helen, and Edward Weeks, editors. *Selected Letters of James Thurber.* New York: Penguin Books, 1984.

Rosen, Michael J., editor. *Collecting Himself: James Thurber on Writing and Writers, Humor and Himself.* New York: Harper & Row, 1989.

Rosen, Michael J., editor. *People Have More Fun Than Anybody: A Centennial Celebration of Drawings and Writings by James Thurber.* New York, San Diego, and London: Harcourt, Brace and Company, 1994.

Rosen, Michael J., editor. *The Dog Department: James Thurber on Hounds, Scotties, and Talking Poodles.* New York: HarperCollins, 2001.

Kinney, Harrison, editor, with Rosemary Thurber. *The Thurber Letters.* New York: Simon & Schuster, 2002.

The Tiger Who Would Be King (illustrated by Joohee Yoon). New York: Enchanted Lion Books, 2015.

Rosen, Michael J., editor. *Collected Fables.* New York: HarperCollins, 2019.

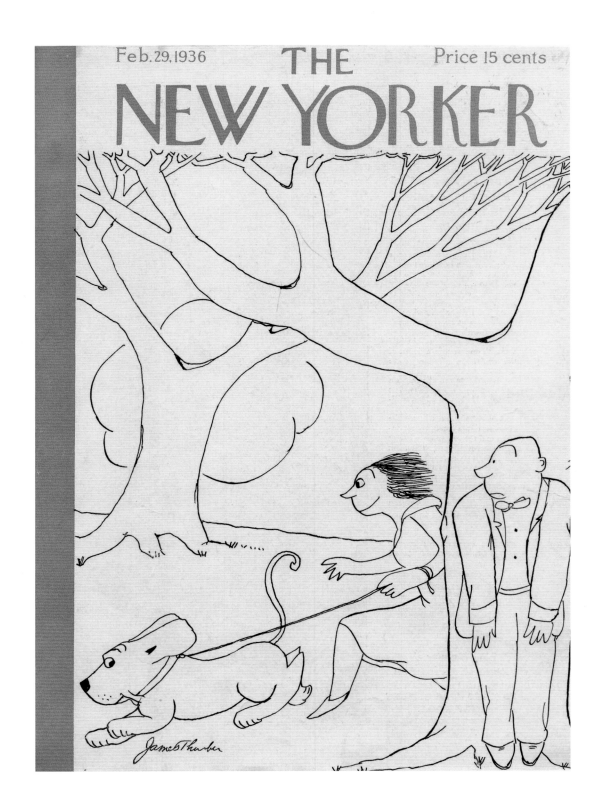

Notes and Sources

Acknowledgments

1. Letter to the Thurbers, January 5, 1954, in *The Thurber Letters*, New York: Simon & Schuster, 2002, p. 607.

2. Thurber, James, "Toast to a Lady," *New Yorker*, November 12, 1932, p. 11.

Introduction

1. Kinney, Harrison, with Rosemary Thurber, *The Thurber Letters*, New York: Simon & Schuster, 2002, p. 379.

2. "Author's Memoir," Thurber's prefatory note to *The Seal in the Bedroom and Other Predicaments*, New York: Harper & Brothers, 1950 edition, unpaged.

3. Thurber, Rosemary, personal correspondence with the editor, May 2, 2018.

4. "Thurber and His Humor," *Newsweek*, February 4, 1957, p. 53.

5. Sheed, Wilfred, "Blind Wit: James Thurber's Tragedy," *Slate*, September 18, 2003.

6. Kinney, Harrison, *James Thurber: His Life and Times*, New York: Holt, 1995, p. 660.

7. Letter to Helen Thurber, December 8, 1951, in the personal collection of Rosemary Thurber.

8. Short essay in the keepsake from Princeton University Library's exhibit "Some Original Drawings by James Thurber" (1944).

9. Thurber, Rosemary, personal correspondence with the editor, January 10, 2018.

10. "Thinking Ourselves into Trouble," *Forum*, CI (June 1939), p. 310.

Dorothy Parker's Introduction

1. Letter to Harold Ross, 1938. Kinney, Harrison, with Rosemary Thurber, *The Thurber Letters*, New York: Simon & Schuster, 2002, p. 585.

Chapter One

1. From an inscription on a cartoon, *New Yorker*, February 15, 1941 (see page 107).

2. Benét, Steven Vincent, and Rosemary Benét, "Thurber as Unmistakable as a Kangaroo," *New York Herald Tribune*, December 29, 1940, p. G6.

3. Nash, Paul, "American Humourous Draughtsmen," *Week-end Review* (London), August 8, 1931.

4. *Newsweek*, February 4, 1957.

5. Interview with Alistair Cooke. First aired on *Omnibus*, the Ford Foundation TV Program. Reprinted in *Atlantic Monthly*, August 1956, pp. 36–40.

6. Thurber, James, acceptance speech, National Cartoonists Society, November 2, 1956.

7. Benét, Stephen Vincent, and Rosemary Benét, "Thurber as Unmistakable as a Kangaroo," *New York Herald Tribune*, December 29, 1940.

8. Updike, John, "Technically Challenged Carefree Ineptitude: James Thurber," in *Cartoon America: Comic Art in the Library of Congress*, Harry Katz, ed., New York: Harry N. Abrams, 2006, p. 218.

9. Murrell, William, *A History of American Graphic Humor (1865–1938)*. Published for the Whitney Museum of American Art. New York: Macmillan Company, 1938, p. 197.

10. Ibid., p. 203.

11. Munger, Guy, "Thurber's Whimsy," Greensboro, *NC News*, October 1, 1950.

12. Murrell, William, *A History of American Graphic Humor (1865–1938)*. Published for the Whitney Museum of American Art. New York: Macmillan Company, 1938, pp. 210–211.

13. Ibid., p. 238.

14. Mankoff, Robert, "James Thurber's Giant Swoop," *New Yorker* online, from his column, "Cartoon Desk," June 15, 2011.

15. Kinney, Harrison, with Rosemary Thurber, eds., *The Thurber Letters*, New York: Simon & Schuster, 2002, p. 585.

16. Letter from Carl Sandburg, May 5, 1947, cited in Kinney, Harrison, *James Thurber: His Life and Times*, New York: Henry Holt, 1995, p. 886.

17. "Show of Paraphrases," Our London Art Critic, *The Scotsman*, February 20, 1939, p. 14.

18. Blunt, Anthony, Storran exhibit review, *The Spectator* (U.K.), 1937.

19. Kinney, Harrison, with Rosemary Thurber, eds., *The Thurber Letters*, New York: Simon & Schuster, 2002, pp. 382–383.

20. Ernst, Margaret S., preface to *In a Word* (illustrated by James Thurber), New York: Alfred A. Knopf, 1939.

21. Kinney, Harrison, with Rosemary Thurber, eds., *The Thurber Letters*, New York: Simon & Schuster, 2002, p. 502.

22. Whitman, Alden. "Katharine Cornell Is Dead at 81," *New York Times*, June 10, 1974.

23. Branscomb, Lewis, interview with Dr. Paul Underwood, 1985.

24. Ibid.

25. Diary note by Bonnard, February 1, 1934, quoted in *Bonnard*, exhibition catalogue, Paris: Centre Georges Pompidou, 1984, p. 190.

26. Thurber, James, "Proper Care of the Eyes Is Vital, Humorist Writes," *Columbus Sunday Dispatch* (Columbus, Ohio), January 17, 1960.

27. Kinney, Harrison, with Rosemary Thurber, eds., *The Thurber Letters*, New York: Simon & Schuster, 2002, p. 205.

28. Letter to Duke Damon, February 11, 1937.

29. Thurber, James, "Proper Care of the Eyes Is Vital, Humorist Writes," *Columbus Sunday Dispatch* (Columbus, Ohio), January 17, 1960.

30. Letter to Herman and Dorothy Miller, March 19, 1940.

31. Ibid.

32. Letter to Herman and Dorothy Miller, May 23, 1943.

33. Undated letter to E. B. White. Charles Holmes, *The Clocks of Columbus*, New York: Atheneum, 1972, p. 237.

24. Cowley, Malcolm, "James Thurber's Dream Book," *The New Republic*, March 12, 1945, p. 362.

35. Thurber, James, *The White Deer*, New York: Harcourt, Brace and Company, 1940, pp. 3, 4.

36. "Important Authors of the Fall, Speaking for Themselves," *New York Herald Tribune Book Review*, October 8, 1950, p. 4.

37. McCrary, Tex, and Jinx Falkenburg, "Personality Closeup," *The Detroit Times*, March 9, 1950.

38. Weathersby, W. J., "A Man of Words," *Manchester Guardian Weekly* (Manchester, UK), February 9, 1961.

39. Jennings, Paul, "Thurber: Man Against Monster," *The Observer* (London), November 5, 1961.

40. "Priceless Gift of Laughter," *Time*, July 9, 1951, p. 89.

41. Ibid., p. 88.

Chapter Two

1. *New Yorker*, July 9, 1932, p. 7.

2. Obituary, November 11, 1961, *New Yorker*, p. 247.

3. Thurber, James, "Author's Memoir," *The Seal in the Bedroom and Other Predicaments*, New York: Harper & Brothers, 1950 edition, unpaged.

4. Ernst, Margaret S., *In a Word* (illustrated by James Thurber), New York: Alfred A. Knopf, 1939, p. 7.

5. Ibid.

6. Letter to Ann Honeycutt, February 19, 1934. Kinney, Harrison, with Rosemary Thurber, eds., *The Thurber Letters*, New York: Simon & Schuster, 2002, p. 187.

7. Price, Victoria, quoting her father in *Vincent Price: A Daughter's Biography*, New York: St. Martin's Press, 1999, p. 56.

8. Millier, Arthur, "Melancholy Doodler," the *Los Angeles Times Sunday Magazine*, July 2, 1939, pp. 6, 12, 17.

9. Letter to Miss Frances Glennon, June 24, 1959. Thurber, Helen, and Edward Weeks, eds., *Selected Letters of James Thurber*, Boston: Little Brown, 1981, p. 121.

10. Kinney, Harrison, with Rosemary Thurber, eds., *The Thurber Letters*, New York: Simon & Schuster, 2002, p. 243.

11. White, E. B., *New Yorker*, November 11, 1961, p. 247.

12. Thurber, James, *The Last Flower*, New York: Harper & Brothers, 1939.

13. "Sex ex Machina," *New Yorker*, March 13, 1937, pp. 16–19.

14. Ibid.

15. Morseberger, Robert E., *James Thurber*, Twayne's United States Authors Series, New York: Twayne Publishers, 1964, p. 19.

16. "I Break Everything I Touch," *The Man*, 1941.

17. As quoted in Lerner, Michael A., *Dry Manhattan: Prohibition in New York City*, Cambridge: Harvard University Press, 2008, p. 4.

18. Sheed, Wilfred, "Blind Wit: James Thurber's Tragedy," *Slate*, September 18, 2003.

19. Morseberger, Robert E., *James Thurber*, Twayne's United States Authors Series, New York: Twayne Publishers, 1964.

20. Letter to Wolcott Gibbs, undated, September 1936. Kinney, Harrison, with Rosemary Thurber, eds., *The Thurber Letters*, New York: Simon & Schuster, 2002, p. 230.

21. Letter to Theodore Rousseau. Ibid, p. 579.

22. White, E. B., introduction to *Is Sex Necessary? Or, Why You Feel the Way You Do*, New York: HarperPerennial, 1978, p. xii.

23. Thurber, James, *Let Your Mind Alone*, New York and London: Harper & Brothers, 1937, p. 72.

24. Nugent, Elliott, *Events Leading up to the Comedy*, New York: Trident Press, 1965, pp. 70–71.

Chapter Three

1. Benét, Stephen Vincent, and Rosemary Benét, "Thurber: As Unmistakable as a Kangaroo," *New York Herald Tribune*, December 29, 1940.

2. Ferguson, Otis, review of "Fables for Our Time," *New Republic*, September 30, 1940.

3. Thurber, James, "The Lady on the Bookcase," in *The Beast in Me and Other Animals*, New York: Harcourt, Brace and Co., 1948, p. 66.

4. Thurber, James, "Author's Memoir," in *The Seal in the Bedroom and Other Predicaments*, New York: Harper & Brothers, 1932.

5. Thurber, James, "You Could Look It Up," *Saturday Evening Post*, April 5, 1941.

6. Thurber, James, "Preface," in *My Life and Hard Times*, New York: Harper & Brothers, 1933.

7. James Thurber, "Statement," in *I Believe: The Personal Philosophies of Certain Eminent Men and Women of Our Time*, Clifton Fadiman, ed., New York: Simon & Schuster, 1939, p. 300.

8. Kenney, Catherine McGehee, *Thurber's Anatomy of Confusion*, Hamden, CT: Archon Books, 1984.

9. "The State of Humor in the States," *New York Times*, September 4, 1960.

10. See Elderfield, John, Proceedings of the British Academy, 122, pp. 53–85. © The British Academy, 2004.

Chapter Four

1. "Mr. Thurber Observes a Serene Birthday," *New York Times Magazine*, December 4, 1949, pp. 17–19.

2. Kinney, Harrison, *James Thurber: His Life and Times*, New York: Henry Holt, 1995, p. 698.

3. Kinney, Harrison, and Thurber, Rosemary, eds., *The Thurber Letters*. New York: Simon & Schuster, 2002, p. 55.

4. Haldane, J. B. S., *The Causes of Evolution*, London: Longmans, Green and Co., 1932, pp. 153–54.

5. Thurber, James, "Statement," in *I Believe: The Personal Philosophies of Certain Eminent Men and Women of Our Time*, Clifton Fadiman, ed., New York: Simon & Schuster, 1939.

6. Letter to Miss Frances Glennon, June 24, 1959. Thurber, Helen, and Edward Weeks, eds., *Selected Letters of James Thurber*, Boston: Little, Brown, 1981, p. 121.

7. "Lo, the Gentle Bloodhound," *Holiday*, September 1955, pp. 36–37, 60–62, 64–66.

8. "True Fables," *Manchester Guardian* (London), February 19, 1957.

9. Thurber, James, *Fables for Our Time*, New York: Harper & Brothers, 1940.

10. Ibid.

11. Ibid.

12. Thurber, James, introduction to "The Race of Life," in *The Seal in the Bedroom and Other Predicaments*, New York: Harper & Brothers, 1932.

13. Ibid.

14. Ibid.

15. Thurber, James, "The Day the Dam Broke," in *My Life and Hard Times*, New York: Harper & Brothers, 1933.

16. Ibid.

17. Thurber, James. "The Case Against Women," *New Yorker*, October 24, 1936, pp. 15–16.

18. Ibid.

19. Ibid.

Chapter Five

1. "Thurber Responds to His Award of the Ohioana Sesquicentennial Medal," October 24, 1953, in *Thurber on Humor* (pamphlet published by Ohioana Library Association, Columbus, Ohio), 1953, p. 9.

2. Thurber, James, "My Senegalese Birds and Siamese Cats," in *Lanterns & Lances*, New York: Harper & Brothers, 1955, p. 195.

3. Morseberger, Robert E., *James Thurber*, Twayne's United States Authors Series, New York: Twayne Publishers, 1964, p. 106.

4. Holmes, Charles S., *The Clocks of Columbus*, New York: Atheneum, 1972, p. 154.

5. Fadiman, Clifton, *Reading I've Liked*, New York: Simon & Schuster, 1941, p. 293.

6. Plimpton, George, and Max Steele, "James Thurber," in *Writers at Work: The Paris Review Interviews*, Malcolm Cowley, ed., New York: Viking Press, 1959, p. 97.

7. Thurber, James, "The Car We Had to Push," in *My Life and Hard Times*, New York: Harper & Brothers, 1933.

8. Kinney, Harrison, *James Thurber: His Life and Times*, New York: Henry Holt, 1995, p. 140.

9. Ibid.

10. Letter to Mr. Rushmore at Harper Brothers, undated, likely 1932.

11. Kinney, Harrison, with Rosemary Thurber, eds., *The Thurber Letters*, New York: Simon & Schuster, 2002, pp. 220–221.

12. Thurber, James, "If You Ask Me," a column for New York's PM magazine, October 22, 1940, p. 11.

13. Lucas & Prichard, "'The Male Animal': James Thurber and Elliott Nugent See the Comic Side of Civilized Matrimony," *New York Times*, January 21, 1940, p. 115.

14. Thurber, James, "Thurber Reports on His Own Play, 'The Male Animal,' with His Own Cartoons," *Life*, January 29, 1940, p. 28.

Afterword

1. Thurber, James, "Author's Memoir," in *The Seal in the Bedroom*, New York: Harper & Brothers, 1950 edition, unpaged.

Chronology of Exhibitions

1. Washington Square Outdoor Art Exhibit website, www.wsoae.org.

2. Kinney, Harrison, with Rosemary Thurber, eds., *The Thurber Letters*, New York: Simon & Schuster, 2002, p. 237.

3. "Forty Original Drawings by James Thurber," a folded sheet printed by Valentine Gallery, New York, NY, 1934.

4. "Morose Scrawler," *Time* (New York), December 31, 1934, p. 38.

5. *American Art News*, December 22, 1934.

6. Benvenuto, *Columbus Dispatch* (Columbus, Ohio), February 23, 1936.

7. "Lunacy or Art, Thurber's Is a Good Show," Benvenuto, *Columbus Citizen* (Columbus, Ohio), 1936.

8. Letter from London to Ronald and Jane Williams, July 11, 1937. Kinney, Harrison, with Rosemary Thurber, eds., *The Thurber Letters*, New York: Simon & Schuster, 2002, p. 241.

9. Letter to S. and G. Gump Art Gallery, *Art Digest*, June 1, 1937.

10. *Sunday Journal & American* (New York), December 17, 1939.

11. Hartell, John, *Ithaca Journal* (New York), August 26, 1944.

List of Illustrations

ILLUSTRATIONS ARE identified by their captions or a brief, bracketed description of the subject, followed by their first appearance in print, if any. Information about each book can be found in the appendix "Books by James Thurber."

Au Quatrième

About the Editor

MICHAEL J. ROSEN served as the founding literary director of The Thurber House in Columbus, Ohio, the home James occupied during his college years, for nearly twenty years. During that period, he helped conceive all of the literary center's programs, including the Thurber Prize for American Humor, writer residencies, readings and workshops series, and a set of humor biennials published by HarperCollins. Working with the Thurber estate since the mid-1980s, Michael has edited five other volumes of Thurber's uncollected and/or unpublished works—*Collecting Himself* (HarperCollins); *People Have More Fun Than Anybody* (Harcourt); and *The Dog Department* (HarperCollins); a "best of" volume for the Folio Society of London; and, mostly recently, *Collected Fables* (HarperCollins). He is also the author of a variety of some 150 other books for both adults and young readers.

This book coincides with the exhibit, *A Mile and a Half of Lines: The Art of James Thurber* at the Columbus Museum of Art, for which Rosen is curator.

About the Contributors

A master of historical styles and movements, graphic designer SEYMOUR CHWAST is known for his diverse body of work and profound influence on the visual culture of this epoch. Cofounder of the internationally recognized and critically acclaimed Push Pin Studios, Chwast has developed and refined his innovative approach to design over the course of six decades. Personal, urgent, and obsessive, his eclectic oeuvre has delighted and guided subsequent generations, while revolutionizing the field of graphic design and its potency within American visual culture. Chwast has published a wide variety of monographs, children's books, and other visual compendia.

LIZA DONNELLY is a cartoonist and writer with the *New Yorker*, a resident cartoonist at CBS News, and a contributor to the *New York Times*, *Forbes.com*, and *Medium*. She has been profiled globally in numerous publications and her work has been exhibited around the world. Donnelly is also a cultural envoy for the U.S. State Department, traveling the world in support of free speech and women's rights. She has created sixteen books, including nine for young readers and a critically acclaimed history, *Funny Ladies: The New Yorker's Greatest Women Cartoonists and Their Cartoons*.

IAN FRAZIER grew up in Hudson, Ohio, attended Harvard College, and became a staff writer for the *New Yorker* in 1974. In 1997 his collection of humorous essays, *Coyote v. Acme*, won the first Thurber Prize for American Humor. Among his longer works of nonfiction are *Family*, *On the Rez*, *Travels in Siberia*, and *Great Plains* (a *New York Times* best seller). In 2009 his third humor collection, *Lamentations of the Father*, won that year's Thurber Prize; Frazier is the only person to win the prize twice. He lives in Montclair, New Jersey, with his wife, the novelist and short-story writer Jacqueline Carey. They have two children, Cora and Thomas, both of whom also write. Frazier's freelance work can be seen in *Outside*, *Smithsonian Magazine*, *The New York Review of Books*, *Tablet*, and *The Rotarian*. He is at work on a book about the Bronx, to be published in 2022.

MICHAEL MASLIN sold his first idea to the *New Yorker* in 1977 and has continued to contribute to its pages for forty years. He is married to fellow *New Yorker* cartoonist Liza Donnelly. For decades, he has written *Ink Spill*, a robust blog dedicated to news of *New Yorker* cartoonists past and present. Along with many collections of his cartoons, Michael recently published *Peter Arno: The Mad Mad World of the New Yorker's Greatest Cartoonist* (Regan Arts, 2016).

ROSEMARY THURBER, James Thurber's only child, manages the Thurber estate along with her daughter, SARA THURBER SAUERS. Sara, a book designer and letterpress printer who teaches at the University of Iowa Center for the Book, is the designer of this book, as well.

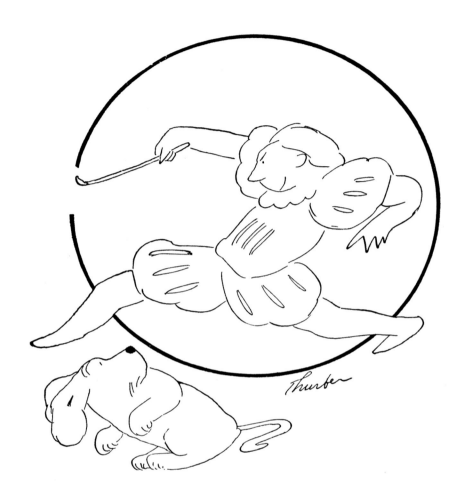

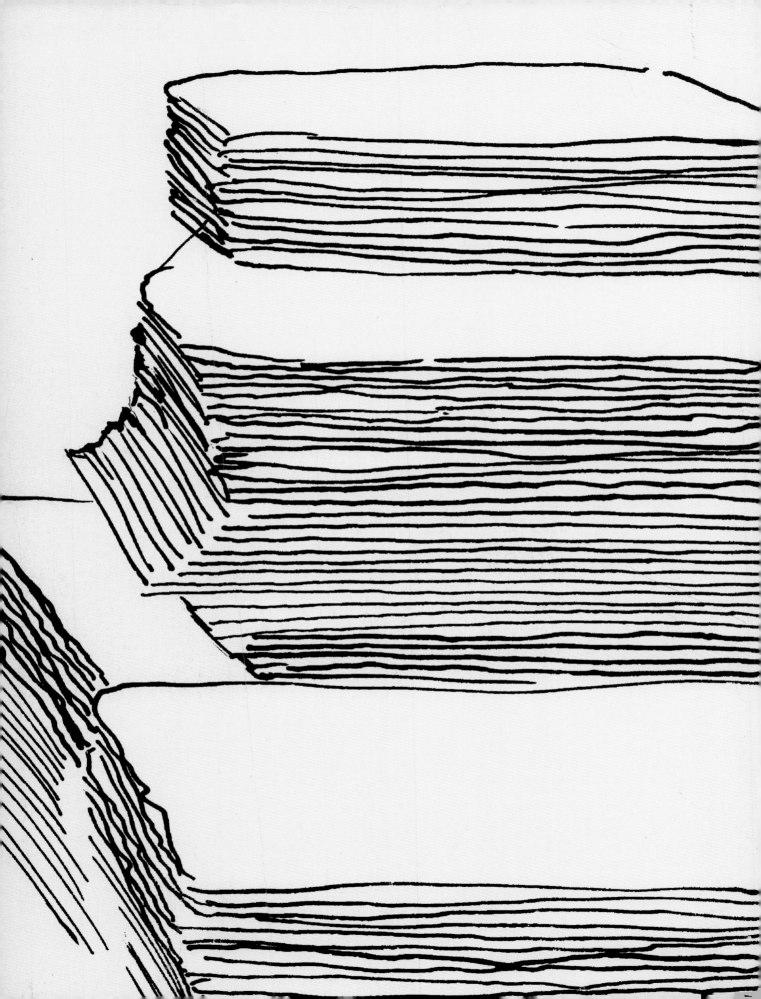